Helping
Themselves

GREGORY MOTTON

HELPING THEMSELVES

The Left-Wing Middle Classes in Theatre and the Arts

with illustrations by the author

LEVELLERS PRESS

Helping Themselves first published in 2009 by

Levellers Press
2 Middle Street
Deal, Kent
CT14 7AG
levellerspress@yahoo.co.uk

ISBN: 9 7 8 0 9 5 6 4 3 6 4 0 5

The moral right of Gregory Motton to be identified as the author of this work has been asserted in accordance with the Copyright, Designs and Patents Act 1988.

Printed in Great Britain by Athenaeum Press Limited, Gateshead.

CONTENTS

FOREWORD

ON THE EVE OF directing my first Gregory Motton play, *A Message for the Broken-Hearted*, the playwright sat me down over a friendly cup of tea and began quizzing me as to what I thought the play was really about. During the design process leading up to this, I had noticed a few moments when he had been unusually abrasive and forthright, pointedly telling me that, despite the complete lack of wing space, he wanted a big table to appear in the last scene 'like in a Bernard Shaw play'. As I tried to laugh this off, I realized that Gregory was absolutely serious and eventually a table duly appeared. So when the cup of tea was suggested, I was rather apprehensive and rightly so, because I emerged three hours later from the conversation, chastened, realizing that I had completely misread his play. But I was also energized and focused on what I now saw as a clear and important task: the realization of that play. I can only hope that readers of this book will emerge with similarly powerful and positive feelings about the plans outlined here.

Born in Wood Green to an English father and an Irish mother, Gregory went to comprehensive school. After bailing out of York University before the end of his first term, he pursued the path of the autodidact. His learning is broad and deep and, as you will witness here, applies to much more than the writing of plays. In London he started a theatre company called Ezra that he was then sacked from by his partner, found his way to Kate Harwood at Riverside Studios who put on his first professional production of a play called *Chicken* and thence to the Royal Court as well as the Bush, the Liverpool Playhouse and many theatres in France and elsewhere. He is an accomplished painter, speaks fluent Swedish, and has four children.

Interestingly his first plays from the late 1980s were often accepted as a critique of Thatcherism, the fragmented form seemingly hinting at the fractures of a world where the Prime Minister had announced there was no such thing as society. But while I wouldn't presume to speak for

Gregory on Mrs Thatcher, I doubt his plays would ever use form in so simplistic a manner. As his *œuvre* has progressed and his identity has become clearer, it also meant that it was difficult to put him into the slot marked out for the radical playwright. This wasn't the slot he craved in any case but the process whereby the Establishment can only see what it is bound to see, in this case a young playwright must be attacking the Conservatives, began a process of growing awareness about the unwritten cultural codes that govern acceptance or rejection, a process which finds eloquent and fulsome fruition here.

As a middle-class theatre director, I belong to the very lowest order of being in Motton's demonology. Added to which I spent nine years on the staff of the Royal Court Theatre, an institution that, as the acme of British playwriting and home to four of Gregory's own premieres, comes in for special treatment in this book. I vividly remember my first day at work in April 2000, sitting at a very stylish desk in the newly refurbished building, making a telephone call to Gregory. We joked, even then, that I was calling from the belly of the dragon. But four weeks later I found myself at the doctor's, convinced that I was suffering from multiple sclerosis or some other terrible wasting disease, as my muscles were in constant pain. After some routine tapping, pulling and manipulating, the GP, who remained terribly nonchalant, made some general enquiries about my situation and, when she discovered I'd recently started a new job, declared my illness to be the result of stress. Sure enough, the pains melted away. She was right, I was indeed experiencing real stress as I began to learn in detail what the ideology of the building was, the ways in which it differed from my own thoughts, how to reconcile the gap and then find ways to express it. It's of course a necessary part of anyone's induction into a new job, but it did surprise me at the time how painful the process was, and it is perhaps the clearest indication to date that the dragon really does exist. At the time the Literary Manager, Graham Whybrow, would periodically accost me in a corridor wanting to know what my insights as a newcomer were, because they were all under the influence of group-think and Graham assured me that there was only a small window of opportunity before I too fell under its inevitable spell. How right he was! It is Gregory's singular achievement in this book to

set about slaying the dragon of group-think. And the first step you must take as a dragon-slayer is to identify the beast and his lair.

During my very happy time at the Royal Court, we celebrated the fiftieth anniversary of the English Stage Company, which involved much digging in the archives and reassessing of the legacy. We did try to avoid any sense of complacency and sincerely wanted to keep the tradition moving forward, but even as I write these words, I can feel Gregory looking over my shoulder and sadly shaking his head. How I wish we'd had this book then: the corrective lens Motton brings to bear and his merciless skewering of attitudes, platitudes and postures is at times painful to read, but the argument throughout is wide-ranging, the thesis lucid, the polemic bracing, the humour acidic and the feeling passionate. Gregory's reading of the political, social and cultural history which has made the British theatre what it is today is absolutely salutary, cogent and valuable, and everyone who works in it should be forced to read this book. I hope it will act upon them as a hugely beneficial and communal emetic.

Ramin Gray
Director

Relationships of ownership
They whisper in the wings
To those condemned to act accordingly
And wait for succeeding kings.
I try to harmonise with songs
The lonesome sparrow sings,
And there are no kings
Outside the Gates of Eden.

(Bob Dylan)

1 A MIDDLE CLASS REVOLUTION

THE PAST FOUR DECADES have seen a social revolution. It is part of the propaganda victory of the new middle class establishment that they have managed to present their rise to ascendancy as a popular movement, and to associate it in people's minds with socialism, and, by extension, with the working classes. This impression is false.

In fact, the shift of power was marginal; the middle classes have taken power from the Old Establishment which was formed of the upper and upper-middle classes. For one sliver of the middle classes to wrest power from those just above themselves has cost a great upheaval, as the ideological weapons they used to take power, and to reshape society to their requirements, has created fall-out that has changed our society radically, largely to the detriment of those at the bottom end.

After twelve years of Labour government the inequalities of income remain more or less the same as before; in fact, the gap in wealth has widened. The number of people on low income[1] is still lower (just) than it was during the early 1990s but much *greater* than in the early 1980s. But the proportion of people on very low income[2] remained unchanged for the past eight years, and has now actually gone *up*. In fact, in 1979 it stood at 2.9 percent; it is now 9.4 per cent!

While the government has taken some action against poverty, removing 600,000 of the very poorest children out of poverty, this has all been through the action of Working Family Tax Credits, a means-tested benefits-in-work system. (In fact, the lowest incomes from work have actually become even lower so that there are now 800,000 more in need of this benefit in work than ten years ago.) The real difference in the wealth gap is not between under the Tories and New Labour, but between Britain as it was in 1979 and subsequently. Inheriting the crushed unions from

1 'Low income' defined as 60 per cent of median income.
2 'Very low income' defined as 40 per cent of median income.

the Tories, the Labour government has overseen no progress in working class incomes through work. Tellingly, in 1979 there were 7.6 million on low income and now there are 13 million. In 1979 there were 1.3 million on very low income; now there are 5.6 million. The working class slice of the pie remains the same, and for the worse off, it's smaller. The UK has a higher proportion of its population on relative low income than most other EU countries.[1] One significant detail is that the geographical separation of rich and poor has increased,[2] which indicates that the better off are very well aware of the social problems accompanying this inequality in wealth, and do their best to keep away from them. These social consequences are even less talked about by the left than the material inequalities. In fact it is a distinct feature of the middle class left, that they deny the existence of the worst social problems. Except when it comes to deciding where to live.

The Labour government since 1997 has shown that left-wingism in Britain at present has barely any connection with the working classes. There has been no significant alleviation of poverty, and the social problems besetting the working classes have been consistently ignored by the government and their supporters. It seems that under a Labour government the working classes have ended up with no voice in politics, to the extent that Labour Party members openly talk of their fears that the working classes will turn to the far right out of sheer frustration with what is supposed to be their own party.

Left-wingism, which has in the meantime positively thrived, has become essentially a middle class phenomenon; that is, it is controlled and defined by the middle classes, and it serves the interests of the middle classes. It does not take into account the actual opinions and outlook of the working classes, and does not pay attention to their problems or interests. This has been so to an increasing extent since 1951. You could say that the more the middle classes have sought to identify them-

[1] Of the 27 EU countries, only four have a higher rate than the UK: Greece, Italy, Spain and Latvia.

[2] Source: Joseph Rowntree Foundation, *Poverty and Wealth across Britain 1968 to 2005* (2007).

selves with socialism and the working classes, the less the interests of the working classes have been represented in society.

How small a part does material equality play in the minds of the middle class socialist? The huge discrepancies in pay between the middle class and the working class are now taken for granted and do not form a part of any left-wing consciousness, which now focuses instead on marginal issues which have little bearing on the working class experience.

One might expect a proper working class government, for example to end the use of bailiffs (except for the collection of fines imposed by the criminal courts). For the poor, who are routinely preyed upon by loan companies, and who for the past 20 years at least have suffered enormously from debt of different kinds, this essentially violent and invasive phenomenon is a distressing, frightening and humiliating feature of life at the bottom end of society. This is where it really bites, this is what it means to be poor. This outmoded use of thuggery against the weak and vulnerable ought to be outlawed. And would be if it were used against the middle classes as it is against the poor. But to the average Labour government minister, it is as alien as the plague.

It is sad fact of modern politics that the life experiences of the lowest sections of society remain out of view to the influential classes. And there is no prospect of that being changed by radical or conservative politics. The surge in the power of the middle classes, and their displacement of their upper class rivals, has left the poorest in the same state they were always in.

Not even the small shopkeeper, at the top end of the working classes, benefits from any consideration from the new middle class establishment, who have failed to see the importance of protecting, for example, the small local shops against the national chains. The consequences of this in the larger economy are now at last being recognised in the weakness of the economy (in which all power and money has been concentrated at the top, which has collapsed), which lacks sufficient regenerative ability because the small business has been systematically sacrificed to the interests of big business, regardless of the impact on the economy or the community.

Much of this has to do with the make up of the new establishment who are typically professionals in the media and administrative sectors, to whom the problems of the poor, and those of the small businessmen or shopkeepers, are equally remote. There is even a vague sense that the material concerns of such people, the very poor and the not so poor, are beneath the lofty moral (political) outlook of the middle class left.

Until universal male suffrage in 1918 the working classes had no actual representation in politics at all and had only been able to promote their interests by agitation and organisation, such as Chartism and the trades unions; other than that they relied on the political parties of other classes to represent their interests, which they did of course only to varying limited degrees.

The founder members of the Labour party were working class: Kier Hardy, Ramsay MacDonald, David Shackleton, Arthur Henderson, George Barnes. Labour enabled trades unions to finance candidates, and the support them as MPs at Westminster. Though its early successes were not conclusive – the 1924 government wasn't even a majority – the subsequent split and collapse of the Liberal Party soon meant that the Labour Party was the only viable opposition. This of course changed everything. Clement Attlee, Hugh Dalton, Hugh Gaitskell, Harold Wilson, Roy Jenkins, Anthony Crosland, Richard Crossman, Barbara Castle, Dennis Healey, were all middle class; most were public school educated (the rest grammar school) and all had been to Oxford. The Labour Party was a route to power which anyone could take.

By 1987 they had abandoned nationalisation, and by 1993 their ties with the unions. By 2008 Conference was dominated by the Parliamentary Labour Party and guest speakers, and declared that 'we are, we always have been and we always will be a pro-business government'. This conference was also the first at which trade unions and constituency parties did not have the right to submit motions on issues which would previously have been debated on the floor. Blair's New Labour had changed its name and taken a significant step away from the working classes and the unions: the Labour party was now like a new Liberal Party, the party of the non-Conservative middle classes. The Labour government signed up to the EU treaty which outlawed the

minimum wage, and which had extensive measures to ensure that cheap labour could be used in Europe whenever capitalism needed it. The EU effectively set the trades union movement back to the 19th century, with the added twist of branding the working classes who protested as racists and nationalists.

This meant that left-wingism too had changed. It was still an ideology, still based on adaptations of Marxist analysis by Marxist philosophers such as Althusser and Marcuse, but it was now an ideology which no longer laid any emphasis on the levelling of wealth. It didn't regard the economic interests of the working classes to be of primary importance, and it certainly didn't identify itself with any other aspects of working class outlook. Left-wingism had shifted its interest to other isolated issues of race, gender and sexuality which it could happily pursue without the middle classes having to give up any of their ascendancy in the market place, or the power that went with it. The middle class revolution, effectively, stopped there. It turned out that the new Althusserian brand of socialism could even be used *against* the working classes, to silence them, and to exclude them from politics. In effect, the working classes were surreptitiously made the new undeclared enemy, who could be defeated by silent and indirect means. Laws were passed to silence aspects of working class opinion which didn't agree with the middle class version of socialism. It was now difficult for the working classes to express their concerns over housing and immigration, for example, and over certain aspects of gender and sexuality politics, without literally risking arrest, as the confused police were now being used to control what people said. Their predicament has been acknowledged by the senior Labour politician Frank Field,[1] who has said publicly that he realises that the working classes must have a right to their opinion on council housing, education, crime and immigration, and social security. This limited acknowledgement has failed to heal the rupture between the working classes and what used to be their political party.

The Labour party's relationship with the unions, too, has in the end been a betrayal of the original purpose of the party. In the 1960s

1 See his own website, www.frankfield.com.

and again in the late 1970s the unions' attempts to gain wage rises was treated as inflationary, whereas it was the CBI's resolve to pass on wage rises as price rises that was inflationary. The working classes were effectively forced to accept the status quo on wages, which again meant the middle class revolution was actually a block on working class interests. The middle class Parliamentary Labour Party saw to it that it was not possible for the working class share of the wages bill to ever be larger.

Thus the British working classes were denied the advantages won in other countries such as Sweden, where collective bargaining had won higher wages for the working classes, and where this, along with high taxes, had achieved a high degree of equality as well as continued prosperity. In Britain social and economic conditions for the working classes were doomed to remain the same.

It was at the same time as the Labour party was moving away from the working classes, that the newly powerful section of the middle classes – the urban middle classes, the beneficiaries of the social revolution in progress – grew to identify with aspects of left-wingism, and to call themselves socialists. As these were typically a prosperous and successful group, often working in broadcasting, journalism, advertising, education and various levels of administration in many different fields, their influence was considerable in many important spheres in society. This gave two results: they have greatly influenced the development of society and opinion; and they have brought about the changes in left-wingism and in the definition of socialism, and in the Labour Party itself which they have in effect colonised. Both these effects have resulted in the further marginalisation of the working classes.

It is hard to overestimate the influence of this left-wing section of the middle classes over the past decades, in or out of power, in shaping the way people think. Crucially they gained control of education early in this period, and even during the long years of Tory rule it has been largely their (Maoist) theories which have shaped education, the system and the syllabus. It has been an area where ideas formed according to far-left principles have been able to transform the very notion of teaching. Again, the complex theories of the new middle class version of socialism have taken over from any idea of socialism giving working

class children equal access to education. The result has been a complete collapse of standards, right up to university level – which various governments have sought to conceal – and a dramatic widening of the gulf between the elite and the many millions of those at the bottom end. The lower working classes, who are the ones the new theories are really applied to, have been effectively cut off from knowledge (even that word is frowned upon in education circles), and have had to make do with learning government jargon by rote. It is something that could only have happened when the interests of the people were seen exclusively from a middle class viewpoint. A working class government never would have thought of abolishing knowledge in schools, for example, as they cannot afford to do without it. Only middle class parents can accept the idea, because they know they have access to knowledge anyway, by other means.

Over the past 30 years, the influence of the left-wing middle classes over morality in particular has been conclusive, and a complete transformation of Britain's morals and behaviour has taken place. There has been a drastic 'liberalisation' of behavioural standards through parents and in schools, and then a reform of police and courts to accommodate it. The result has been a spectacular leap in the crime rate, so large that it almost defeats any attempts to measure it, despite government's efforts to conceal it and manipulate it, as well as Home Office claims that it might merely record an increase in *reports* of crimes.[1]

There are now literally millions of crimes per year, and it is one of the most tangible changes to society, at least for the working classes, whose lives are the ones most affected by it. The other result is the enormous prison population: since the prisons are full of the worst educated people from the most disadvantaged sections of society, this is not something which concerns the left-wing middle classes overmuch.[2] But it is the direct result of the liberalisation they have created, as well as the transformation of the police from a crude but effective part of the community,

1 The number of indictable offences per thousand population in 1900 was 2.4 and in 1997 the figure was 89.1: that is, *more than five million crimes per year.*

2 The UK prison population is around 88,000, the highest prison rate per population in Europe.

to an arm of an increasingly repressive and powerful state (see the GM protests) who are nevertheless completely ineffectual against street crime.

The transformation of Britain from a country with one of the lowest crime rates and prison populations,[1] to one with two of the highest, from one with a famously low level of violence, to one with a famously high level, are aspects of the reform of values which get the least attention from the left-wing middle classes, as they too, like the destruction of education, affect them least.

A working class government simply could not ignore this phenomenon. To see a working class view you would need to see what the *The Independent Working Class Association* say about it, for example. But successive Labour governments have ignored it, despite being partly elected to solve the problem. Under them, violence in Britain has reached a level where many fear to leave their homes, and children go in fear of their lives.

The urban middle classes' identification with left-wing ideas ought to be seen, then, in the context of the middle class revolution which has taken place. For it is notable that many of the aspects of this new left-wingism coincide with another sort of liberalisation – the kind required by consumerist capitalism. The removal of traditional impediments to the appetites and desires which are the engine of consumerism has been a parallel feature of the past decades, and again it is the urban middle classes who have driven the changes. Inhibitions, morality, and all forms of moderation were gradually removed by advertising: moral inhibitions were replaced by a cult of individuality, which became egotism, which became downright violence; and all these changes were in part promoted by advertising (that feeble word no longer does justice to the social engineering tool it now is) and selling, and these were driven by the middle classes. After the explosion of personal freedoms in the 1960s they had no difficulties synthesising left-wing libertarian ideas with the hard-nosed egotism involved in selling, even as it later developed into its later, more nihilistic forms, including the promoting of violence.

1 In 1931 the prison population was 10,000; in 1961 it was 20,000; now it is 88,000.

The constant targets for change have been all the characteristics of Britain which the urban middle classes identify as typical of the old establishment: old-fashioned taste, morality, methods in teaching, manners, styles, entertainments, speech patterns, etc. This has included canonical literature, that is to say most of what is good in English literature; ideas of decency; standards in education; restraint in various modes of behaviour; censorship of sex and violence. It has included many aspects of the national character, the whole of British history, knowledge and understanding of our political system and our system of law, anything in fact which belongs to the past. All these have rightly or wrongly been associated with the old establishment, and then destroyed. The Carthagisation of the old order and the idea of Britain that, in middle class minds, goes with it, has meant that not only has their class taken over the reins of power, but also the whole country has been transformed in the process.

Left-wing ideas were a suitable tool to remove the vestiges of the old order, much (but not all) of which was based on old ideas of privilege and hierarchy. The ideas have been used, however, to remove one privileged class and replace it with another. The liberalisation of all conduct and the elevation of the individual above the community are purely middle class, capitalist ideas, grafted on. And yet the outcome of the revolution has shown that it is the latter ideas, rather than the levelling of hierarchy, which are the most characteristic of the new era. For while certain older forms of hierarchy have certainly been removed, these have simply been replaced by similar new ones: the hierarchy of money, where the middle class thrive and the working classes do not, and a new one of ideology, which condemns the working class to be subjugated in their opinions even, by the new masters, who have pushed them to the margins of social and cultural life, and even colonised their political party.

The revolution is complete, the old values of the old establishment have been removed. The new masters and their new values have formed a country that is virtually unrecognisable. Now that everything that aggravated the middle classes about the old way has been removed, the burden of the nihilism and chaos which characterises New Britain is the lot of the poorest to deal with.

2 THE FLOOD GATES

Herbert Read and the Surrealists — art and rebellion against the status quo

THE TREND IN BRITISH politics described in the last chapter is within the context of the Europe-wide, or (with exceptions) worldwide, growth to ascendancy of the middle classes, and the parallel growth of capitalism, liberalism and socialism, and the extension of their influence over the formation of opinion. Between them, these three ideas – partly compatible, partly not – were more or less to dominate the world over the 20th century. In a pluralist society such as Britain, the three could exist and thrive alongside each other and, to a large extent, merge. It is also the era of totalitarianism, and of the expansion of the state.

Part of the transition from the old order to the modern world has been the resolution of the dichotomy between classicism and romanticism, in favour of the latter. This dichotomy had a political manifestation in the French Revolution and the conservative reaction against it. Throughout the early 19th century when reaction and liberalism struggled for ascendancy, one major victory for romanticism was the rise of nationalism which later reshaped Europe's political barriers. This marked the beginning of the end of the era of the great empires and the aristocratic domination of Europe constructed by Metternich at the Congress of Vienna.

The classical ideas, which were largely pan-European and which spoke of a natural order, of reason and harmony, and which tended to argue for hierarchical regulation of society, gave way to the passionate and romantic nationalist mythologies of romanticism.

The pan-European aspect of liberalism in the days of the French Revolution and Napoleon's continental system, and the exporting, by military force, of revolutionary ideas across the Europe, was more or less

gone, surviving only in the socialist writers. Liberalism was anti-aris-
tocratic and led to the populism of nationalistic enthusiasm: classicism
was associated with the ruling aristocracies; it was their art and their
architecture, and their system of conservatism, based on harmony and
stasis, and, in Europe, secret police.

Romanticism combined the liberal ideas of the French Revolution –
which also claimed to be based on Reason – with the ideals of individual
heroism, of Byron's *Manfred*, and Goethe's *Young Werther* (both these
combined their romanticism with aristocratic spirit and a love of clas-
sicism too). Along with this went the notions of mythical and spiritual
and political rebellion, of Shelley's *Prometheus*, and the brutal philoso-
phies of Nietzsche.

The struggle between the two outlooks was never conclusive, and the
alignments never clear-cut. The two sides shared some of their origins
and attributes, and had ideas in common, even to the extent of being
two sides of the same coin, or process. They survived each other's
onslaughts and by the late 19th century you certainly wouldn't be able to
conclude that one idea had finally triumphed over the other. In England
at that time it would be noticeable, though, that classicism informed
many of the attitudes of the aristocracy, while romanticism was associ-
ated with rebellion, against authority, and even sometimes against God.
One represented a view of nature and harmony; the other the troubled
human spirit. The English public schools, for example, were reformed
by the inspiration of Dr Arnold, from the ideal of the *aristocratic* gentle-
man, educated solely in the classics, to the more romantic ideal of the
Christian gentleman, and the beginnings of what might be called a
liberal education. In art and architecture the socialism and mythologi-
cal romanticism was united in the work of William Morris and the pre-
Raphaelites, as well as the gothic revival of Ruskin, Pugin and others.

When the great cataclysm came, and the Great War sent millions to
their unnecessary deaths, it is perhaps not surprising that on the face of
it, of the two outlooks to come out most discredited, it would be the one
most readily associated with the old order, classicism. And such indeed
was the case. The upper class generals 'led' from the rear without taking
the field, and sat drinking champagne in châteaux while giving orders for

hundreds of thousands to meet their deaths. Their cowardice and military ineptitude, which ought to have led to them facing military tribunals and being shot – as indeed many a poor shell-shocked soldier was shot for 'cowardice' – was a significant nail in the coffin of the old order. The consequences of their apparent contempt for the lives of their men (which would have had the Duke of Wellington, whose principle was to win by keeping his men *alive*, groaning in his grave), was witnessed first hand from both sides, by their sons and grandsons who as junior officers led from the front and suffered as a class the highest casualty *rate*, and saw the full reality and horror of the war. This was the younger upper class generation, many of whom could no longer believe in the certitudes of the old order.

In terms, though, of the actual causes, rather than the *conduct*, of the war, the romantic and nationalist ideas which formed Europe from 1860 to 1914 were just as much to blame. Certainly German nationalism and the ruthless machinations of Bismarck and von Schlieffen were among the obvious direct short- and long-term causes of the war, as least as much as the personality defect of Kaiser Wilhelm.

In this context it is perhaps curious that it was only the old established order which got it in the neck from history and from the survivors of the First World War.

It is even more of a pity when we remember that it was nationalism – rather clearly rooted in the ruthless romanticism of Nietzsche, and in the totalitarian fantasies of Rousseau – which thrived and then led directly to the most awful of wars soon to follow, which claimed 50 million lives.

I choose to write about Herbert Read here, not only because of his influence, which was great but which has waned, and not because his ideas are extreme in one direction or another, but because he is representative of a trend in thinking which came to form our own. Many of his ideas are now taken for granted by the average gallery visitor or theatregoer. Herbert Read sits unnoticed, and unrecognised, at many a middle class dinner party. His ideas and opinions are now the commonplaces which form the orthodoxy to which most middle class people, especially those interested in the arts, adhere.

In 1936 Herbert Read, art critic and poet, and decorated veteran of the trenches, defended the Surrealist Exhibition against its detractors, among them J B Priestley. He wrote an introduction to the catalogue in which he claimed that surrealism had decided the classicism-romanticism argument for good.

I think it is interesting to look at what he said because it is part of a turning around of our attitudes and judgements – in morality in general and in art in particular. Read didn't have the benefit of hindsight – I imagine I might have written as he did – but looking back I see that future developments do indeed shed some different light on his judgements as they do on our contemporary attitudes and presumptions. It is time we began to look at them differently.

Surrealism itself does not maintain a very active or significant position in British minds, but its existence did form many of our ideas, not least because of its role in weakening the values of the social order that went before.

'The Surrealist is opposed to current morality because he considers that it is rotten', wrote Read in his Introduction to the Surrealist Exhibition. He goes on to list inequality of wealth, the waste of the world's resources, the starvation of many and the existence of war, hypocrisy, and the repression of sexual instincts as the 'most general features' of this morality, 'for which the surrealist has nothing but hatred and scorn'. (He doesn't specify which of the surrealists he has in mind as being driven by these philanthropic concerns; Dali was a fascist, Breton et al were Trotskyists who nevertheless denied the priority of the proletarian struggle.) At any rate the surrealist's code of morality, he says, is based upon liberty and love:

> it is his belief that the whole system of organised control and repression which is the social aspect of present day morality, is psychologically misconceived and positively harmful.

This little quote alone might be said to summarise the opinions of the middle class left in Britain today, insofar as they regard 'morality' as the remnants of the previous morality. (They do not call their own set of values a morality.)

The surrealists had the solution, though:

> the fullest possible liberation of the impulses – what law and oppression have failed to achieve will in due course be brought about by love and fraternity [...] The surrealist is not a sentimental humanist,

Read argues,

> but his analysis of the sexual, affective and economic life of man has given him the right to use the words cleanly.

Soon after this, the war against Hitler prevented this experiment from getting under way, and it wasn't until prosperity and peace were established fifteen years after the war that these ideas and ideals (as well as a strongly surrealistic strain in popular music lyrics) had their day. We, unlike Read, have had the chance to see how it unfolded.

Read describes, with some scorn, the attack J B Priestley made on the Surrealists in 1936 (one which was echoed by a weaker establishment as it was swept away in the 1960s). Priestley said in 1936 that:

> the surrealists stand for violence and neurotic unreason. They are truly decadent. You catch a glimpse behind them of the deepening twilight of barbarism that may soon blot out the sky, until at last humanity finds itself in another long night.

With hindsight it is Priestley's words which have greater resonance than Read's defence of the surrealists, as they most nearly describe what was in store. Read dismissed Priestley's concerns as do all apologists for the new, and called it 'the fulginous perspective', and claimed to know what 'a man of Priestley's prejudices' meant by decadence; but I wonder if he really did know. We can wonder if even Priestley knew how real the decadence would be. All such concerns were temporarily eclipsed by the fight for the survival of civilisation against violent onslaught.

After the 'froth of society' had dispersed from the 1936 Exhibition, the 'serious public of artists, philosophers and socialists [as Read called them] remained', and the 400 year-old battle between classicism and romanticism was, at least for the serious-minded Read, decided once and

for all, not in fact by a dialectic synthesis which Read said he had hoped for, and which 'might have been called Reason or Humanism,' but by in a fact a 'liquidating' of classicism, 'showing its complete irrelevance'.

Read was in no two minds about the nature of classicism:

> It has always represented the forces of oppression. It is the intellectual counterpart of political tyranny [...] and it is now the official creed of capitalism.

He quotes the critic H J C Grierson, whose moderate view he rejects:

> a classical literature is the product of a nation and a generation which has consciously achieved a definite advance, moral, political, intellectual, and is filled with the belief that its view of life is more natural, human, universal and wise than that from which it has escaped [...] the work of the classical artist is to give individual expression [...] to a body of common sentiments he shares with his audience: thoughts and views which have for his generation the validity of universal truths.

This was a damning definition for Read, who saw in that position the complacency of the establishment, whose particular values classicism represented. What is interesting now is to see how little it differs from what one might reasonably say about the *current* artistic establishment, who are the inheritors, not of classicism, but of its opponents, of Read and his romanticists, the surrealists, the self-styled anti-establishment artists, who now form today's Establishment. Read it again and compare...

Grierson went on to say that Romanticism was a corrective to classicism's order and synthesis: 'a reminder of the finite nature of that synthesis, a reminder that our clothes no longer fit us, that the classical has become merely the conventional, that our spiritual aspirations are being starved'. In other words, that there was room for both and that one was a corrective of the other. Such compromise goes against the Romantic spirit; it would have made Nietzsche quite sick.

Read rejected Grierson's view, saying that 'the society of synthesis, of natural order and balance of forces merely represents the dominance of one particular class'. He also says that:

> the norms are always typical patterns of order, proportion, symmetry, equilibrium, harmony, all static and inorganic quali-ties, which repress the vital natural instincts of growth and change: they are not freely determined preference but merely an imposed idea.

Read could not, perhaps, be expected to know from a merely British context that his analysis might just as well apply to a society built on a non-classical orthodoxy, that the chief elements of it pertain in any society and has nothing essentially to do with *classicism* in itself, but more to do with power, *however* and by *whomever* that power is constituted.

But he needed only to look at Russia to see how the predominance of a political class manifested itself there – or indeed at Germany.

We, as inheritors of Read's generation's thinking, ought to be able to see that in our own society, after the revolution against the old order, despite the changing of the guard that has occurred, not much else has changed. The 'economic and therefore cultural dominance' of the middle classes is very plain to see in our own contemporary society, even though that particular class has Read's own thinking as part of the foundation of its ideology.

We have to ask whether the ideology is actually different, and if it is different, is it any more desirable. The stasis of classicism is supposed to be replaced by organic change. Indeed there is a sense in which 'change' is a feature of our society, but when change is all in the same direc-tion, getting rid of the old guard and establishing the new, when does it stop deserving to be called change? It has already now reached a state of stasis, as anyone who has ever tried resisting or arguing against the dominant orthodoxy will know.

What does Read mean by organic? A change of power and the setting up of a new regime is no more organic than the retention of power: both are features of nature to some degree; both are even a feature of dialec-tics, which is probably the sense in which Read uses 'organic'. And once the new regime has set itself up, the 'change' it orchestrates and controls, is not change at all, any more than the 'permanent revolution' of Maoism

is real change. The kind of change we have in our society is the new kind of change – change that is a function of the powerful forces that hold on to power.

Capitalism requires and creates change of a kind: the kind of change that prevents other aspects of society from resisting its demands and its power: the kind of change that weakens the whole of society so that it can control it all the more. Left-wingism, its close friend and ally, also requires and creates change of a kind: the kind of change which re-enforces its ideology, and its power, regardless of the cost to those with no power to resist. Indeed change itself has been raised to the status of an absolute good, and resistance to change has been established as an absolute bad; this is a direct manifestation of the ideology of the new regime. And that orthodoxy, just like the old one Read described, sets its values up as 'self evident, universal, unchanging and unchallengeable', identical in that respect to the one it replaced. The difference now is that we have change – that is no change; we have rebellion – that is no rebellion; individualism – that is not individualism; even community that is not community; respect that is the very opposite…the list goes on, the circle is fully drawn.

So, rejecting Grierson's picture of society being a compromise between order and change, Read defines the two principles thus:

> There is a principle of life or creation, of liberation, and that is the romantic spirit; there is a principle of control and repression, and that is the classical spirit. Naturally there is some purpose in the latter principle – the instincts are curbed in the interests of some particular ideal or set of values, but on analysis it always resolves into the defence of some particular structure of society, the perpetuation of the rule of some particular class. Romanticism, is not just the spirit of revolt, it is the spirit of life itself.
>
> The universal truths of classicism are merely the temporal truths of an epoch, the universal truths of romanticism are coeval with the evolving consciousness of mankind.

Not only this but, according to Read,

> it is now that the artist can repudiate the bonds of classical
> theory with the aid of modern dialectics and modern psychol-
> ogy, of Marx and Freud, putting their beliefs on a scientific [sic]
> basis.

Read says that the surrealist asserts the impossibility of producing a
work of art by the conscious exercise of talents:

> The notion that a work of art can be created by observing a set
> of rules is only to be compared with the notion that a human
> being can be produced in a test tube.

Well, the rules, having been abolished, have returned; and you can find
them, sometimes even written down, in theatres. We have come full
circle: well, humans are made in test tubes and the Royal Court teaches
the rules of play-writing. Either the theatre is way behind the plastic arts,
or it has jumped ahead and gone straight to the point where the rules of
the new order can be imposed in the same way as the rules of the old
order, in direct contradiction to the libertarian or romantic ideals their
revolt was based upon.

Rejecting Hegel's (whose dialectic he otherwise follows) ideal of
a 'reflective and ratiocinative culture' (where you think before you do
something stupid), Read explained that surrealists 'assert with the
strongest conviction our disbelief in the inevitability of the desirability of
such a culture […] For good or for evil,' he says, perhaps rashly,

> the instinctive components of our being are irreducible and irre-
> placeable and we ignore them at our peril […] the mass hysteria
> manifested in nations such as Germany is the collective aspect
> of general repressions.

This is the same as the basis of the ideas of the 1960s.

Here he, and the surrealists, make a serious mistake in their under-
standing of psychology: he takes the controlling of instincts, which is
essential to individual and social health, and which is indeed the basis
of civilisation or even the possibility of *any* civilisation, and confuses
it with the possession by archetypes, which has nothing to do with the

kind of repressions he means. In his example and application of his idea, he forgets that the British, for example, were in a sense very repressed as a society, yet could hardly be called warlike in 1936, having more or less completely and disastrously, disarmed ourselves.

The silliness of Read's 'psychology' continues. He goes on to attribute the existence of war itself to repression:

> We are beginning to know sufficient about our civilisation to be sure that war has no simple explanation in economic forces [clearly Read abandons Marx for a moment, rejecting him in favour of his own understanding of Freud] but is probably not unrelated to the frustration of certain primitive impulses during childhood, a frustration which is prolonged and enforced by adult codes of morality.

War exists, apparently, because little boys are told 'no' to their desires.

Read himself knew war first hand and was decorated twice. Indeed he gives a convincing account of the 'dreary shattering of human flesh in conditions of physical and mental disgust'. It is surprising that he could mistake the social and economic and even psychotic causes of war for neurosis. He might have done better to describe it, using the ideas of Jung, as the grip of an archetype upon the collective unconscious.

It is indeed one of the most remarkable features of intellectual life in the previous century, how the ideas of Freud gained such widespread credence and influence, especially amongst the middle classes, to certain sections of which Freud's theories constituted a kind of bible, and a kind of science, whose methods and ideas were beyond question. It is now at last unravelling. The dishonesty and crude distortions and manipulations in his reports of his findings and his methods of arriving at them are astonishing, and amount to simply putting words and ideas into his patients' heads, with an extraordinary degree of force. Contrary to all scientific rules (and using methods even modern Freudians would condemn), he decided what he was looking for and set out to find it, and shamelessly twisted the facts to fit his theories. By his own admission he didn't cure a single patient. He treated epilepsy as hysteria and repression, and then concealed his failure to

cure the patients. He claimed to have revealed, by his strangely insist-
ent methods, memories of infant sexual abuse in 100 per cent of cases,
whereas he had not in fact uncovered a single one. He erected the
theory of infant molestation as the root of all neurosis (yes *all*), and
then abandoned it, as its unlikelihood became evident. He contrived
to make it seem as if he was forced to retract his theory by hostile
colleagues, whereas in fact he had found it untenable himself. He
claimed the world hadn't been ready to hear of such things, whereas
reports of actual abuse were widely circulated in the medical world
(see Kraft-Ebbing, for example). It was the unlikelihood of his theo-
ries which aroused opposition, but not as much as it ought to have
done. He altered his previous findings in retrospect to make them
fit his new theory (that of infant sexual *fantasy*). He claimed that the
reports of infant sexual abuse, which had so convinced him, had been
in fact fantasies – whereas he had received no such reports at all, and
the fantasies had been his own which he put into the mouths of his
patients. In this way he erected the whole infant sexual fantasy theory,
which he made the base and foundation of the whole structure of the
psyche, out of an attempt to salvage his previous failed theory of sexual
abuse, which he had based upon fabrications.

And remember, it was not Freud who 'discovered' the unconscious,
and he never claimed it was. His contribution was precisely his method,
now completely discredited though still widely practised, and the
contents (infant sexual fantasy) and structure of the psyche, which were
based on his own perverse fantasies, and the fabrications he foisted on
his patients whom he never cured.

Millions of the middle classes have regarded his ideas, and the
methods and techniques they spawned, as incontrovertible truth for a
hundred years. Scores of thousands of Freudian psychoanalysts erected a
system whereby the mere denial of their postulations was taken as proof
of their veracity (a real tribute to the paranoid justifications of the lunatic
who came up with them). Freudian analysis is still widely used as a tool
of literary criticism: Freud marvelled at the fact that the repressions in
Hamlet were so concealed that it had been left to *him* to finally uncover
them. The whole affair, which is not yet over, has to figure as one of the

most salutary warnings about the ruthlessness and plain dishonesty of intellectuals, academics and scientists (no different from any of us), and of the dangers of gullibility. The political significance, if you can call it that, hangs around the fact that *common sense* is the 'methodology' (ha ha) which the academics and indeed the middle classes in general, claim to be the dangerous and dubious one. (See the chapter on common sense later in this book, pp 180–90.) The past 100 years has been one particularly riddled with far-fetched ideas which have found their way into the formation of powerful agencies and bureaucracies. Their chief defence against attack is their complicatedness and the deliberately obfuscatory language they are described in. Technical jargon really does hide a multitude of sins, until it is too late to stop it. The use of such language to foist bad ideas on the rest of us is a political issue. In other words, a victory in that area might shift power, in all sorts of areas, towards the working classes.

Read said (and which bourgeois left-winger would disagree with him?) that:

> The dilemma which faces all moralists is that the repression of instincts is apt to breed a worse disease than free expression. Incidentally it entails a feebler art.

He seems to understand Freud to mean that the aim of a healthy society is to release the repressed instincts and to attribute neuroses to this repression. However, this is not correct. We only have to remember what Freud saw as being the contents of the repressed urges to realise that he cannot mean they should be released – unless incest with our parents is the aim? People find it hard to remember or believe just how reductive Freud's description of the psyche was (despite his later attempts to wriggle out of the worst reductivism of his own theories and the unlikelihoods). But even Freud stated very clearly that 'Our civilisation is, generally speaking, founded on the suppression of instincts.'

Read cited Freud (not Jung, with whose work he was also well acquainted) as being the tool of the new approach. But nowhere does Freud advocate the release and indulgence of these urges. The acknowledgement and understanding of these urges and their influence upon

the formation of our desires and drives, was the psychoanalytic tool for the treatment of neuroses. It was not intended to be a way of life.

Freud's outlook was always that of a Viennese bourgeois. It is shocking to remember how important a part his perceptions have played in forming our idea of the psyche. The reductive aspect is quite well known and was opposed by Jung, But Jung's ideas were too complex and wide-ranging to gain the same popularity as Freud's. Reductive ideas are enormously attractive exactly because they offer to simplify everything.

The popular misunderstanding, including Read's own, of the idea of repression is something which has inadvertently formed a range of mistaken presumptions. Repression is a natural and essential part of the human function, but most people imagine the reverse; they imagine that repression is a form of mental disease. In fact it is no more a disease than breathing.

Modern minds associate the repression function with the perceived Victorian 'disapproval' of sex. If it had been Jung and not Freud who had found his way onto every bookshelf and into every modern middle class mind (in whatever compressed form) the conflation of repressive function and sex puritanism would not have occurred.

One of the sources of argument between Jung and Freud was that Freud saw his sexual theory as 'a bulwark against the black tide of occultism' which he sought to repress. Was he seeking to repress it because he had a neurotic fear of it (or something else he mistook for it), in his own unconscious, or did he simply mean that the instinct of irrational fear needed to be repressed and that his theory was necessary to achieve that? At any rate the surrealists, and Read, to the extent they chose Freud as their hero, chose the wrong man for their purposes, since Read saw surrealism as having a desire to 'unlock the *metaphysical*', whereas Freud's theories more or less denied the metaphysical.

The more fundamental aspect of Read's misunderstanding of repression is where it concerns society, social behaviour and civilisation.

Civilisation, any civilisation – not just ours, from a large modern one to a small village in the forest – depends, as we have seen, on regulation of instincts, not the imagined sexual urges of Freud's theories. Our

culture is formed by the means by which we find outlet for the psychic energy generated by the repressed contents and the act of repression. Our social arrangements, symbolic or ritualistic, cathartic or sexual in form, art or dance, stories and beliefs, all reflect the contents of the unconscious. It is hard to describe the mechanisms without using the word 'balance' so hated by Read and those of his frame of mind. But balance is not just the mealy-mouthed compromise that preserves the advantage of the powerful: it is the condition in nature which enables survival, and continued functioning, especially in psychological terms. Indeed, when the balance is upset by oppositions inherent or external or new, as dialectic describes, then new balances (syntheses) have to be found. In psychological terms it means the new or newly revealed contents of the unconscious, which have pushed up into the conscious in some form, have to be assimilated or absorbed. But at whatever stage of this constant process, it remains true that the civilisation depends upon the regulation of instincts and other contents of the unconscious; this regulation, of course, includes being aware of them, understanding them, and making them conscious where necessary or possible.

If that were accepted by the powerful middle classes who control our society, then the weird embarrassment which paralyses so many of the *repressive* functions of civilisation would cease, and we could retake thee path towards peaceful, civil and relatively non-violent society we once had (but whose existence we strenuously deny).

The middle classes' distaste for repression has led to an excessive, and perverse, liberal attitude in areas where is it not appropriate. In fact, we might say that they have a *dissociated* attitude to repression and author-ity: they seek to deny it, to pretend it is not desirable or necessary. The result is that, since repression and authority of some description *is* neces-sary, they approach it with a built-in dishonesty. This gives us a left-wing government which is in fact continually revoking traditional freedoms to the point of becoming oppressive. It gives us a society which is lax in its norms of behaviour, and which shrinks from all forms of normal punishment of children, but thinks nothing of putting those same chil-dren in jail in large numbers, when they reach eighteen, when it finds they grow up to be violent and dishonest.

The popularity of Freud with the middle classes, and the compara-
tive neglect of Jung, is an important feature in the development of our
current orthodoxy. It has the same cause, no doubt: Freudianism is an
urban bourgeois theory which appeals to the urban bourgeoisie; it is a
theory which explains humanity in terms of the level of sexual repres-
sion peculiar to that class, and has given birth *through misunderstanding*
to the false idea of a solution which appeals to that class's descendants,
as much for its novelty as for anything else – 'the fullest possible libera-
tion of the impulses' – and has fed their ideas on everything from child-
rearing to television, with disastrous consequences which they are still
afraid to acknowledge.

It is not difficult to see where this little misunderstanding has led to
in our society. It has been far-reaching and has determined much of the
course our society has taken for the past decades, with terrible results.
The mass of people stand in wonder as one 'repression' after another
is thrown aside, and civilisation, which depends on the repression of
instincts, gives way to violence and cruelty unimpeded. Read says that
'nothing is simpler to demonstrate, in every age, than the depend-
ency of the official codes of morality on the class interests of those
who possess economic power'; and indeed he is right, although in our
present arrangements, that phenomenon seems to have escaped notice.
For of course the same applies to any moral code, even one *less* strict
than the previous one, even one with no morality in it; it still reflects the
power of the powerful.

The release of impulses which makes up our current morality suits
very well the capitalist class, the bourgeois left and right who own or
control the means of production (including, importantly, television,
music, newspapers, theatres). Our current form of capitalism depends
very much on the release of appetites, upon the gratification of every
egotistical impulse in each one of us, and it is that which determines our
moral and social judgements.

We shouldn't make the mistake of only calling *restriction* moral-
ity. A morality which *permits* is also a morality, and increasingly what
is powerful and relevant in our society is what is *permitted*, not what
is forbidden. Many more lives are blighted by what is permitted by our

morality, than by what is forbidden. And the permissive aspect of our morality serves the capitalist middle classes just as well as the restrictive aspects served the ideals of order and balance and civilised values before. It is surely no accident that the class domination we endure now is content with a society bereft of good order. Tranquillity and freedom from violence are not essential to a class who on the one hand can buy their own way out of most social ills, and on the other feed on the sale of the trappings of self-indulgence and contempt for others.

The certitude which possesses the cynic when he denies the possibility of virtue has a curiously self-righteous ring to it. Cynics have the upper hand and virtue is now almost the same word as hypocrisy. Read says this about the desire for wealth and triumph over others:

> We are ashamed of them only in the degree of our sensibility and altruism. But the individuals who possess this altruism and sensibility are certainly not the priests and preceptors whose position and authority is assured by the social system of which they are an integral part [...] The only individuals who protest against injustices, or who make their protests vocal, are in effect poets and artists of each age.

The infantilism of that particular view is now commonplace; and one indirect consequence of it is the weakening of democracy, as we dismiss the possibility of holding leaders accountable, and so paradoxically drift towards a European autocracy. (We will see if the recent opportunity for people to flex their muscles, having caught the politicians with their noses in the trough, will revive a talent for democracy.) Generally, as long as a popular singer or a TV actor is prepared to go out and demonstrate against something, we are happy and reassured in our judgements.

Read, though, doesn't want to give the impression that surrealism is a 'sentimental movement of the heart' (God forbid) and finds it to be anti-emotional as well as anti-rational – while in the very same sentence he says the basis of surrealism are 'the elements of natural science and psychology'. Since, as we have seen, he regards psychology as a science, he is indeed contradicting himself.

This is a common flaw in his kind of thinking which dismisses things in terms of the category to which he thinks they belong. Sometimes it is hard when reading his work to remember from one moment to the next, the categories he has allowed and disallowed.

The significance of this is found in the very nature of the (Hegelian) idea of dialectics which Read uses, and upon which is based much of his thinking, and also most oppositional outlooks, including Marx. The idea of thesis/anti-thesis/synthesis is useful and attractive, but it has a problem at its centre – it is difficult to distinguish between a *thesis* and a *synthesis*. But before that point it is also difficult to distinguish between a simple compromise and a synthesis. Read says:

> between one phase and another there must intervene an active principle, one of opposition; to produce a new situation from an existing situation of equilibrium there exist two elements so opposed to each other and yet so related to each other that a resolution is demanded; and such a solution is in effect a new stage of development (a temporary state of equilibrium) which preserves some of the elements of the interacting phases, eliminates others, but is qualitatively different from the previous existing state of opposition.

Read points to the problem while trying to point away from it:

> superficial critics may pretend to be unable to distinguish such an equilibrium from an ordinary compromise, and it is to be feared that in practice most dialectical solutions are of this kind.

Yes, indeed they are; for, as he describes them, they are the same thing. He distinguishes thus: 'but a real synthesis is never a reversion but always a progression'. But that is simply to say that anything new, even a compromise, is not the same as it was before the compromise; and indeed it isn't, otherwise it would be still be the same unresolved opposition. Upon that false distinction is built the contempt for compromise exhibited by Read in his earlier comments; upon this is built the distinction between radicalism and moderate conservatism.

Without the distinct identification of phenomena into dialectical groups – if, instead, things just change gradually for varieties of reasons – then the progress of history, whether it is Hegel's own, or Marx's remaking of Hegel's system to denote the five stages of economic change, no longer has its vital deterministic aspect. Instead we would have a series of situations with conflicts or oppositions built into them which require resolution; and no-one could predict what the next one will be. Indeed this seems far more probable; in reality not only are the thesis, antithesis and synthesis not related, but of course run contiguously with one another in all kinds of related and unrelated spheres, ranging from classes or nations to two neighbours disputing over a fence, to a piece of grass and a snail. To see any relationship between those seems fanciful in the extreme, unless you believe in God.

While Marx's teleology is no longer so popular, having failed to fulfil from the very start its own predictions (the revolution should have happened in Britain, not in Russia), there is still among the left-wing middle classes an unconscious presumption of a teleological element in history which is similar to Hegel's original (Protestant) one but which is even more like what used to be called the Whig version of history. In other words, they believe in progress, and this progress is identical to the triumph of the urban middle class and its way of thinking. It is also identical to Civilisation, Reason, Rationality, Humanism, Morality, and now Rebellion and Socialism. You could almost add being *working class* to that, as they have replaced that class with themselves and their imitation of it. The items on this list, insofar as they would normally differ from the fact of middle classness, are simply adjusted until they are identical: for example, socialism no longer means sharing out the money, or even representing the interests of the workers; rebellion no longer involves a change of power of any kind; democracy no longer, in the European Union, means choosing a government or dismissing a government; morality no longer involves moral judgements; and civilisation no longer involves the repression of instincts or violence; but all only mean the continued prosperity of the middle classes, peppered with *gestures* resembling the items listed here.

The belief in progress is a very important part of the current ortho-

doxy and of course forms the current orthodox outlook on art and more importantly education. We can find in Herbert Read one of the early examples of the beginnings of the new establishment. His activism – I use that word because he was eager in his search for ways to conquer territory for the new way of thinking – made him want to 'revaluate art and aesthetics'. It was his judgement that the general body of existing aesthetic judgements were merely conventional. This drift into being mere convention is in fact identical, you will remember, to the way Grierson described a part of the push and pull of romanticism/classicism which Read dismissed. 'For the most part,' wrote Read, 'they are dogmas handed down by tradition or inculcated by education', which for Read at that time signified ill enough. 'I am not saying,' he said, 'that the whole façade of our culture is false, but it has an architectonic completeness which is historical rather than actual.'

He describes a façade lined with saints in their particular niches and ranks; he says our culture is of the 'guide book variety':

> but we never stop and ask on what system and by whom the stars were awarded. If we did we should discover some dusty college of pedants, their noses buried in a profit and loss account of bibliographical data, critical overdrafts and vested interests.

He expresses, then, a distrust of academia as it was in the 1930s; such clichés as 'dry as dust' he applied to such places live on today, even after that particular dust has been swept away, and replaced with a brand new dust. It refers presumably to the fact that the classical values of aesthetic and literary judgement had been accumulated over many years, and had *become conventional*. The 'pedantry' is the erudition of scholars, soon to be swept away. He envisages gleefully indeed that

> school masters and professors would wander about helplessly deprived of their glasses; textbooks would be irrelevant, and teaching [regarded as] an impudent imposition.

How right he was! Read's vision is most interesting for its accuracy, and its falseness. Indeed all the old school of erudite masters (the ones with

glasses from reading too much) humbly drawing their straw of know-
ledge and insight to the stack, were swept away. They were replaced by
the era of the intellectual empire builder whose every idea has to be
born on the destruction of his predecessors. Each academic doesn't any
longer supply a piece of insight; he supplies a system which destroys and
disproves all others.

The new era also gives us academics who transcend the text. At
school level, books are a thing of the past, and 'old fashioned' teaching is
indeed considered by the government teacher-trainers to be literally *an
impudent imposition upon the pupil*, and is more or less banned from the
classroom. (Anyone who doesn't believe this should consult the govern-
ment teacher-training syllabus.)

In the universities, however, nothing could be further from the truth
than the intention of Read's vision, and yet his revaluation has been
more than fulfilled. The massive new impetus to criticism given by the
French intellectuals of the 1950s and by Americans thereafter has more
than renewed the vigour and confidence of academics. Dry as dust it
definitely is not, at least not in its own eyes: it is vital and strong, and
sexy. It has burst out of its cupboard and taken control. For now the old
reverence for the canon has gone, these conventions are now a memory
only, a footnote in a vast new library of 'ideas' – academia has raised
itself above the text.

The inevitable consequence of the deconstructed text is that the
teacher is the *guide raised to undreamt-of importance*; the text, in the
new academic context is UNABLE to say what it is, it is the text which
is dumb and myopic, and the teacher is the INDISPENSABLE guide, the
guru who is to open the eyes of the initiated, into the esoteric world
of literary criticism, and the literally unlimited power it wields over
the text. The teacher is the priest, the guide, the holder of the keys, the
secret lion tamer who can reduce the most formidable text to a docile
pliable lamb to be slaughtered, to be led by the nose wherever he, or any
student willing to learn the techniques and tricks, chooses to lead it. The
teacher holds the keys to enlightenment; he can instruct the student in
the science of unlimited possibility and the extinction of the meaning-
ful text. The very word author is guilty of having the word 'authority'

hidden inside it. Under the teacher's instruction it is the student who can decide the meaning of a text; he is released from the constraints of literature itself into a vast prison complex of diversity of interpretation, into a world where meaning is a system or a series of systems and can be learnt. Never has the power of the academic been greater and more unrivalled by literature itself. Literature, the text, is a starting point, nothing more. And of course, since it is so unimportant, it begins in the end to matter less what exactly the text is; anything will suffice as a starting point. It is not what the text says itself, it is what you can say *about* the text that gives it meaning. No doubt this process is called empowering the student; in fact it subjugates both literature and the student. For once the teacher, or the academic writer, is set above the text, then so is the state. The power of the text to resist or deny ideology is removed.

Set against this, surrealism's 'demand' for a revaluation of all aesthetic values seems almost childlike in its innocence. Read proclaims that surrealism has no respect for academic *tradition*, least of all 'the classical capitalist one of the last 400 years'. And that would put him safely on the side that's winning. None of the bourgeoisie would disagree with him for a second. The surrealist would be at home at any bourgeois dinner table across Britain, or Europe. But he might just find himself overwhelmed by the new academic disciplines; his lack of respect for them could never match, in its scope and thoroughness, *their* lack of respect for *him*.

The new academic has taken the romantic artist's lack of respect for the restraint of society, and built himself a counter revolution so strong that the Spanish Inquisition looks like rural deans dancing on the quad alongside it. Academia has ensured that there can never be any such thing as the rebellion of the artist against society, which Read saw as its natural role and function. Academia has erected an impregnable wall against any meaning whatsoever (except the meaning they give it themselves), in any text (except their own texts). The wall is in the nature of a labyrinth: the assailant will be lost in it before any blow is struck; the rebel will starve to death outside the city wall; the keeper of the gate will be left still in full control as the exhausted bodies of futile texts pile up, limp and hollowed out. The very simplest intention can

be denied to any text; the more it insists upon itself and its own nature the less it will be believed – like a visit to a bad psychotherapist. As far as academia is concerned the gates of expression are closed forever, and the key is thrown down a labyrinthine well and can never be retrieved. The established orthodoxy has thousands of trained men and women working tirelessly to dismantle opposition before any word of it can be read. Not since the days of the early Catholic church has orthodoxy had such a grip on the universities; and yet to all appearances it has none at all.

Surrealism, says Read, calls for a revaluation of all aesthetic values, while really it seems from the surrealist output the revaluation is largely of the *uses* to which art should be put, rather than the criteria of aesthetics of painting and sculpture. In film-making too, conventional aesthetics are kept; the surrealist Buñuel's are some of the most beautiful of any kind of film as a result. The hatred of what Read calls the 'classical capitalist aesthetics' is predicated upon the presumed ideological function of classical aesthetics – if that link proves false then, we may suppose, surrealism, or Read's idea of it, looks pretty silly.

There is a certain infantilism in the pose of rebellion when it is aimed at the theory of beauty itself. Read's description of the putative benefits of his 'revaluation' – the rehabilitation of Donne for example – sound positive, as can any description of a proposed dashing aside of old conventions – or what you might call the 'Mary Poppins opening a window' factor – but if the proposed result was to wrest the definition of what is beautiful (or these days what is 'Art') away from the establishment, away from the 'class interests of those who hold economic power', then it has to be declared a complete and utter failure. More than that: you could say that there has never been a time when Art and the appreciation of it has been so esoteric as during the century that has just passed; never been a time when the common man has been so at odds with his social and intellectual masters over what makes 'Art'; never a time when the common man has so routinely be told 'You just don't know anything about art', as if the appreciation of it depends on fore-knowledge. If the so-called 'classical-capitalist's' aesthetics was the instrument of statis and conservatism, then the 'revaluation of aesthetics', that is the replace-

ment of classical aesthetics with the theories of Modern Art, has made art and the appreciation of it the preserve of so-called intellectuals, or those who can ape their asinine judgements.

With aesthetics removed, it is now of prime importance to *know* which clothes the emperor is supposed to be wearing. To the working classes, who have remained resolutely unwilling to cheer as the emperor passes, 'Art' has never been more 'just a load of old bollocks' than now. This says a lot about the revolution in 'Art' that has occurred. The nation wept tears of laughter in May 2004 when a warehouse, containing much of the output of modern British artists, burnt down. Some of the artists themselves appeared in the streets weeping in sorrow as their work went up in flames. Generally speaking, they rather gave the game away, since much of the modern output is conceptual art, that is to say, the piece of art itself is of small interest after the idea has been expressed. It is certainly not, let us say, art as imitation of nature, which Read and many after him scorned into retreat, and so there is no need to stand and marvel at the style of the artist in imitating it. The honest conceptual artist might indeed be expected to say, if the lure of money were not so strong, that the work itself can be disposed of once it has been seen and duly photographed, filmed and described and talked about. The idea, such as it is, has been expressed. If by some ill-chance, the piece is destroyed, no matter, we can simply make another, a copy, which will express the idea just as well. The anti-art in art would reinforce the conceptual nature of the work; would clarify and prevent confusion and misunderstanding which the high prices for disposables have perhaps allowed. (One argument to justify high prices for this kind of work is that it is to be seen as salary for the artist – which is fair enough, as long as it takes a year's work to produce the ideas involved.)

If, though, the argument for regarding the first production of the piece of conceptual art as something worth preserving is that, in fact, after all it *is* in some way beautiful or in some way does imitate nature, or at least decorate, in an interesting way, as is often the case argued, then it seems the artist has not abandoned classical aesthetics after all and can be judged by them accordingly. Understandably, such artists are reluctant to go so far as to invite that judgement since their imitation,

or interpretation, of nature is not very good, or interesting, and their decorative qualities are certainly on a par only with what you can buy cheaper in any shop. Those two aspects of the work are not, let us say, their strong points. The trouble is, however, that neither is the conceptual element. The so-called concept behind most concept art is so banal as to stretch the word concept to its very lowest limit. Cliché might be a better word. Cliché art.

If the concept artist were to abandon the object altogether and merely write down the concept then, of course, if against all likelihood it were published, they would risk having it ridiculed or ignored, as simplistic clichés still often are. Hence the importance of the object once again. It is not so much that it expresses the concept so very well – often the static awkward nature of the installation in the space it occupies puts such pressure on the kind of idea being expressed that it distorts it. No, it is mainly of value for its ability to indeed distort, to conceal and objectify the idea into new positions relative to the gallery visitor and release the idea from its natural vacuity. Modern Art has been rehearsing Duchamp's urinal joke for a whole century. How he would thrill to the number of dollars it has all generated, for the ocean of urine that it has engendered.

Just as the academics were newly empowered by the deconstruction of the text, so the gallery owners became the new king-makers, wielding immense power in an art world where aesthetics (ie objectivity) had been removed, and where any man or woman's cliché was as good as another. It became simply and literally up to the galleries to decide who would be successful, for there was nothing else to choose between all the hopefuls. It was and remains a matter of pure chance who will be the lucky chosen ones. Saatchi and Saatchi, the same advertising agency that gave us Margaret Thatcher, gave us a whole load of other tarted-up rubbish we had to pay dearly for. If you'd put it in a play it would seem far-fetched (although far-fetched clichés got popular in theatre at the same time). If there is supposed to have been a democratisation of Art by making it easier to be an artist, the result has been the creation of an ever more powerful class, an aristocracy of *choosers*, which shifts power away from the artist, away from art itself, back to the rich and powerful.

At the end of the story comes the true artist (something Read strongly believed in) who now, in any field cannot compete. For to compete against the ten who are as good as you is one thing, but to compete against an ocean of mediocrity is virtually impossible. The consequences of that change are enormous, in all the arts, and consequently in society. Zeitgeist, the Spirit of the Age, relevance, fashion, are all more or less the same when it comes to galleries/academics/theatre managers, etc, deciding. The more power the people in these jobs have relative to the power of artists, the more the Zeitgeist is handed over from people to more complex unities such as organisations. The trouble with organisations is that they are so much less flexible, so much more resistant to change, and almost entirely unobservant.

In these days the more active a 'building' (as organisations call themselves) perceives itself to be, the more passive it actually is; passive in that it is a willing tool of the establishment and its orthodoxy. This is because only individuals, outsiders at that, can or will resist the main flow. Any institution that did so consistently would risk failure or closure, and while some individuals may be willing to risk that fate, no organisation is. The theatre/gallery which is in tune with what it thinks of as the Zeitgeist or fashion is most unlikely to hear the voices of unfashion (that is, *not* of the Zeitgeist) – and they are the instruments of change. What an active building can give us is a very successful array of instruments of *no change,* ie fashion.

> Bureaucrats and tyrants have talked of the Spirit of the Age to suppress criticism of those who reject their vision of the age.
> (Karl Popper – *The Poverty of Historicism*)

Theatres should remember that, when they talk of 'relevance'.

None of this is what Read envisaged when he talked of 'revaluation', and it is telling to see how contrary to his hopes some of the outcomes were. That applies to the current generation of people who have more or less absorbed the same ideas: the consequences are not what they envisage – the difference being, of course, that they have the consequences right before their eyes and have made themselves blind to them.

Read, for example, attributes to the past errors of 'classicism' the

phenomenon of conforming mediocrities in every age. To him they were the 'stuffed corpses of classicism'. Whereas his revaluation, as I have described, has given power to a whole class of stuffed mediocrities of a similar type. And indeed, no institution is going to employ anyone who might fail to chase away dissidents. Every building, every theatre, has its Salieri on its staff. You don't need classicism for that; human nature provides them unaided.

Read's rebellion against the establishment, as it was then, contained in its childish self-contradiction the seeds of vulgar destruction that it was to bring in its wake. He demanded, for example, that 'the ghoulish activity of the actual recovering and editing of the material of ballads and anonymous literature be halted', and demanded, at the same time, that 'they be rescued and fully recognised as the most fundamental and authentic of all kinds of poetry.' He failed to say what the difference was. He also failed to see that, without the dry-as-dust academic ghouls who in the nineteenth century up to the 1950s did rescue them from oblivion, he would not even have known of them.

He professed 'angry and in no sense patronising pity' for Pope and Dryden, and for Michelangelo and Poussin. He talks enthusiastically of Shakespeare being rescued from the disapproval and neglect of the eighteenth century and of Dover Wilson's understanding of Hamlet's incoherence. This he sees as a signal, of a realisation of the romantic principle in Shakespeare. 'At the heart of the mystery is the mystery itself.' The inexplicable is accepted by Professor Wilson at its face-value, its inexplicableness, its irrationality. He cannot have envisaged our own era where even the natural ambiguity of good writing is, in Shakespeare, closed down before it gets to the audience by the director's interpretation. This director's vision, or angle as it is sometimes called, seeks to resolve the play to an interpretation – that is, to reduce it to a simple and yet grossly distorted form (as if an audience can't interpret it themselves if they want to). Often this is by means of by the laughably stupid practice of putting the whole thing in the garb of a totally unrelated era to shovel the glimpse into the ditch of the hole the director is in, so that the question the production raises in the audience's mind at each moment is: *does this correspond to 1930s Germany?, 1950s Haiti?, 1980s Britain?, 1940s*

China?, etc, etc, while the actors fence each other with automatic pistols. This week my daughter saw a production for schools of *A Midsummer Night's Dream*, where the fairies were dressed as of 1920s lounge lizards with suits, cigars and hot pants. A wonderful interpretation, which however cut her class off from the much more inspiring and mysterious notion of supernatural woodland creatures, of which *A Midsummer Night's Dream* is such a perfect expression.

In Read's revaluation along romanticism's principles, Byron too is released from the disapproval which surrounded him. Curiously, Read sets the more or less harmless roué Byron alongside the Marquis de Sade and talks of the 'evil of such characters transcended by the individual will'. To Read, the root of Byron's 'evil' is his incest with his half-sister, which 'by all the rules condemn such a life as worthless'. It seems that after morality is 'revaluated' by Read, there is no difference between someone who tortures and rapes and mutilates innocent girls (de Sade), and someone who falls in love with his half-sister (Byron); both are worthy of the same treatment, apparently. Perhaps Read himself wasn't sufficiently reconstructed by this point.

In actual fact, in the revaluation that has continued in education, relentlessly, Byron, Pope, Dryden, Donne are fast on the way to becoming forgotten names, as their place in the 'pantheon' is taken by 'poets' selected by the education authorities for their suitability for children and their usefulness in the government's indoctrination of children. Each poem and each line deals with an 'issue' precisely along government lines, like a poor-quality Soviet government tool, or a fascist parrot. (And incidentally these dull, bloodless state poets are widely hated by the children, so there is hope yet.)

In most schools the barest fragments of real poetry remain, and for many children Shakespeare is presented in disembodied, so-called 'key scenes'. Read would, I presume, have been horrified. I am not blaming him, or even the ideas as they were intended; but it is fair to say that seeing what they led to, they need to be *revaluated*, urgently. This has to include all the presumptions which accompany them and form the standard orthodoxy of ideas of the average left-wing bourgeoisie, who send their children to private schools when they can.

Read's revaluation of literature involves Lewis, Maturin and Mrs Radcliffe occupying a much higher rank than Scott, Dickens and Hardy. (He uses word 'rank', even though despising the allocation of rank implicit in the 'guidebook culture' of old-fashioned academia.) Again it seems his enthusiasm leads him to prefer the esoteric and clever Lewis and Maturin to the chaotic multiplicity of Dickens and its colour and its root in popular life, and to Hardy's mournful simplicity.

Read admires Edward Lear and Lewis Carroll for their unconscious significance, which seems a reasonable judgement, especially if he remembers the value of it *remaining* unrevealed. But he declares that Lear is a better poet than Tennyson. And Carroll he counts alongside Shakespeare. He shows himself inexplicably unable to find any resonance of unconscious material in Tennyson. Which can only mean that he finds it in Lear because it signals its presence quite deliberately. To make such a judgement insists upon such a perverse reading of Tennyson as can only be achieved by the operation of prejudice or inverted snobbery – not really a good basis for revaluation. To replace an ideal of aesthetic objectivity with judgements based on a notion of class war and social engineering leads only to perverseness. It replaces reasonableness with resentment; it leads away from moderation to extremism; it makes the unreasonable possible. In this case, it has led to the disappearance of poetry from the classroom. And then it led to propaganda replacing poetry.

In painting Read approves of the art of ideas as against, say, the painterly preoccupations of the Impressionists and their forebears throughout the development of painting. Nothing could be more futile and unnecessary, in the opinion of the surrealists, than an art exclusively concerned with the rendering of some aspect of the natural effects of light, of space, of mass and solidity:

> Monet's 32 paintings of the haystack are no more worth than 32 renderings of the artist's reaction to toothache.

Read imagines that even Cézanne felt the pointlessness of his spatial preoccupations and this led him to chose to paint the bathers instead of the mountains. He depicts the whole of English painting from the

Middle Ages until the Romantic movement as 'almost completely dead', while allowing that early 'Gainsborough came close to Douanier Rousseau' (which seems to be putting the cart before the horse).

Predictably enough, he calls the history of Turner the 'history of the emancipation of a great artist from the fetters of naturalism'. He says of him: 'a little dogged in spirit, he lacked the final courage to take leave of his senses.' But since Turner only proceeds from one form of naturalism to another, it seems Read conflates naturalism with classicism, or that when speaking of Turner, he refers to his early works as naturalism but his later ones as something else, while when he mentions the Impressionists all their work is naturalism. He rejects Turner's early work because to him it seems like a too literal imitation of nature (and he confuses that approach with classicism), and approves of his later work because it seems to him to be romantic, that is to say expressive of the artist, not intellectual but not chained either to sensory perception.

It seems that Read is, to coin a phrase, judging merely by appearances. He lumps together classicism and painting which is concerned with sensory perception merely because it looks more 'conventional'. In this his judgement would again, I venture, coincide with the conventional modern view: today's urban middle classes want something 'rebellious' from their art, or it says nothing to them. To them conventional-looking painting is dead.

Read's ability to perceive the very things he is looking for in art is reduced rather than increased by his ideas. Why cannot he see the same spirit at work in a different way in Turner's early work as in his later? Why does he say that only Samuel Palmer and John Martin can be rescued from the dustbin of nineteenth century? What form of blindness prevents him, and many like him, from seeing what is there? Has he, for example, dismissed *all* the members of the Royal Academy? On principle? And if so, what kind of principle is it?

Read says the English plastic arts had to wait for the inspiration of Picasso to show any real revival which produced potentially great artists – and Wyndham Lewis is for him the typical example. (To be able to say this at the close of the 19th century which had produced so much great British painting demonstrates the impoverished, dull pedantry of

the modernist view; the result is that all Victorian painting has been removed from domestic walls and replaced by the ubiquitous Matisse cut-outs – a move from the sublime to the ridiculous.)

By any measurement Wyndham Lewis is only a minor talent. What makes him qualify for Read as 'potentially great' can only be that he does the right *kind* of thing: sadly, that is to imitate. Lewis imitates the Futurists after imitating Picasso and Braque's Cubism. And the habit of imitation of styles came to be the future of 'modern' art, until copying became at last respectable – and now there are thousands of the once-despised amateur or Sunday painters aping the work of the establishment, now raised to the status of professional artist. Because with aesthetics gone it is easier to pass muster. Painters of very little talent are accepted as artists, on account of the style they copy – a legion of Ben Nicholsons, aping Alfred Wallace – and because these styles are invariably very easy to copy, based as they are to a degree on infantilism, and simplification that can reduce art to formulae. It is seen as healthy that art is often no longer about the skill of the artist. And the first basic step in the argument is usually to point out that the ignorant and uninitiated have the foolish misconception of art that the *point* is to admire the skill of the artist. Any academic will tell any fool of that kind that art is not about that, it is about so many other things, and it certainly doesn't matter and is not of any interest to see whether or not a painter can exhibit his skills at imitating nature. Techniques of painting were abolished long ago from art schools and what is taught there is art theory, which essentially boils down to 'How to copy other people's *ideas*'. Now, was it the Surrealists who, in Read's words,

> are opposed to any intellectualisation of art, to any preference that is to say, for rational as opposed to imaginative elements?

Well, the result of Read's ideas, perhaps inadvertently, is the complete intellectualisation of art. Read said (of painting as an ocular exercise):

> against such an art it was necessary to protest, and the best protest which should have been final in this effect was the invention of collage by Braque and Picasso – the work of art

made out of any old pieces of stone or newspaper but where
despite the lack of the fiddling kind of finesse was undeniably a
work of art.

Read clarifies that surrealism doesn't wholly reject aesthetics as such: it
included

Dali's '*Vermeerish*' style, and Picasso's '*bold plangent brush-
work*', there is no one style, no one criterion; the artist is only
using the medium to express ideas, and can only be judged not
by the way he uses the medium, but the success with which he
expresses the ideas.

Read has a surprisingly literal understanding of 'ideas' for a critic
supposed to be representing the ideas of surrealism. He seems to only
acknowledge as 'ideas', and therefore as suitable for art, that which can
be expressed in literal terms: that is to say, more or less verbally. The
art he talks of at best expresses verbal ideas pictorially; analytical ideas,
ideas which can be simply expressed by juxtapositions, etc. He acknow-
ledges Turner but only because he thinks he is a romantic and not any
longer concerned with nature (this same Turner who declared on his
deathbed, 'the Sun is God'). Read's notion of 'ideas' in art exclude what
Wordsworth would have called 'intimations', and which, for Wordsworth,
were experienced when the inward eye encounters nature – not, that is,
analytically, but reflectively. To depict nature, to 'imitate' it, as a means of
expressing these intimations, surely accounts for a very large aspect of all
kinds of painting; just in the same way as literature is expected to depict
human nature (naturalism there is not considered trivial or mechani-
cal), so imitating nature in painting is not a slavish, mechanical display
of proficiency, but an act of devotion, and an expression of 'thoughts
which lie too deep for words'. The infinite variety to be found amongst
even the most highly technically proficient art is surely evidence that
great art, insofar as it imitates nature, is a synthesis of the artist and the
natural world. The skill of the artist in 'imitating' nature, is not a banal
display, it is the means by which he pays homage to the natural world
and expresses his sense of his existence in that world – exactly the same

as the first cave drawings. Purely painterly painting, if there is such a thing, is no less full of 'ideas' than literal painting. Mixing the paint to paint the red earth red, whether done by a savage or a member of the Royal Academy, by Turner or Titian, is as much a spiritual experience or a religious experience or a revelation or an 'idea', as using paint or other materials to illustrate an idea you have previously formed in your head, or could write down on a piece of paper.

Read's dismissal of the intrinsically artistic nature of imitation, which had been taken for granted since man was in caves, could be cited as signifying the death of painting in Britain. For the decades which followed, painting techniques were no longer taught in the art schools and still aren't. There have been some painters of note, a few: these are self-taught and their technique is often crude, and the great legacy of nineteenth-century painting is lost. That such a loss to art is not mourned is testimony to the slow destruction of the artistic sensibility and its replacement with simplistic ideas and prejudice. The irony is that this has come about by the over-politicisation of the romantic ideal; the rebellion *of* the human spirit has become a rebellion *against* the human spirit and its mysterious participation in nature

The severance of art from technique has been achieved (except that there are still painters quietly trying to uphold it or to recover what can be recovered). The alternative, Read said, is of art heading towards a uniform standard of perfection. What modern ideas have ultimately given us, instead, is the uniformity of mediocrity.

To illustrate further the futility of painting technique, Read tells of finding some driftwood and how the selection of this found object is 'as expressive of my personality as if I had carved it. Selection is also creation.'

The problem here is not the driftwood, but the personality of the artist, the expression of which Read seems to think is the purpose of art. (Popular modern cliché N° 1.) The next problem is the word 'Creation', which again Read seems to think is in itself interesting, as art. (Popular modern cliché N° 2.) By these two measurements the selection, of one's penknife, condoms, breakfast cereal expresses the artists personality, and is thereby creation, and is therefore interesting as art.

It has to be one of the most lamentable inheritances of romanticism that it has deemed the personality of the artist to be in itself interesting. The other one, vaguely related to it, is the idea that *creativity* is the same as art.

Creativity is a feature of every man's day; whatever his job, he creates something at some level. The false importance given (by romanticism) to that word leads romantic 'artists' to believe that their 'creativity' is the same as art, no matter what level of 'creativity'. The bricklayer with good reason might then wonder if he isn't more 'creative' than the so-called artists who call the selection of their domestic objects 'art', merely because they have called themselves artists.

Once we have established that everyday activity is also creative, and once we decide that all 'creativity' is art, then there is logically really no need for art. And if there is no need for art, that means that the careers of those calling themselves artists on these criteria ought to end, their job of proving their point well done. And yet never before were 'artists' commanding such immense salaries as during this period when 'art' is proved to be the same as everyday creativity. The purpose of this has been that the whole point of such art is to *reveal* to the people the artisticness or creativity of their own activities. One might think that the point has been poorly made over the past seventy years and would be better made if the 'artists' no longer craved the status and money which raises them to the level of great aristocrats above their fellows.

It is hard to see that the art of ideas which now dominates is anything else than the classicism of old in a new guise, remembering what Read said classicism was:

> the official codes of morality of the class interests of those who possess the economic power.

Once objective judgement is outlawed from art, and aesthetics is deconstructed, then there is nothing to stop a class domination of art, a class using art to dominate society, which Read himself described. The means by which the banality of the idea is concealed and presented as otherwise is the means by which the 'tyranny' (Read's word) of the establishment upholds itself. The Theories of Modern Art, in other words.

If the point of the modern rebellion against aesthetics was to destroy complacency in art, and to free it from the grip of the capitalist bourgeoisie, then it has utterly failed. The gilded sceptre may have been dashed from their hands, but they now hold a rubber baton, and it's much easier to wield.

The class interests behind the so-called revolutionary ideas has meant the defeat of the people, and the defeat of art. The net result of modern art has been to exempt art from aesthetic judgement, which didn't just mean a spectacular drop in standards, and the abandonment of some of the most valuable aspects of art. It meant the replacement of beauty to which anyone can have access, with esoteric doctrines, behind which is concealed the raw power of class domination.

3 A POODLE IN CHAINS

The Arts Council and Theatre Funding[1]

THE ARTS COUNCIL EXISTS because we expect there to be a buffer between the government and the arts organisations it funds; otherwise we should simply have funding given out directly by the Arts Ministry. This is the *arms length* principle.

The reason we expect a buffer is because government subsidy of the arts gives control of the arts to government, which interferes. It was precisely for this reason that the whole idea of subsidy was resisted throughout the nineteenth century.

And yet, since the creation of the Arts Council after the war, there have been long periods where it in effect became a tool of the government – under Wilson, 1964 to 1969; under Thatcher and Major, 1979 to 1997; and under Blair and Brown, 1997 to now – a period which covers more than the past 30 years, more or less half the lifetime of the Arts Council. There have been two simple ways that it has been the government's tool: by the direct appointment of a government supporter to the director of the Arts Council; and by the voluntary absorption of the government's ideology and jargon into its own.

It is interesting that the second of these periods began when a government which no longer believed in consensus took power. Consensus was the nebulous but effective sense of common agreement and purpose which was felt to characterise British politics of the post-war period. To cynics it is the manifestation of the old establishment's aegis over national life. It operated by quangos – boards of control in administra-

1 I am indebted to Olivia Turnbull's book *Bringing Down the House: The Crisis in Britain's Regional Theatres* (Chicago University Press, 2009) for much of the factual background to this chapter.

tive areas, such as the arts, made up of non-elected, appointed members of the public who were largely taken from the ranks of the old establishment upper classes. Consensus meant that these people could more or less be trusted to know instinctively to what decisions the consensus steered them. In the Arts Council, it was felt this consensus tended towards an emphasis on quality rather than access, and on a London bias in terms of funding.

If this was the case, then the tearing up of consensus by its sworn enemy, Mrs Thatcher, took the Arts Council and its clients out of the frying pan and put them straight into the fire. For while some would say that the old consensus was open to abuse, or indeed *was* a system of abuse or bias, its very informality and vagueness already put it one step better than the crude effectiveness of what became the more or less direct government control under Thatcher's Conservatives and then New Labour – two ideological governments.

The story doesn't make sense without including the clients themselves, and the part they played in making sure that the two ideologies – the corporate one and the political correctness one – took such a firm hold of the arts in Britain. Their willingness to adopt the language and the ideas of these ideologies played the decisive role. At first glance it is hard to understand how readily they gave in to ideas which one may have thought were inimical to their professions: incomprehensible, that is, until you remember who these people were, their beliefs and motivations.

By the 1970s theatres were in the hands of a class of people whose vision of what theatre was or should be had less to do with actual plays, or actors, or writers, and more with a 'building', a large and heavily staffed organisation whose activities included plays.

The Arts Council, when it started after the war, felt that the popular fare of regional theatre, with long runs of copies of successful London shows dominated by lead actors, was second-rate and vulgar. The solution to this was seen to be to send out high-quality art to the masses. An expanded repertory system was seen as a better choice than what was seen as a too London-based touring system. The repertory system had

started at the beginning of the century, and had suffered a few setbacks: the Great War; the Great Depression; and, in some cases, a lack of popular support. The early experiments, the Manchester Gaiety and the Birmingham Rep, had failed due to lack of audience. The former had put on 100 plays (over fourteen per year) and still failed. By 1939 many reps did twice-nightly popular plays at popular prices

Quite whether there is good reason to share the Arts Council's judgement of commercial theatre is another matter. Repertory theatre was not always the depressed and depressing crude fare, dominated by an ageing ham, that is always portrayed in novels and films. In many instances these theatres presented a variety of straight plays, including some Shakespeare, with a few comedies only, performed competently by a company of about eight actors, to full audiences of no particular pretensions except the desire to be entertained by a good play. Such a modest and unproblematic picture may seem far-fetched now, and impossible, since the past has been so thoroughly discredited. We have only witnesses' descriptions to go by, and they vary. But we may have already had the germs of what Keynes was hoping for when he envisaged the Arts Council, which then killed them off. He wouldn't have known, as he wasn't by all accounts the man most likely to attend such lowly places. (It's funny, really, how it is often popular entertainment which is seen as a problem to be solved.)

This antithesis between popular entertainment in theatre and 'worthwhile' art is expressed from a position of exasperated defeat 40 years later by John McGrath in *A Good Night Out*.[1] Funding had the effect of establishing the supremacy of *a certain kind of* taste in theatre, using public money at the expense of the commercial theatres which were driven to closure by its intervention. But despite the development of a whole system of local authority and Arts Council funding to support the system, it is arguably a failure, consuming vast amounts of money and producing rather little, performing to a small audience that refuses to grow. We have no actual reason to think that the plays put on by today's theatres are any better than those put on by the reps before them.

1 John McGrath, *A Good Night Out* (Nick Hern Books, 1996).

The effect of the competition with taxpayer-funded theatres upon the small commercial theatres was disastrous. State subsidy pushed up wages and costs immeasurably and skewed the market, leading to their decline and closure. But it is surely worth considering what might have happened if state subsidy not intervened. Would cheap commercial theatre have died under the impact of cinema and television (which certainly had an impact on subsidised theatre)? Or would it have survived and perhaps developed? In the conventional history of theatre it is hardly a footnote, like 'Red Indians' in old-fashioned histories of the Americas; commercial drama is regarded as unworthy rubbish that stood in the way of worthwhile drama (which paradoxically by the 1970s meant political plays in some way claiming to be 'about' the working classes). But was it really going nowhere? It was this strain of entertainment which grew out of the music halls as well as straight drama, which became radio series like *ITMA, The Navy Lark, Much Binding in the Marsh, Round the Horne, Monday Night at Eight,* which also finally gave us *The Goons,* and other British comedy and also straight British films – which, at least on a dramatic if not always on a cinematographic level, had much to recommend them.

It is possible to look at even this early part of the history of the Arts Council and regional theatres in class terms, and when you do it all seems rather unfairly weighted against popular taste in favour of what the better educated sections of the middle class decide is good, not just for them but for everyone else. This early defeat of popular taste is perhaps a decisive one for the twentieth century. This seems especially unfair when that section of the middle classes are precisely the ones best able to pay for their tastes if they want to. Their expensive tastes maybe would have benefited from some pressure to be less so. It still isn't scrutinised and they will never let it be, no matter what the pressures of funding: that issue is never raised. But it led not just to vastly expensive opera and national theatres, but to horribly overstaffed theatres and administration giants producing a very slight programme. The fact that this programme often claimed to be aimed at either 1) popular taste, or 2) the working classes, seems to show that the a certain middle class *version* of popular taste takes precedence over popular taste itself,

no matter what the cost. It is possible to see the subvention of regional theatres as a chain of Marie Antoinette Dairies, to pay for which the real dairies had to be closed down.

The idea of the Arts Council grew out of the war and the CEMA (Council for the Encouragement of Music and the Arts) and the need to bolster culture against the privations of the war – part, you might say, of a general concern with morale. The experience of the incredible efficiency achieved during the war in all spheres no doubt left a tantalising impression upon government and administrators. Not only did Britain achieve self-sufficiency in food up to 80 per cent, but industrial production (most of it armaments) kept pace and eventually outstripped the Germans, for all their 'efficiency', slave labour and much larger population. The benefits of a completely planned economy, where government regulates production and distribution and even determines the placement of labour, must have been a real revelation to the Conservatives and Labour members of the coalition alike. One can wonder which species was most surprised by what it revealed about the benefits of state socialism. The experience of it no doubt contributed to the consensus after the war where the idea of a 'common good' was not just an idea but a recent and successful memory. (One might conjecture how successful Britain might have been in that mode had we not had to single-handedly foot the whole bill for Germany's war, payable to the USA who used it to engineer the eclipse of the British Empire and influence, by American power. Our inability to recover industrial production enough to withstand the oil crisis 30 years later, led to the collapse of that consensus.)

It was Maynard Keynes himself who oversaw the genesis of the Arts Council – though he died one year before its inception – and it is interesting to think of the Arts Council as equivalent to Keynesian economics. Indeed, it was when the Keynesian period of economics ended in 1979 that the Arts Council ceased to be the arms length body, functioning somewhere between classical establishment orthodoxy and state socialism, that it once was.

From the beginning, Keynes' personal vision of the Arts Council — taking high-quality art out to the people, with a strong emphasis on

the provision of high-quality art in large, London-based companies –
had to vie against another view which laid the emphasis on accessibil-
ity. This was the view of Dr Thomas Jones, whose interest had been in
adult education and taking art to deprived areas. It was under Jones
that, during the war, the CEMA acted chiefly in the interests of social
welfare.

Another dichotomy within the Arts Council is that between the
Executive Council and the Drama Panel. This was in evidence from the
start, as the Executive Council, on Keynes' insistence, was given most of
the power. The importance of this is seen when the arms length principle
is no longer upheld: the predominance of the Executive Council over the
panel, who were closer to arts practitioners, meant of course that, since
the Executive Council was in the government's gift, the Arts Council
could more easily become the instrument of government policy, rather
than responding to the ideas and requirement of the arts community.

Keynes also introduced the idea of plural funding. This obvious
and sensible-seeming idea did, however, store up some trouble for the
future, when the problems of serving two masters proved so difficult.
In fact, plural funding exacerbated the contradictions between high-art
and public-amenity aspects of funding purpose, already present from
CEMA days. This problem was made critical when parity funding was
introduced by the Tories, which made the failure to satisfy one of the
masters lead the other master to not pay up either.

After its first five years, however, the Arts Council found that the
critically-acclaimed work of its directly-funded theatres received very
little public support, and they withdrew from all but one of them. The
Arts Council still had only faint enthusiasm for regional theatre and
was still steered strongly towards funding London-based companies.
High-quality shows in regional theatres where there was not much local
support seemed like a waste to an executive committee not convinced
of the point of accessibility. Keynes himself believed in the trickle-down
effect of high art which would eventually create an audience for itself:
the history of regional theatres has shown only slight evidence of this
ever happening, despite long years of funding.

It is argued that the Arts Council in the 1950s had few working class

people on the council, and that this shows the conservative nature of consensus, consensus being the way the conservative establishment held power by a sort of balancing act whereby it came out on top by a system of minor concessions.

However, this can be applied in the same measure to post-consensus Britain, which gave us a theatre still dominated by Oxbridge. Despite identifying itself as populist, the new establishment has the very same elite nature as the old one, and the Arts Council has the same structure, ie it is still entirely controlled by the Executive Council. The story of the effects of arts funding upon regional theatre has to be seen with this in mind. The 'natural ruling classes' are now simply 'A2' instead of 'A1'. So when we read complaints about the 'patrician values' of the old establishment of the 1950s, and of the early Arts Council with its emphasis on high art, we must realise that we are being asked to assume that there is something wrong with patrician values when it comes from that class, and that there is something less patrician in the dictates of the new establishment ideology.

The story of funding in the regional theatres is always told as a story of insufficient funding, but could just as well be told as one of the take-over of theatre by a class of establishment bureaucrats whose thirst for funding is often for no better purpose than to provide themselves with jobs and to keep them. Reading the usual story in the press and in books, you may notice the assumption that the popular will falls naturally behind the cry for more money for over-staffed theatres. This is because the so-called 'popular' view never actually includes what the majority of people would actually think. It certainly doesn't include the views of the working classes. One might guess that the working classes of this country might very well think that theatres should not get any funding at all. And where, if that is true, does that put the posturing of the theatre managements who see themselves as popular heroes as they creep around with their self-righteous begging bowls? It is salutary to remember that the great presumption of support really only exists in a small, very vocal, privileged class of *Guardian* and *Independent* readers and BBC journalists.

So, for example, while it is seen to be patrician to want to take high

quality art to the people in deprived areas, as was done in the war and after to varying degrees of success, it is *not* considered to be patrician when the highly politicised left pursue their agenda for improving the public, which they do with a sense of purpose and propaganda, and direct action, in thousands of projects and initiatives, quite alien to more conservative-minded patricians, whose motivation was usually an actual belief in precisely art or education. It is refreshing to free ourselves from the automatic hatred of 'elitist' art and 'elitist 'education, by considering it in this light. The high purpose of both have proved a strain on the box office in different ways. The early emphasis on quality inevitably meant programming for a minority audience, a middle class audience; the political propaganda plays of the 1970s and 1980s inevitably meant programming for a minority audience, a middle class audience.

This has the interesting effect of putting the left-wing theatre folk, who are always in favour of funding, in what they might have otherwise called an elitist position. That is a position which they always despise when anyone else is in it, and for that reason I give it my attention. 'Elitism' is the charge used to justify the removal of much of what is valuable in our culture (from education, for example), and therefore it is worthwhile to remember that the left-wing position is in itself an elitist position, since it depends, in practice, on the middle class left deciding for the working classes what their opinions or tastes ought to be. Either that, or they are admitting to playing to exclusively middle class audiences.

Perhaps by the 1960s, it would have been logical by their own lights to allow the elitist activity of theatre to either decline or pay its way. If the middle classes wanted to watch Shaw, they could surely pay for it? Likewise in the 1980s, if the middle classes wanted to watch *Shirley Valentine* over and over again, let them pay for it. Does it need three quarters of a million pounds of public money to help a theatre to produce it?

The demise of the smaller rep and touring companies who couldn't compete with the unnaturally inflated production values of subsidised theatre, gave us exactly what the nineteenth-century opponents of state funding had warned of. What they hadn't envisaged was the degree to which theatres would suffer state control of its actual artistic policy. No-one would have accepted such a thing in that earlier age; now, in

the golden age of full democracy, we were willing to accept as natural that the arts are determined by government policy. What happened to the romantic artist as described by Herbert Read, for example? He got funding.

The 'success' of funding, the fact that funding was now necessary to survival, meant that the same level of subsidy was to be spread thinner. Meanwhile the opera houses in London took half the arts budget. Eventually this led to a need for local authorities to contribute to funding.

Another transformation came most decisively in the 1960s and '70s when the large civic theatres were built by the local councils. The Civic ambition of these councils, the desire to associate themselves with the white heat of modernisation, led them to suddenly splash out on huge capital projects. Fortunately for them, their accountants were wide awake at the time: while the councils funded the extravagant buildings, they didn't actually give them (or even rent them cheaply) to the existing theatre trusts, whose buildings were sometimes knocked down in the redevelopment. No, they rented them to them at high rents. So high were the rents that they absorbed a very large part of the existing funding. So what happened was literally a raid upon arts funding by local governments: 'Here's a lovely big theatre – now pay for it, with your arts funding.'

The theatres were so lovely and big and modern, they required an army of staff to maintain them. Also they were designed not just to function as theatres, but to provide a range of other civic and social services, to which funding by local government was now duly attached as a condition. Then, after only a few years, these vast lovely modern buildings weren't so lovely any more and, in the way of modern architecture, had fallen into early decay and become gloomy and ugly, as the rain streamed down their ill-designed and ill-made windows and walls: money was needed to repair them.

These big civic theatres were not only a raid on Arts Council money, they changed the nature of regional theatre, moving the emphasis away from theatre to providing a civic building. These overstaffed white

elephants were perfect breeding grounds for both the corporatism and the bureaucratisation of theatre and art which was just around the corner. By the end of the 1980s they typically had staffs way over 50, just to keep them going before a single play was performed. And when no play *was* performed at all, the staff were still there, to complain there wasn't enough funding. By this time subvention in the arts was an end in itself; the art sort of fell off the back of the train marked 'gravy'.

Throughout the period from 1979 till now theatres have always claimed they lacked sufficient funding: they say it when their funding is announced; they say it if and when their funding is cut; they say it when playwrights complain, as 87 of them did in 1995 in an open public letter, that not enough new plays were being done; they insist that they don't have enough money to provide the exciting programme they would otherwise provide. And yet – and yet – staffing levels throughout the whole period grew from high to very high. And never throughout all the 'cuts', real and invented, did they ever consider that the time for shedding their own jobs had come. No, indeed, they preferred to take the theatres down with them, to close, rather than shed staff. When Leicester closed, 60 jobs were lost; when Liverpool Playhouse closed, 70 jobs went.

Not only did local authority buildings effectively rip off theatres and the Arts Council, and burden them with inappropriate buildings, they also exacted another price, that of interference. The buildings were municipal; so were the programmes to be, altering the idea of what theatres were for.

As Olivia Turnbull puts it in her book *Bringing Down the House*:

> Local authorities expected theatres to function as multi purpose arts centres presenting a variety of activities such as arts exhibitions screenings, youth programmes and public amenities. They had after all been erected by local authorities; as part of the welfare states social democratic ethos; in other words they were built to provide a social service.

This huge shift in function raises few eyebrows now. This view of theatre, of art, has taken root as has the natural association of art with left-wing

politics. But this too comes at a cost. Art loses its independence and its enquiring spirit; it means art can easily become various forms of propaganda. And this it has indeed frequently been over the past 30 years. It means bureaucrats get more power over art, which means jargon and lies infect the whole body until it is completely rotten. Add to this the fact that the so-called left-wingism is nothing more than the ideology of the same section of society as the bureaucrats come from, and you have a full scale disaster for truth in art: the death of art, from which you need another kind of revolution to recover.

How do you take back power in the arts from overpaid overstaffed bureaucracies? How does art reassert itself when there has grown up around it a cloying tumour?

Keynes had warned that 'as long as you don't get too much money the government won't ask too many questions'. The gradual growth of funding overall perhaps inevitably led to an end of Arts Council invisibility, and as the money grew, it gradually fell under the government's greedy gaze for power.

When Labour took over in 1964 they published *A policy for the Arts*:

> From this point on, there was no question but that the Arts Council policies should reflect those of the government.
>
> (Turnbull)

Labour put Arnold Goodman, a close friend of the Minister for the Arts, at the head of the Arts Council. In other words, it was a political appointment. A whole range of new, and to us now very familiar-sounding, initiatives and projects followed: grants and bursaries, youth projects, community arts, happenings environments and installations. The bullshit train had left the station on its decades-long journey; the bureaucratisation of the arts was fully underway.

GHETTO REQUIRED FOR SUBVERSIVE WORK!!

Jennie Lee, the Labour government's Minister for the Arts in 1965, increased funding to facilitate the use of the arts for government propaganda and social engineering:

The fashionable language used by this newly subsidised realm – they were committed, doing relevant work, reaching out to the community, was aped by some of the more traditional reper- tory theatres, which suddenly saw merit in holding workshops, running TIE troupes that reached out amongst the young and in putting on the occasional committed play at a point in the season when the inevitable drop in box office would do least harm.

(This quote, from John Pick, was originally used by Olivia Turnbull in *Bringing The House Down*.)

This language, and the thinking that goes with it, is all familiar to us now though new expressions have been added to it, such as 'cutting-edge', 'relevant', etc. And it is now the mainstream of theatre: it has taken over; it is the language the theatre establishment invariably uses to express itself, no matter what they are actually saying.

This new kind of theatre needed a new kind of audience, since the audiences who had attended the regional theatres were actually driven away by it. New 'spaces' had to be found and studio theatres were duly appended to most big regional theatres, and a new ghetto was created to accommodate the fact that, despite its populist self-image, this was really theatre for a small elite audience. The kind of left-wingism which formed nearly all the productions was obviously not something which appealed to the masses. It was and remains something almost exclu- sively for the middle classes.

It is interesting to remember that most theatre which calls itself 'subversive' and 'anti-establishment' is promoted and paid for by the government, local or national, in whose service it is. The 'rebels' of this era are little more than government agents, promulgating the ideology of the triumphant class.

There are two sorts of unhealthy thinking which was made possible by the studio theatres. One is that the 'right to fail' became an easy and cheap luxury to be indulged in like sweets for children (the treat that rots their teeth). Secondly, it allowed theatre managements to embrace the ideology and fashionability of such work, without having to face up

to the fact of its unpopularity. It also meant that all work of any original-
ity could immediately be stuck into the studio theatre and called 'exper-
imental'. The effect of which is a stultifying conservatism in the main
house theatre which has helped make theatre the out-of-date and out-
of-step little backwater it is today. The studio theatres made it possible
for clichés and third-rate ineptness to be planted in hot-houses where
they could grow and develop, until such time as they were able to infect
the whole body of theatre. It is fashionable when consigning a play of
originality to the studio for Artistic Directors to talk of protecting the
work, or the writer, from 'overexposure', as if having an audience is
something harmful to a play or playwright, rather than a healthy test of
viability. The 'right to fail' – which was an idea originally to describe an
attitude to inadvertent disaster brought about by original or before-its-
time thinking – now became a sort of intention in itself, a right to put
on poor work which never had a hope of entertaining an audience. This
is helped by the attitude of certain critics who always attack anything in
studios as fiercely as they can. This ensures that anything which might
have been viable in a proper theatre never gets there: a complicated little
paradox, but less of a paradox when you remember that a *ghetto* is a
place which gives a false sense of unity and identity based on poverty
and powerlessness to escape.

When theatres are able to put all foreign bodies into the foul appendix
of the studio, they can remain unaffected by change (though not forever).
They can fulfil quotas of new plays by putting any old thing on in the
studio, instead of adjusting to new plays by putting them on properly in
the main house. It means new and original writers get into the habit of
not making any adjustments, either, to the demands of a proper audi-
ence of 450 people – they write for the ghetto. I have been guilty of this
myself (*Downfall*). The combined effect is certainly stultification, as orig-
inality is seen to require a cosy little home in the studio, whose precise
reason for being is to receive the political clichés of the middle class left
who needed somewhere to play out their jejune fantasies from the 1970s
onwards.

Labour overspending in the arts and elsewhere came crashing down
when the oil crisis hit and Britain was found particularly ill-prepared.

In the arts this meant that there was a drop in funding from 1974 to 1979 because it failed to keep up with inflation. This little fact is worth mentioning since it is exactly the same as the so-called 'Tory Cuts' in Arts funding: these were never actually cuts at all, just rises which were not in line with inflation, like these Labour ones.

By the late 1960s, after the big blow-out of Jennie Lee's spending spree in her policy in the arts, there wasn't money to keep the 1965 bubble afloat. The expanded role of theatres to fulfil government policy aims for the arts, as well as the flaky plays, the jargon the belt-loosening had spawned, had created a situation where, as David Edgar put it:

> it was possible to write a play for five actors, lasting under an hour, so terrible that no-one would put it on, but it was difficult.

This excess in drivel naturally brought about a backlash of scepticism, and a perception of the vapidity of 'committed' theatre, as it used to be called, and the brief heyday of the first spring of '60s and '70s theatre was turning sour (to be revived later in an even more biased political form). Theatres by the end of the 1970s were overstretched by their commitments to expensive social welfare programmes as part of their operation and their tendency to produce plays which alienated the audiences. The expansion of the audiences, anticipated by Keynes as a trickle down from government arts funding, had not materialised; perhaps also because of the rise of TV, audiences had actually shrunk, and regional theatre was now relying entirely on subsidy as the transformation of theatre into an establishment poodle was well nigh complete.

In 1979, the poodle's new owner was one which never did really like it all that much. Not surprising really, since it was unashamedly left-wing in its bias, and much of its output was already more or less Marxist propaganda.

It is one of the astonishing facts of Tory rule that, not just in theatre, the growth of left-wing ideology into the national orthodoxy continued and even gained pace. During these years, the polarisation of political opinion in the country, due to the deliberate smashing of consensus by the Tories, resulted in a complete inundation of theatre with out-and-out propaganda, and party political agitation against the government.

This was pretty narrow fare, although since the Tories were blamed for each and every social and economic ill, the agitprop theatre by default ended up covering a wide scope, or wish-list.

The Thatcherite assault on consensus went neatly along with the aims of the middle class left-wing revolution and was entirely in step with that social revolution which had been in operation since the war. Thatcherism in these terms can be seen as a continuation of the 1960s revolution. It was the last blow to the old Establishment; the rolling heads of the Tory cabinet – Francis Pym, Lord Carrington, etc – were evidence of this, as Thatcher slew the knights of the old order. The quango of the Arts Council, which was put under the government's control as it had been under Wilson, had the last vestiges of old Keynesianism squeezed out of it.

The strange combination of Thatcherism and left-wing ideology begins here, as the narrow-minded and predictable reaction against her takes up the other half of the dance floor. This was the heyday of Brenton and Hare digging away at the graveyard of the National Theatre, where they were given permanent access to the main stages to promulgate truistic and rather pointless political plays to an audience who may well have felt better for the experience, but who could be seen stepping haughtily over the beggars outside, on their way back to the Tory suburbs. (I know, I used to watch them.)

If Mrs Thatcher's attack on consensus was intended to be against the left-wing, social policy type of arts funding, then it failed – largely because of the action of local governments, who, by 1979, clearly thought it was acceptable to fund open political propaganda with public money (ie, tax paid by the working classes as well as the middle classes). This use of funding, pouring it into openly biased organisations, upheld by local governments during Thatcher's rule, has now returned as the norm for central government funding too. It is never questioned; no-one thinks it is peculiar. The left – the middle class left – has had this massive propaganda advantage for decades. If anyone can ever imagine putting an end to this, it will seriously impair their position. It is notable that during the same period, the working class voice in politics and in deciding social and economic policy has been all but completely silenced. Looking

back, it is possible to even see the Tory rule as one where *some* aspects of working class thinking were no longer something to be ashamed of; it was the period where some working class attitudes had the upper hand more than they did under Labour. Because this was seen as something to do with the working classes earning a lot of money, as they benefited in certain areas from booms in the building trade, this was written off by the left. The prosperity of the upper working classes, and of building labourers, was never something which gave pleasure to the left-wing middle classes. Public school and university-educated Harry Enfield's 'loads-a-money' character typifies the left-wing view of this vulgar lot getting above their station, and enjoying it.

During this period, the gulf in the outlooks of the left-wing middle classes, and large sections of the working classes (the more prosperous ones) had never been so glaring. The failure of the Tories to produce the trickle down they promised, to the other sections of the working classes who suffered so badly under them, sealed their failure to make themselves the working class party.

Tory Cuts

> On average, arts funding remained slightly ahead of inflation in most years of the conservative administration, falling behind in three years only.
>
> Olivia Turnbull

Labour cut the arts budget by £5m which the Tories largely restored (£3.4m) The myth of Tory cuts in the arts is hard to understand. I had believed it until I read about it while researching this book. (It's interesting how propaganda works.)

While adjustments to these figures can be made, for example to show that certain large sums were earmarked for large projects (such as the dreadful British Library at St Pancras), the generally accepted view is of massive cuts under the Tories. After adjustments, it can look as if arts funding went up by six per cent. This was not enough, as it was below inflation and left theatres struggling, and there were of course some

individual theatres which were cut very much (as there were to be under the following Labour government), but it is hardly the vicious Tory cuts of mythology, and indeed the arts did escape the strictures other sectors did suffer. Typically enough, the administrators who were absorbing all the money complained no less loudly. Like spoilt children they learnt quickly that to complain of cuts was always a good way to shift blame to the government, and that it was always believed.

So what exactly did happen, and why did the corporate ethos of the government, through the Arts Council, find its way so easily into the theatres? They adopted it, one has to say, readily.

The Arts Council itself has a fairly convincing view:

> Increased emphasis on education, community and outreach work, increased sophistication in fund-raising and marketing, the need to comply with ever more complex legislation and the greater administrative demands created by the funding system itself, have deflected the resources from the creation of productions.
>
> Arts Council of England, *Drama in England*

'Complex legislation' and 'administrative demands of the funding system' speak inarticulate volumes. A constant thread, anticipated in the nineteenth century, runs through the changes from left and right alike. The story of theatre in modern Britain is one of government interference and bureaucratisation, jargon and ideology from both sides, doctrinal straightjackets wrapped around a dull-brained, rather boring lunatic with no imagination.

In 1986 the government abolished the metropolitan councils, largely because they were putting up open resistance to central government policy, not least in the arts, where they simply spent the arts funding money on highly politicised theatre propaganda. The Greater London Council 'consciously politicised the arts, redefining the term community arts to refer to communities of interest, or minority groups, rather than the term in its traditional sense' (Turnbull).

To offset some of the impact to local arts bodies of the funding lost with the abolition of the municipal councils, the government set aside

£25m. The estimated shortfall was £46m. The loss of £15m of GLC-style propaganda can only really be seen as a benefit to the arts, but of course it was not seen as such, and still isn't. The standard of judgement exercised in a culture which has accepted propaganda as a valid art form is, by definition, lower. The gradual acceptance of this principle in Arts Council funding has wrought a real change, to the point where the values of propaganda come to actually replace those of art. The next step is that 'art' becomes a word to sneer at – it already is – or a word which is 'impossible to define' and therefore almost not a word, and not a phenomenon. Art is not a word used in theatres. Instead, to this day, they will use any number of words usually associated with political speech-making. Either that or they will use expressions like 'cutting-edge' which reduce theatre to an agent of change; the presumptions about the knife and which way it cuts are not gone into.

The phenomenon is still with us; but the memory of the worst, most execrable rubbish which passed for theatre in the 1980s, should make anyone embarrassed, if it weren't so similar to what the foremost playwrights in the land still serve up to us at the National Theatre and other places. As it was, it discredited theatre funding, and the left itself, in the eyes of some bemused sections of the public. The existence of such huge amounts of this sort of theatre weakened the argument for arts funding. It represented also a distortion of the interests of communities, who were in effect only considered if they fitted the narrow left-wing idea of a community. It is from this period of local authority abuse of funding, that the cliché about 'one-legged black lesbians' comes from. There are plenty of anecdotes from Camden and Islington and Hackney, for example, to far exceed the clichés. Real actual communities were of less interest and of course suffered from the diversion of funds into agit-prop. To say even this is, in some quarters, still taboo. Did anyone then, or does anyone now care at all about the real working class communities? Not noticeably.

One of the ways the Tories forced *their* ideology onto the arts was by holding back funding until it was matched by business sponsorship (the Business Incentive Scheme, 1984). The effect of this type of action was to force theatres to spend some of their funding on raising other funding –

setting them off on a long path of distraction which eventually played a large part in actually changing the personnel and outlook of theatres. Partly because of the new personnel, it was a change they embraced in the long term, and the effects are still with us. The presence of more and more staff not directly connected with plays, and who do not necessarily have any understanding or sympathy with theatre or art, inevitably changes the nature of the institutions. The language and the ideology of consumerism were absorbed into the bloodstream of the theatres.

They were absorbed into the Arts Council by the simple means of a government appointment, William Rees Mogg, which once again put the Arts Council no longer at arms length. Another government was therefore openly cheating, violating the principles upon which the institution had been set up. The Arts Council was now under government control. Rees Mogg was a one-time editor of *The Times*. He had already done the Tory job on the BBC and introduced enterprise ideology into it, totally alien to its nature, a horrible transformation from which it still suffers, without having lost any of its spending culture problems.

Interestingly, though, Rees Mogg did say that theatres ought to serve the audiences not the artists, which is a truly populist view, not far from John McGrath's view in *A Good Night Out*. The trouble with that view in the hands of the government was that it was intransigent and ideological and became a distortion instead of common sense. It is indeed a feature of both the right and the left, that they take common sense and transform it into absurdity by the operation of intolerance and narrow-mindedness. The radical left and the radical right alike are not content with sound policy, but seek to control people's thoughts and behaviour beyond a degree previous governments would have thought appropriate. Since the 1960s, significantly during the era of the middle class revolution, we have suffered from increasingly invasive controlling governments, whose aims include social engineering and whose means are forever expanding.

The point has come when the real focus of attention in the arts should be, not on choosing which ideology to follow, but how to resist ideology, to resist the bloating of governmental and all manifestations of the all-pervading bureaucratic power, and the day-to-day reduction of the

freedom of the people. It is appropriate for the arts for one reason, if not more.

Government has taken more power to itself in the absence of the natural restraint of morality. The more immoral and vicious the population become, the more government will want increased power to protect the people from one another. The weakening of morality in this country was immediately accompanied by a strengthening of government power to control us. Artists are still in the business of dismantling morality. They have not seen the connection. And they do nothing to resist the power of bureaucracy, even in the theatres where they work, let alone in society itself. In the Tory era, as in the era that followed, theatres showed themselves distinctly unable to resist the sort of developments in the way things were done in society at large, changes which turned theatres into places of conformity.

The enterprise culture and the corporate ethos of Toryism mired the country in more of the red tape they claimed to rid it of.

One aim of Toryism was to ruthlessly streamline the way we did things, but it became the era of fake goods of little real usefulness, and glossy reports, instead of real work and real products. Around then we started becoming bloated, ignorant and useless little petty bureaucrats, who live with little chance of a future in competition in the global market.

The self-preservation of the bureaucratic classes has a lot to do with our fate. In theatres it meant that, of course, instead of sacking themselves in responses to demands for streamlining as they should have done, to save money and help the theatres to put on plays, they simply spent even more money on proving why they shouldn't be sacked. The Arts Council led the way:

> There was precious little time for the Council to administer the arts countrywide when most of their days were spent examining their backfiles to justify their existence.[1]

1 Andrew Sinclair, *Arts and Cultures: History of the 50 Years of the Arts Council of Great Britain* (Sinclair-Stevenson, 1995).

The government failed, quite simply, to make theatres bite the bullet. They got away with spending money on justifying their staffing levels. Instead of arts we got commercialisation and policy documents. They imbibed Toryism while telling themselves that they were resisting it; they became Thatcherites while ignoring any truth and usefulness that was in it. The Arts Council went further than government (which hadn't cut arts subsidy) with its Christmas Cuts of 1981, and its Glory of the Garden 1984, and its Great British Success Story 1985 which 'attempted to sell the arts to the government in purely commercial terms' (Turnbull). Then, in turn, the theatres went further than the Arts Council by turning themselves into organisations which had virtually turned their backs on art and turned themselves over to the preservation of their own jobs. When I wrote an article in the *Guardian* showing how much of their budgets theatres spent on staff and how little on plays, someone called my suggestion to reduce staff 'Thatcherite'. This puzzled me, because I didn't realise how little they cared about theatre, but in fact it showed at least that they really knew that Thatcherism did mean sacking useless staff – and they refused to do it. If only they had done, theatre would have benefited greatly. Instead it went the other way: the plays had to go, and the staff and their buildings remained.

Meanwhile the whole Tory idea of sponsorship wasn't working. Business sponsorship, for all the time and staff and energy it took up, never grew to more than 13 per cent of local and government funding levels.

By 1988, while despite some prosperity many people in Britain were in real poverty,[1] theatres and the arts in general were producing documents proving their value to the economy. It eventually became possible to sell the arts to the cold-hearted Tories willing to save a buck or two as a means of repairing social damage wrought by their policies. Years of practice had taught the arts creeps to use language to conceal their uselessness to the point where they could reinvent the old Labour idea of art as a social policy instrument, and we were back where we started.

1　Liverpool, for example, had 47 per cent below the official poverty line, and there was 90 per cent youth unemployment in some areas.

As Olivia Turnbull puts it:

> Thus regional theatres were expected to continue presenting
> an education policy and provide extended opportunities and
> employment for members of minority groups such as women,
> ethnic minorities and the disabled.

She goes on to say how the pressures this put upon theatre finances 'forced many regional theatres to reconstruct and *expand their administrative departments* often at the expense of production values'!!! (My italics.)

So writers had to write for tiny casts, programming was made more unadventurous, new plays were cut to a minimum, all justified by Tory 'cuts'. Meanwhile staff grew and absorbed more and more of the money that should have gone into plays.

Meanwhile in the arts as everywhere else, the ethos of capitalism took a very firm hold of everyone's imagination, their thinking and their language and their morality. This is the period when the national character was moved away from the relatively idealistic and less materialistic 1960s to the cynical and distinctly materialistic ways of thinking, so different you wouldn't believe it was the same people.

But it *was* the same people. And it was indeed surprising just how much people in general took their lead from the government. The character of the times changed, and their new nature was formed by the government itself. It would be hard to find a period in British history, except the one that followed it, where the national character was actually formed to such an extent by the government. It is remarkable that, right in the middle of a period when the predominating ethos was filled with notions of rebellion and youth, etc, all the youths and rebels began to form their attitudes along the lines recommended to them by 25 men in suits and a blonde rinse with a handbag and a fake posh voice. But they did, and the whole country and its attitudes and style changed – in theatres as everywhere else. Yes, for all the ideological left-wingism, which they of course retained, they somehow managed to remake themselves as capitalists at the same time. As the years went by it became clear that the left-wing arts establishment was going to take advantage of the prevail-

ing mood, to allow themselves to learn to love and accept the material benefits of their advantaged position in society, their wealth and status. Many of them were of course middle-aged by now and earning well. A change of attitude to wealth suited their circumstances, even if it didn't suit their politics. They learned to ride both horses at the same time: getting rich and adopting the rather queasy style of expensive informality which suited their self-image, their liberal posture. Gone was the starched shirt of the '50s and '60s; this was the era of the gum-chewing business guy, with bronzed knees, khaki shorts and roller skates.

What really affected the arts itself were the other values which that phase of capitalism and consumerism brought with them, and which were so readily learned and accepted. It is hard to describe it all without sounding like the Salvation Army to the younger reader, but the superficiality, greed, selfishness, boasting, stridency, a pompous individualism, egotism, cruelty and impatience, found its way into the arts overnight; it was like an orgy of vileness. Sometimes the posture was so-called 'ironic', what they called 'postmodern'; at any rate it became normal, until eventually it became a necessary qualification for success and acceptance in the arts.

This period, when all the personnel of the arts were to a man leftwing, was the same time that the crudest values of consumerist and post-consensus cruelty were made the stock in trade of the arts. They drank very deeply of the cup, and loved every drop of it. It transformed them and it destroyed the idealism and romanticism of the 1960s, and swapped it for the checklist-issue politics, which somehow was able to travel happily alongside the new brutalism.

It was in this period that socialism and capitalism united to destroy the institutions of society which might resist the requirements of capitalism to completely control the imagination of the people in order to sell to them. The family was weakened directly by advertising and then television (as the underlying meaning of the programmes grew closer to that of the adverts); families no longer ate together (children stopped learning to converse with adults). Both agencies sought to further promote the 'teenager' to create a market (just as they later created the tween-

ager), and the cult of individuality – another ruse to sell identity aids to the lost individuals they were creating. It all fitted in well with left-wing-ism's desire to separate the victim unit (person) from its harmful environment and better control it and form it. The dislocated society partly created by consumerism in the 1980s is never seen as a bad thing by the left; that is a conservative response. To the left it looks like a mass of individuals liberated from the instruments of oppression – the family, education (elitist pre-New Labour education), religion, morality and any other form of social control. For this reason, the plays produced by left-wing theatre go very nicely with the social changes brought by capitalism – both ideologies were creating the same results. At this distance it is hard to put the width of a £50 note between them – they are one and the same social phenomenon, united in their values. It was perfectly to be expected then that the New Labour government which followed, confirmed and consolidated that unity of purpose, but this was not Tony Blair's invention. New Labour simply formalised the conjunction into a state-led social revolution, which anointed the wealthy left-wing middle classes as its reigning aristocracy.

In the 1980s and '90s this gave us two strands of theatre: the crude agitprop funded largely by the GLC, local councils, to be found in the lesser theatres, and which was concerned mostly with gender, race and sexuality expressed as clear-cut political issues of left versus right; and then a newer, more successful form of synthesis, where left-wingism and capitalism were combined to form so-called 'radical' new forms. In fact these were stunning exercises in irresponsibility and collaboration, which celebrated and exacerbated the very worst effects of both the ideologies. They were to be found in the important theatres such as the Royal Court and the National Theatre, and their influence was accordingly greater.

The left-wing administrative class didn't vanish or step aside during the Thatcherite period: they adapted and became Thatcherites, and clung onto their positions, and in fact expanded their power and influence, by their public opposition to the government. The Tory rule was not a time when left-wingism was in retreat; far from it. It aligned itself with its natural ally, capitalism. That class took Thatcherism as another

arrow in their quiver – Blairism, as everyone knew at the time already, was largely a product of Thatcherism (not least because it benefited from the crushed unions). It is not altogether surprising that Thatcherism in the end was a manager's creed – though its ethos seemed to involve hacking at the middle men, it all of course ended by subjecting all areas, even hospitals, to its manager fetish, and in the theatres as elsewhere this completely undermined any intentions to cut away useless bureaucracy. The managers took a final and strangling grip and, by the end of it, were unassailable.

At the same time the luxury of blaming the 'cuts' for their weak programming was one the managements indulged in to the utmost. It became impossible to criticise theatres because the criticism was automatically deflected to the government. This fooled people into thinking that the only issue involved in subsidised theatre was how much money Big Brother decided to give them. It was taken for granted that less money meant fewer actors, writers, directors, and plays. 'Lack' of funding was used to justify a failure even to have any ideas. To anyone who had actual criticisms of the attitudes behind the programming it soon became clear that more money would mean more of the same. The businessmen who now peopled the boards in a way ensured that this was so. Again, Keynes' warning was proving accurate; theatre was now receiving so much money that it couldn't be left to mere artists to control, and in fact it couldn't be left to be spent on mere art either. The paymasters now had a big claim on the way the buildings were to be used. The horrible growth of funding meant that the sheer scale of each 'building', as theatres were now called, put it safely out of reach of practitioners.

This *coup d'état* by operation of scale is a feature of the modern world; it is the process by which any system, from democracy itself – see the EU – down to the tea trolley is made so large and complicated that any sort of direct action or rebellion becomes impossible or unthinkable. (When it comes to the tea trolley you might on occasion have poured your own tea and left your 50p for the tea lady if she wasn't in attendance; the modernised catering department would see you arrested first or restrained by security guards, and you'd have to be mad to try it, and if you did people would think you had got what you deserved.) The scale

of the theatres and the amount of funding they consumed not only made it seem inevitable or even normal that they were dominated by managers and staffs of administrators, but made the idea of change *impossible*. Once funding had reached a certain level and the buildings had reached a certain size, it became too fantastical and naïve to suggest that theatres ought to be smaller or more informal or simple, or to involve only actors, for example. The *coup d'état* whereby managers took over made rebellion seem impossible even to the rebellious-minded. There is a good way of preventing a village from ever returning once you have destroyed it, and that is to build a bloody great administrative tower block where it used to stand. The Romanianisation of theatre was completed during this period, only to be further consolidated under a flood of money in the later part of the New Labour Government which finally did give the arts all the money it had dreamt of. The last thing theatres needed by then, however, was more money.

An effect of the polarisation of politics in this period was that the Tory government was well aware of the strong left-wing bias in theatre and the arts, and this made them less than well disposed towards it. Considering the poor quality and lame thinking of much of it, they were justified in objecting to public money being used in this way, if only because it did not reflect the general outlook of the population. The theatre establishment meanwhile saw to it that the pressure this put them under was used to stifle any opposition to that very same one-sidedness. If you were, as an artist, trying to make something that was neither commercial nor left-wing, you hadn't a chance. The constant 'crisis' which in most cases was almost entirely the result of overstaffing rather than 'cuts', meant that war-time measures were adopted by 'beleaguered' theatres, the first casualty being art.

When funding went *up*, under David Mellor (1990–92), audience figures went down: 13.4 million in 1990 to 10.7 million in 1993. The excessively dull repertoire was now an addiction, and the extra money was needed for staff.

To the hygienic bureaucrats who ran the theatres the slightly scruffy aspect of anything not actually brand new, especially modern-type buildings, were wholly unacceptable, and high on their agendas was

'refurbishment'. One might hear it said that these theatres, built though they were in the 1960s or '70s, were 'not built for today's audiences' and, indeed, for the kind of future a certain type of person had in mind for theatre, where well-heeled audiences went for a meal and a drink and a splash of violence on stage, then a comfortable (ie, modern) environ-ment was more or less essential. Refurbishment was and is one of those words which can be used and no questions asked. It always means a lot of money and it always means 'modernisation', another word which brings no questions. Both phenomena have the effect of taking the theatre in a particular direction towards a particular audience and atmosphere; both made any possibility of rebellion or seizing power by artists, more unlikely, both made art itself seem as if it ought to be a conforming part of some sort of system, of the contemporary scene – like a sort of deco-ration. It's a bit like the way an old fireplace in an old house after it has been modernised becomes a 'feature', not where you light a fire to keep warm, the high-tech heating takes care of that – just as windows don't let in air, the air conditioning does that. (This little metaphor describes the place of art in the modern theatre; it also describes the windows.)

Enter the Lottery: the ethical epitome of Major's Britain, right down to the gawky phrase 'good causes' so that the money is going to some-thing that is 'all in a good cause', worthy of our charitable sentiments – which puts the arts on a par with either a broken rabbit or someone in serious need, when in fact it resembles neither. The lottery produced more money than even the organisers had expected, an ocean of it to slosh over the 'cash-starved' arts world. Sadly, someone decided it should only go to capital projects, maybe hoping for a Tennessee Valley effect to trickle down from all that money. It couldn't have been worse designed for theatre which was still hamstrung by the building spree of the 1960s. The last thing they needed was more buildings. This is what happened to Norwich Playhouse: drunk with joy they received £400,000 plus £2.5 million private and charity money (!) to build a new 310-seater; but they forgot to wonder if they had the money to run it once built. No extra money was available for that, of course, and so since audience figures were low they had to close by 1997. Yes, close. The building nearly became a theme pub, and it was only reopened in 2000 with a loan from

a bank, and then only as a touring venue. That's how alluring the childish fantasy of refurbishment and rebuilding is.

In the 1990s the over-staffing and over-spending were not much talked about, it was taken for granted. The odd bit of information did appear, though:

> York Theatre Royal spent £133,000 on front-of-house staff. Birmingham Rep welcomes the same numbers each year for half the cost but makes up for it by spending twice as much as York on just about everything else, from telephone calls to travelling and entertaining (£21,000), stationery, postage and printing (£35,000). Birmingham also spent a quarter of a million on admin and marketing staff, plus a further £264,000 on marketing costs, and £380,000 admin costs. It all adds up to more than the Arts Council grant and almost half of what the theatre spends on production. Not surprisingly, Birmingham Rep is in debt. It has been allotted a £5 million stabilisation grant. Manchester Royal Exchange gets £1.3 million from the Arts Council and produces nine plays. Box-office and other trading rakes in £2.1 million. There are over 100 staff.
>
> Gregory Motton, *Guardian*, 1998

Tory rule, in the conventional view, was a 'sustained assault on the theatre community' (Turnbull), despite the fact that there was no overall cut in arts funding. But the assault came from within, and the theatre 'community' was taken over to such a degree that there was no-one left to point out what was really wrong.

If this had not been true, if the theatre had any independence or guts then the Tory cold shoulder would have seemed like halcyon days compared to Tony's bear hug. But the left-wing lackeys ran to their daddy with bright uplifted faces. New Labour, like the Wilsonian forerunners in 1964, knew the value of the arts to a social engineering controlling government such as they were, and intended to be. There was now no notion of 'arms length' left at all. The sole purpose of the arts was to 'improve' the people along the lines set out by the government; there was no question about it. Education, Education, Education, sadly had

nothing to do with anything so old-fashioned as knowledge and train-
ing for children (that was something they actually despised). It meant
re-education, in the Stalinist sense, and to this end theatre and the arts
were dragooned. It was announced that there would be increased finan-
cial support for the arts and everyone heaved a sigh of relief. Tory 'cuts'
were over.

Immediately then, New labour CUT arts spending. Yes, only the
fourth actual cut in the whole history of the Arts Council, and five thea-
tres closed: Liverpool, Stratford East (that great working class theatre in
the East End of London), Ipswich, the Old Vic and Greenwich.

This cut was followed though, by an increase in 1999 which shot arts
funding up to the heights of...still below 1990s levels. (Source: Turnbull.)
The abiding image, though, is still of Tory Cuts and Labour spending.

This huge 'increase' in spending came with strings attached, and the
Arts Council was now 'expected to demonstrate how arts organisations
were contributing to the governments political social and economic
objectives' (Turnbull).

If anyone doubted the government's intentions and motives, their
raid on the Lottery money put it beyond doubt. While the principle
had always been that lottery money must not replace government
spending (a view reiterated by Blair just before he reversed it), the
New Opportunities Fund effectively ended this principle and raided
the money to fund government projects. By 2000 it took 60 per cent
of all the lottery money previously allocated to the arts, and the so-
called good causes went from getting 16 per cent of lottery money, to
five per cent. The era of huge grants (under Major) was over. To alle-
viate the disastrous effects of the huge capital grants which were now
effectively draining Arts Funding because the new buildings were so
expensive to run, the Arts for Everyone scheme released lottery money
for revenue funding.

However the whole process of applying for lottery money was yet
another bureaucratic distraction, which became a *raison d'être* for even
more administrators. By 2004 Director of the Theatres Trust Peter
Longman was describing a crisis of confidence in theatres 'greater than
any time since the war', while audience attendance was by 2000 at an

all-time low due to the poor work being produced, according to an independent report commissioned by the Arts Council itself.

The Crisis brought the National Policy for Theatre in England, 2001, which promised three-year cycles of funding and money to clear debts. But as well as excluding many theatres altogether without reasons given, this policy made it very clear that the government's own objectives were to be imposed on recipients, explicitly.

It was hard at the time to see the sinister aspect of these words of Blair's:

> For too long arts and culture have stood outside the mainstream, their potential unrecognised by government. That has to change and under Labour it will.

'Outside the mainstream' here seems to mean 'not part of government'. An interesting view of life.

As Olivia Turnbull puts it:

> Labour saw the arts as vital instruments in the transformation of Britain into a multicultural utopian enterprise culture [...] the arts could be used to combat [...] social exclusion [...] boosting people's self esteem, raising morale and empowering individuals. In other words the role of artists was to help the government deliver ministers' policies.

Just as under the Tories, the arts also had a role in regeneration of the old industrial areas, as Britain continued along the road of leaving actual production to the Germans and the Chinese. In other words, we could have theatres opening up in disused industrial spaces, where we could watch plays about greenhouse emissions, while the clothes and household goods of the audience watching them are being manufactured in China, where we have in effect exported our pollution and where emissions are not controlled. The 'economy of the imagination', to which the arts was to contribute, is a very nice expression for an economy of *thin air*. It seems fitting that the arts, as government poodle, should be forced to contribute to vacuousness on such a grand scale and with such long-term bad effects.

At the Haymarket Theatre in Leicester, the 'New Audiences Development Scheme' meant targeting the Asian community, who had not previously shown any interest in the theatre there, and trying to get them to. This was done by aiming specifically 'Asian' plays at them, and at subsidising specifically *their* tickets. The result, understandably, was not good. A report afterwards found that the effect was 'damaging', that it alienated other audiences (including other minorities), perpetuated a sense of 'otherness' within the Asian community, and failed to encourage 'cross over'. Which is an inevitable verdict on multiculturalism (as opposed to multiracialism). Leicester lost its original audience and ended up closed, making the legion who staffed it, unemployed.

'Multicultural' is often used interchangeably with 'multiracial' but it is not the same thing at all, and it is not something to which any government can be seriously committed, since it is a random, open-ended notion which it makes little sense to actively promote, as it doesn't need promoting. People are already different.

To the government, does 'culture' include legal and moral values, for example? Would the Labour government for example encourage such diversity as clitorectomy? Or stoning for 'adultery' (or for victims of rape which is what it sometimes amounts to where it is used)? Does it extend to pouring acid down the throat of an unwanted suitor for a female in your family? In fact it is impossible to approach the question of social and legal values without taking a moral position. And it would be better for all members of our society if we did exactly that; there are higher values, more useful ones, than *seeming* to be tolerant: peacefulness, living free from threat and violence are among them. Luxuries perhaps for those who feel they already enjoy them, but far off for many in our society.

A government which has shown itself unwilling to allow even political difference to be openly expressed, is hardly likely to have any genuine enthusiasm for cultural diversity which would directly go against any of its own precepts. The idea that any society would actively promote cultural diversity rather than racial diversity (to which it is barely related), is questionable, and a government which claims to be doing so

is either lying or doing a disservice to its people. The French left, for example, think the British enthusiasm for this idea is nonsensical: there it would be contrary to good republican principles of equality and fraternity. Here to speak up against it makes you into some kind of fascist.

There is no right or wrong over it, once we decide that each set of beliefs and values is as good as another. That works both ways. It means that, just as one society's existing norms are no better than another's, there cannot be any moral good in any adjustments. Therefore there is no intrinsic moral value in promoting diversity, or in introducing elements merely because they are not already part of the system of values. The atmosphere of morality which surrounds the words and the policy of cultural diversity is incongruous; behind it stands the morality which is called political correctness, which is in fact a moral precept, but here it is mistakenly applied. If cultural values are relative, it simply leaves it as a matter of local preference.

While it is at best *permitted* for a representative government to have a different view from its people, it is absurd for them to have a preference which it seeks to promote as a policy on an issue where there is no substantive fact involved. In other words, it is absurd for a government to have, as a policy, the intention to change our values, without saying what they are to be changed to. A people's preference for its own values is almost tautological. To have a government that opposes this preference on principle is perverse.

In truth, they don't. They are only pretending to because they somewhat stupidly think that it is 'morally' required of them to do so. Their confusion rests partly on a naïvely limited view of what 'Culture' means. One can almost imagine they think it means the same as 'religious festivals', or 'national costumes'. (Indeed, any parent ought to have noticed that 'Religion' in schools is taught solely with reference to the way various feast days are celebrated: the actual beliefs involved are barely mentioned. So much for cultural diversity!)

At the same time as wanting to seem to promote 'cultural diversity', the government also claims to be actively seeking for unity and a sense of community and shared values. The left now notice a lack of cohesion in society. In some sense this situation is that of the revolutionar-

ies wanting to quell the disorder they created, once they have seized the reigns of power from the old regime.

The way the active promotion of cultural diversity has been handled has inevitably resulted in creating alienation and division, partly because the left, in that strange temperamental sulk they have had for four decades, harbour an inexplicable resentment for anything which is in their view native to Britain. English culture, for example. The English race has to be the only race on earth deemed unworthy of recognition or acknowledgement, promotion or protection. The only time you ever hear of the English race therefore is in the mouths of racists and the far right. (The dinner party noise on this one is that there *is* no English race, we're all mixed up over the course of history, etc, etc, as if that isn't the case of most races on earth.) This neurotic hatred of all things English or British, so characteristic of the left, is thankfully not shared by the working classes, and not shared by immigrants either. It is an attitude exclusive to the white urban middle classes, funnily enough!

There has been a long-term intrusion into the arts of this kind of idea which is reductive at best, and plain stupid or misguided at worst. Funding is no longer free from direct government control, and yet funding predominates in the arts. The result is a pervading sense of *asking for permission*, which after long use, begins to bite at the early stages of even thinking. Theatre writers and theatre managers are used to looking over their shoulders at an increasingly narrow-minded sort of puritan master, whose clumsy precepts preclude the kind of discoveries or developments which go against government policy and even simply government taste or opinion. Moral responsibility, which I believe is a valid and vital element of art, has been discarded and replaced with its fake and confused cousin, ideological rectitude.

The Arts Council has come a long way from its beginnings, and almost all of the developments have been bad ones; it has lost its idea of the culture which it thought the populace would benefit from seeing; it has lost its idea of who the populace were; it has lost the idea of the Arts Council being at arms length from the government; it has replaced all this with the Government itself, and its policies – the arts are now merely

there to implement its policy. On top of this, it swelled the theatres up to such vast scales that they are out of the reach of the theatre practitioners themselves, forever. The monolith of jargon and the twisted ideas that go with it is almost impossible to reproduce here, and those kinds of ideas and that kind of language is hardly worth the candle, it will pass away and be overcome by its own absurdity. But what won't go away, unless we actively get rid of it, is the mechanism by which each government now routinely imposes its mad little version of life upon the arts. What won't change unless we change it, is the fact that the arts, through funding, has become the establishment's poodle, and one which breathes its foul breath in a cloud that obscures any hope of art or truth or change.

4 LOOK BACK IN ANGER

ONE OF MY MODERN favourites, which I would place on a list of little-known neglected plays, would have to be *Look Back in Anger* by John Osborne. This gem from another age would have made a very interesting focal part to an enlightened audience, for the Royal Court's celebrations of 60 years at the top of social comment.

Neglected and barely remembered as it is, this play puts down a timely marker in the snow before the thaw and is very interesting to review, now it has all turned to slush then melted away. How interesting for the writer it would have been, and the Royal Court itself, to see just where they had put down that marker now that it is so clearly visible. Unfortunately, snow-blindness still afflicts those to whom the play would be most instructive.

It was written in the middle of a Conservative government that had already lasted since 1951 (not much by today's epic standards, but it was to go on until 1964), following the Attlee government which had, after its commendable achievements, 'expired into the arms of the civil service'. While the play was being written (it was completed by February 1955), an ageing Winston Churchill, then 81, was at the head of the government. Foreign affairs might not seem altogether unfamiliar: Britain's ally the USA had recently been engaged in a pre-emptive war of containment to halt the spread of an evil empire, and Britain, whose own troops were committed as part of a UN force, was trying to influence the US military and political strategy from its own junior position, and to prevent the USA from using the A-bomb on the too-numerous influx of support from a neighbouring territory. Meanwhile, the Europeans were planning a unified defence policy, raising questions about Britain's future sovereignty.

On the home front, as well as in foreign policy, there seemed little to distinguish between the two parties. A modernised Conservative party had already accepted, not to say embraced, the NHS and the welfare

state, while in government the Labour party had shown itself well able to steer the stately if Quixotic course of British foreign policy as the Conservative establishment itself had done. Other aspects of society remained unchanged.

This is the era of *The Gentian Violet* (the 1953 novel where a man is elected as a Labour and Conservative MP at the same time), and of 'Butskellism' (derived from the names of Conservative Home Secretary, R A B Butler, and his Labour counterpart Hugh Gaitskell), the era of stop-go-ism and the sort of short-term prosperity that that brought. Neither party, between 1950 and 1979, did anything to halt the gradual decline (they called it privately 'managing decline') in productivity and all the problems which accompanied it. This has continued right up until now when we face a future where we cannot pay our way, and will most likely end up being a source of cheap unskilled and unintelligent labour packing and marketing Chinese goods. (Something one can imagine Jimmy Porter predicting, although he didn't. He did predict, however, that all our children would be Americans – which was, like, *sooo* going to be true?)

The old establishment was still in place, albeit slightly modernised; the impression of continuity was exaggerated by Churchill being PM and the old warhorse atmosphere of his approach to cabinet (he called them Overlords). It is worth remembering that the war government was a coalition in which Stafford Cripps, Ernest Bevin, Arthur Greenwood and others got their experience as government ministers in a cabinet generously loaded with Labour ministers. The continuity wasn't merely that of the Tory old guard, as the usual historical summaries have it: there had been continuity even in Attlee's government.

The targets of *Look Back in Anger*'s barbs were: the church; the newspapers; the military; the convention of Sunday itself; the upper classes; Alison's brother Nigel from Sandhurst (like at least one Royal Court grandee at the time); homosexuals (like many a Royal Court grandee at any time); people who didn't approve of other people's loud music; the curtain-twitching aspect of conventional morality; pusillanimity in the upper classes; also their brutality, snobbishness which regards the working classes as uninteresting; the returning colonials; the Edwardian

ideal of upper middle class colonial life; Americanisation; snobbish-
ness, which failed to acknowledge Jimmy's qualities and which saw him
as vulgar. These together amount to what was perceived at the time as
a description of something larger than the sum of its parts, we must
presume: a description of British society and its conventions which in
the play are painted as stale and lifeless.

The portrait, as well as Jimmy's and the play's attitude to it, was
sometimes ambiguous and sometimes contradictory – not at all the
same thing. For example, to resent the curtain-twitching and to resent
Americanisation at the same time is not ambiguous – it merely lacks
any foresight and understanding, to the point of being contradictory
– whereas Jimmy's attitude to Alison's father and to the Edwardian
dream is ambiguous: he has mixed feelings and is undecided. In general,
the play is a mixture of these attitudes; they are all representative of
Osborne's temperament and political outlook. The problem with contra-
dictions is of course that they can be dishonest, like hypocrisy (ie, if I say
I want no more car fumes I can't insist on keeping a car), whereas ambi-
guity is an acknowledgement of the complexity of things, and is more
likely to be closer to the truth of most matters, as good and bad rarely
line themselves up in accordance with our own feelings. Ambiguity is
potentially interesting, whereas being contradictory is just a matter of
subjective emotional indulgence, and is of no real interest, especially
when it is projected as a view of society.

It matters quite a lot if the play's view was accurate enough not to be
misleading. At this distance it is hard to tell. But it is rarely remembered
in the theatre these days that the impetuous outburst of an impatient
and not particularly fair-minded young man is of limited reliability as a
judgement on the state of the nation.

Britain had just fought an enormous war and was physically, psycho-
logically and economically exhausted. It had, to its great credit, won the
war, while losing the peace – to its allies, the USA.

Britain had just created a health service and welfare state, in advance
of any then available in Europe or America, and despite shortages and
austerity following the war, had managed a huge housing programme
and to have created some semblance of prosperity, which meant bath-

rooms and healthcare and, by 1956, luxury goods on Hire Purchase. The real problem facing Britain was the failure to renew the production base.

There could, then, have been other ways to describe Britain which would have been more accurate and useful; other ways which would have considered more deeply what was really wrong, if anything, and what the difficulties ahead might be and what might be needed. The reaction of a young man, Jimmy Porter or John Osborne, to his personal predicament, is not necessarily likely to produce that. On the contrary, a disinclination to think outside of his own ego is a distinct feature of Osborne's work, which undermines the quality of his writing. Not always, however: his depiction of Martin Luther in *Luther* indeed treats of this very problem. In that play we see the symbiosis of an individual man's nature – his psyche even as it manifests itself in his bowels – and the great blockage, or even necrosis, afflicting the Catholic church and the world it dominated. A fortunate coincidence that resulted in one of the great revolutions of history. (In fact, in Hegel's view it was the final dialectic moment of synthesis.)

Luther is possibly Osborne's masterpiece. In it he objectifies the kind of symbiosis of the individual and society and has understood it better and, perhaps more importantly, chosen an example where the personal and the global tragedy are more perfectly linked. *Look Back in Anger* only really gives half the equation, while most imperfectly and possibly inaccurately hinting at the other half

To some extent the chief impression of *Look Back in Anger* is not the result of the play but of its reception and its subsequent influence. In many ways it is not a good or big enough play to warrant its effect. Notwithstanding this, it has earned itself undoubted significance. In my view, it is of the wrong kind. The presumptions which have gathered around it, in terms of where it points to, are all in one direction, and largely the wrong one.

The play's title is ingeniously incomprehensible – 'Look back' from where, at what/when? When is the action of looking back taking place? It is a great title, but even more so as hindsight gives it an aspect of prophesy not generally appreciated by its self-appointed inheritors. Now is about the time when Jimmy Porter could well look back in anger at

what has become of his rebelliousness; right now it would be a fantastic title to that very same play written now, about then, in the light of what became of it all. It is one of the great missed opportunities in theatre that they didn't celebrate the 60 years with something meaningful; what a neat full circle it would have been. Unfortunately the blindfold was strapped firmly to the head. They hadn't yet noticed what had happened to society.

In America at the same time they had the film *Rebel Without a Cause*.[1] This title, while lacking the authentic feeling that comes from subjectivity, is at least pretty well observed, albeit from above – one can almost imagine the title being dreamed up by a committee of producers in despair when they realised their film had no real point to it. I have watched the film a number of times and I still can't identify the rebellion: I can agree that there is no cause; but it seems to me that a rebellion without a good cause is nothing more than bad manners or selfishness or plain stupidity. It is perhaps typical of our era that rebelliousness in itself is seen as a quality. At any rate, the ill-defined nature of that rebellion, as well as of Osborne's anger, is certainly a principal feature, subsumed in both cases by subsequent events and the course of social and political developments. What was indeterminate at the time is now a first step along a known path – we all know what it led to. In England it identified itself as left-wingism – not least in the Royal Court, where by the 1980s its adherence to the left was totally explicit – but Osborne and the play are to a large degree conservative.

'Disaffection' ought probably to be a better, less misleading term than 'rebellion' for the feeling anyone of any age can have at any time. It is a precursor of change sometimes and it is a word less easily derailed into any particular political sideline (although it is now associated with youth). It doesn't contain the Freudian delineation of the structure of things along patriarchal lines he set up, which has been so misleading over the past 60 years and has led to such distortions as we labour under now. For example, where is the seat of power in a society that is not 'patriarchal'? Or is there no power at all? And unless there is no power at

1 Directed by Nicholas Ray, 1955.

all, then we have to conclude that not all power is patriarchal. Thence we can conclude that the patriarchal description of power, or its association to power, is misleading, both as a definition of power, and as a definition of patriarchy. I think it is worth mentioning in this context because it is one of the presumptions surrounding the past 60 years, in rebellion and left-wingism, that all power is bad and that all power is patriarchal, and that all patriarchal power is bad.

The rebellion in *Look Back in Anger* is not in its nature anti-patriarchal. The rebellion in *Rebel Without a Cause* is positively *pro*-patriarchal; the boy's main complaint is that his father is not man enough, not patriarchal enough. The father is a man emasculated by his wife and aspects of his class environment, his sort of job, or simply his own personal nature. In psychological terms the story is about the struggle of the boy to find his masculinity without a model to copy. The solution isn't the bravado of the mob, simply because the hero is too well balanced between masculine and feminine for that; he needs a model which is a satisfying combination of the two, not an unreasonable expectation in any society or circumstances.

In *Look Back in Anger*, Jimmy Porter embodies masculinity and it is certainly easy to imagine him taking a place in a patriarchal society. In the play the female psyche manifests itself in Alison of course, and Helena is a sort of male woman – Jimmy gets, in Helena, the woman he deserves, one shorn, albeit temporarily, of her perception and of her inhibitions, and the violent power of passive resistance.

The essentially female which in Alison Jimmy finds so enraging and which he calls 'pusillanimity', is entirely absent from Helena; she is also completely unsexual. As Jimmy says, sex between them is unproblematic, and to the outsider it seems to be so to the point of being unerotic. It is interesting the attention 'pusillanimity' gets, since it coincides so closely with the word *anima (the female archetype, the feminine aspect of his own psyche)*, for which it could almost be a misnomer. In this case Jimmy is raging against his anima, which he has projected into Alison, and her ironing board; he leaves us in no doubt of the lust he feels for her in that guise, which to my mind is a healthy sign that she embodies the anima for him. (In Helena he is embracing his own animus *(the*

male archetype), an essentially fruitless union.) Alison is attracted to
Jimmy for the same (converse) reason: he embodies her animus. The
fact that he so strongly resembles her own father bears this out, perhaps.
He is attracted to a very female woman and she to a very male man who
resembles her father; the end of the play – the rather forced synthesis –
seems to show a happy marriage of the two, a conjunction where the
polar opposites are combined through mutual acknowledgement, here
based on their respective failure to fulfil their roles successfully.

Disaffection has been closely associated with youth in our own epoch,
and youth has come to mean something younger and younger. An angry
young man in the 1950s, even, is a very different prospect to the 'young
man' of today, who is a deal younger. The disaffected youth is now a teen-
ager, even a young teenager. He or she is now quite likely to be easily
capable of torture, murder, rape and maiming, is completely sexualised
and brutal, armed and without any conscience or mercy. The gulf is vast.
This idea of disaffection is so completely transformed that it needs to be
accounted for, not by me but by those who still celebrate and respect it:
those who find it interesting; those who fail to resist it, or to see it for what
it is; those who fail to attack it, and fail to defend the weak and defence-
less from its savagery. Any article, any play, any book which talks of disaf-
fection, which talks of youth, which talks of 'rebellion', must face these
facts; must find responses appropriate to the lethal seriousness of these
facts; must take responsibility: must, in fact, imagine their loved ones at
the mercy of it (if they need that aid to their imaginations and under-
standing). Not to do so is dishonest and cowardly, and that is a charge
I lay at the whole establishment, the artists and writers and playwrights
and directors who trade on the culture which has produced this beast.

The more disaffection has been associated with youth in itself, the less
political it has become. By political I mean simply connected to actual
substantive wrongs or complaints. Despite eager efforts to put words
into the mouths of those who have nothing to say, disaffected youth is
limited largely to destructiveness or violence. They are not youthful and
idealistic, they are young enthusiasts for brutality and oppression. Right
under the noses of the romantic left who believe in youthful rebellion,
that youth and that rebellion has turned into oppression of a very real

kind: oppression which, for those subject to it, in the housing estates or the streets of our cities – the young, the frail or the merely unsuspecting – can be no different from what it would be if the area was run by Nazi brownshirts. That this situation has not drawn the attention of the theatres, interested as they are in disaffection and in social comment, is the real judgement of the worth of the theatre.

Once disaffection is the preserve of a group of people whose main response to life is to oppress others, then 'rebellion', and all that it was supposed to stand for, is over. If 'art' doesn't adjust to the fact of the demise of what is largely its own creation, then art will remain a collaborator to oppression. To adjust, it has to reappraise its words. All the words it has grown accustomed to using, so glibly in the past, now represent something else. The change necessary to adjust to this would be enormous; it would be a wonderful thing because it would force writers to actually think, once again.

The developments in the nature of rebellion have failed to register upon the appreciation of *Look Back in Anger*, and of the inheritance it has left to the Royal Court. Strangely, it is as if the Royal Court exists in a vacuum; in its celebrations of itself, it made hardly any reference to the society it now finds itself in, and to their role in creating that society. Strange in a theatre which defined itself very much in terms of its relationship to society, and at some points explicitly in terms of a particular political viewpoint. The Titanic too was indeed a wonderful ship. Only in this case it wasn't the ship that sank, it was the sea that caught fire and died of pollution.

Here is an example of something theatre would find it difficult to get angry about because it's not really their style and they don't know anything about it…

Unless we count *Joking Apart* by Alan Ayckbourn, the difficulties of putting children on stage has prevented any comment on the comedy, then the tragedy, of the deeply misguided ideas which have governed upbringing over the past decades. This has now turned into a national disaster, but one which of course doesn't feature in Theatreworld's view of things.

Britain's experiment with lax parenting has shown the not too surpris-

ing result that: if you bring children up to be rude, arrogant, selfish, nasty, drunken and aggressive, they will become so. It has taken at least two decades for the results to sink into the national consciousness, but there it has had to overcome a quaint, rather sentimental belief in miracles. This belief hopes that if you withdraw all censure from a child's behaviour, and then proceed to soak it in images and examples glorifying bad behaviour ranging from rudeness to extreme violence, the result will be a well-adapted and helpful member of a community. This miracle is patiently waited for by those to whom it is a central belief in their ideology; it must be so. One can only hope that there is still some trace of childhood left, some few years, or even months, in a person's life, during which this miracle of innocence can occur to fulfil these optimistic expectations, and that the awaited miracle will come to save us before the progression from cradle to knife-wielding, merciless fiend is immediate.

It is interesting to see how the experiment, which began with just allowing rudeness (a sort of pettish middle class rebellion against what they considered the excessive politeness of between-the-wars England) and low-level bad behaviour, will go before it is recognised as a failure. Perhaps when childhood is eclipsed altogether by violence which it is on the way to being, the question of how to bring up children will no longer be applicable. Then we can simply start putting toddlers in prison when they commit their first or second murders, This would probably suit the promoters of 'laissez-faire' parenting pretty well, since although they find it abhorrent to reprimand a small child for bad behaviour, they have no difficulty whatsoever in putting large proportions of the population in prison. One in 740 is actually in prison tonight. In America, where a whole society is avidly devoted to the principles of 'laissez-faire', this excellent combination of material inequality and moral 'freedom' has produced a prison population of 2 million, that's one in every 143 people, actually in prison at any one time, the highest imprisonment rate in the whole world.

In the chapter on Herbert Read, we saw one of the origins of the idea that it is wrong to say 'no' to a child: when, in a vague Freudian way, the practice was seen, rather stupidly, as the cause of war. We have

now seen how *not* saying 'no' to them leads to them being violent. It has made children arrogant to the degree that using violence to get their desires, including just a desire for entertainment, seems to them to be their positive right. Add to that the sad fact that a human being, *if it has learnt nothing else as a guide to its restraint*, will do more or less what it feels it can get away with. The middle class hatred of authority (unless it is their own ideological one) in Britain since the 1950s has more likely its roots in their own struggle for power, in their rebellion against the values of the old establishment. Their suspicion of all ideas of restraint and their contempt for the very word Morality have foisted upon society an era of the most dreadful carelessness about the development of the young mind. The vile doctrine of so-called permissiveness (and this is nothing to do with the word as it is applied to sex, by the way) has thrown children to the wolves, and they have grown up as beasts. The whole idea of 'permissive' parenting is a lie. It tries to give the impression that it is the children who are in some way the beneficiaries. In fact it is merely an excuse for parents to abandon their duty to care for their children properly. Letting the children watch TV all the time, letting the children play on their computers all the time, letting the children do whatever 'peer pressure' tells them to do, letting them eat what they want (poorly prepared takeaway food in front of the TV), letting them be out unsupervised, letting them grow up before their time: it all suits the lazy selfish parent who cannot be bothered to cook for their children and eat with them, or talk to them; the parent who is not prepared to face the at times difficult struggle to imprint the rule of decency on the human heart (where it is in fact not indelibly written already at birth, no matter what the optimists think). The parent might be lazy, it might be 'busy', it might not have time or the inclination to fight that battle or to put that amount of effort or energy into its children; it might be drunk or drugged itself, it might even be addicted to drink or to drugs, or to television or to violence; it might tell its children to shut up, or it might reply inattentively (depending on the social class) or it might slap the toddler for their own failure to control its behaviour. And when the child is 12, and unruly, and the outside influences are so much stronger than the half-hearted selfishness of the

parent, such 'permissiveness' is only too glad to let the child run wild outside and to let them find their morality, or lack of it, from the violent bullying pecking order, where they learn to prey on the outnumbered or the weak. Anything rather than have to know what their children are doing and take responsibility for it.

'Permissiveness' is nothing more than permission for the lazy or inadequate parent to give up. For every gang member on the street there is a lazy irresponsible parent at home. This parent will claim they lack the authority to control their children, and will claim that they cannot compete with outside influences. A whole generation of parents have failed to impose themselves as parents, and have allowed 'society' (the wolves) to bring up their children for them. The nightmare will only end when parents realise once again that it is their right and their duty to impose their parental guidance and care upon their children; to replace the ravenous and predatory influences with proper parental care. It is not enough to love your children (though that is of course essential); you are also responsible for forming them. Hard to see why, but it is fashionable to think that it is somehow wrong to form your children; but if you don't teach them right from wrong, someone else might teach them wrong is right.

It's a shame it is always largely misinterpreted because *Look Back in Anger* contains, in its wistful conservatism, traces of the response to our present society that it looked forwards to, that is now missing.

Morality in *Look Back in Anger* is depicted as largely hypocritical and conventional (as if the two are the same thing). The Sunday papers embody the hypocrisy and Alison's mother embodies the conventional, which here amounts to no more than snobbery. Helena combines the two, as her sense of outrage does nothing to prevent her stealing her friend's husband. Cliff is simply kind and mild-natured and predictably no link to morality is seen here. In Jimmy himself we are told there is a 'pretty literal-minded notion of loyalty', to himself, and to Hugh's mother (who owns the sweet stall). We are, I think, expected to see in Jimmy the operation of a personal code of morality which is vaguely toted as superior to any conventional one – except that it clearly isn't in this case if we

are to judge the tree by the fruit it bears, as for example in Jimmy's attitude to his wife's miscarriage.

In this particular we could say that the play exhibits the now orthodox idea that morality is a matter for the individual to select for himself, as and when it suits him, and that this is in itself better than conventional morality; whereas in truth it depends on the relative merits of the actual morality employed. The seeds of modern egotism are certainly there, foreshadowing the future of a Royal Court where writers have nothing more to advocate than one after another individual code of morality (or non-morality, or selfishness), a different one for each character; where judgement isn't merely suspended, there is no judgement; where a constant parade of egotistical individuals stride boldly across the stage leaving the burned corpses of their victims behind them – and of course a society to match.

It is hard to separate this militant individualism from the widening gulf in our new society between the haves and the have-nots. For not only do we now have a society where the material gulf between rich and poor has widened under a Labour government, but where a very clear gulf has grown between those who still benefit from vital *cultural* phenomena such as morality and understanding and knowledge, and those who do not. This curious effect – the creation of a mass of people who are culturally deprived more than anything else – surely deserves attention from writers (some writers even seem to think of that as a state of freedom); but all it ever gets is description in usually disengaged and non-analytical plays. Writers cannot engage with it properly because they refuse to face the conclusion it demands. *Look Back in Anger* and to a large extent the whole of the Royal Court output that followed it must be looked at again in the light of the society it helped create.

The drama of the past 60 years, let us call it the new conventional drama, needs to be re-examined, not celebrated but criticised, and to a large extent rejected, at least as much as the conventions in art and drama of the previous epoch deserved to be.

A renewal of our whole outlook, no less than that which occurred in 1956, is needed now. It is a real mystery to me why no-one is looking back in anger at the last 60 years. For some reason those few writers who

are dissatisfied with the way things are, make no connection between present circumstances and the ideas and habits of thought which have got us here. And of course the actual people who suffer the ills of our society have no voice on our stages, not this time because there are no 'working class writers', as the Royal Court called them, but because no matter what class they are, they are not yet allowed to speak up against the ideology which has created our new society. The next play to actually change things, as *Look Back in Anger* did, will have to be one that does that.

5 THE ROYAL COURT AND THE WORKING CLASS WRITERS

WHEN I SET OUT to write this book I read the Royal Court's book about itself, a well-written and entertaining book called *The Royal Court Inside Out*.[1] It was, I am sure, a difficult book to write – how to capture so long and full a history and to represent as many people as possible and do justice to the people and the institution? It is understandably a broadly positive book, and with good reason: the Royal Court, whatever its faults, is a theatre we couldn't do without. It is just a shame there aren't six or seven theatres like it. Like the rest of British theatre, though, it seems to lack a talent for self-criticism; also, its history and its achievement bear with them the contradictions and failings that characterise British theatre.

It is virtually the only British hand that has ever fed me, and now I have to bite it.

From reading the rest of this book so far, the reader will have already guessed that I might regard with suspicion the Royal Court's claim to have something to do with working class writing. I am not the only one. John McGrath, for example, wrote about it in *A Good Night Out*. In an idle hour I looked up the educational backgrounds of the Royal Court luminaries as they appeared in the first 200 pages of the book. I have to say even I was surprised, incredulous. The results are printed below. (Fees given at current prices where known.)

1 Ruth Little and Emily McLaughlin, *The Royal Court Theatre Inside Out* (Oberon Books, 2007).

Dramatis Personae
(in the order in which they appear)

Name	School	Fees	University
Caryl Churchill	Trafalgar Girls School	Can$12,000	Oxford
Edward Bond	Holloway (left school at 15)		
David Hare	Lancing College	£26,000	Oxford
Howard Brenton	Chichester High School (grammar at that time)		Oxford
Nicholas Hytner	Manchester Grammar		Cambridge
George Devine	Clayesmore	Fees unknown	Oxford
William Gaskill	Salt High School		Oxford
Lindsay Anderson	Cheltenham College	£27,000	Oxford
Tony Richardson	Ashville College	£9,300	Oxford
John Osborne	Belmont College public school	Fees unknown	
John Dexter	Elementary school		
Anthony Page	Winchester	Fees unknown	Oxford
Peter Gill	St Illyatids College (Catholic church school)		
Christopher Hampton	Lancing College	£26,000	Oxford
John Arden	Sedberg School (public school, founded 1525)	Fees unknown	Cambridge
Angus Wilson	Westminster School	£27,500	Oxford
Jocelyn Herbert	St Pauls Girls School	Fees unknown	Slade
Ann Jellicoe	Queen Margarets School	£22,500	Central
Barry Reckford	Kingston College, Jamaica		Cambridge
Arnold Wesker	Upton House Secondary School, Hackney		
Wole Soyinka	Government College, Nigeria	fees unknown	Leeds
Harold Pinter	Hackney Downs (then a grammar school, now the worst school in England according to H M Gov)		

Name	School	Fees	University
Shelagh Delaney	Broughton Grammar School		
Joe Orton	Marriott Road Secondary Modern, Leicester		RADA
David Storey	Queen Elizabeth	£9,300	Slade
Heathcote Williams	Eton College	£28,300	Oxford
David Edgar	Oundle	£25,200	Manchester
Mike Leigh	Salford Grammar School		RADA
Stuart Burge	Sandhurst and Felstead	£23,400	
Nigel Williams	Highgate School	£14,000	Oxford
Max Stafford-Clark	Felstead	£23,400	Trinity, Dublin
N F Simpson	Emmanuel School	£13,743	
Angus Wilson	Emmanuel School	£13,743	

Yes, only four were from standard state schools; the others were from fee-paying or grammar schools. The grammar school quota was five, and we ought to remember that grammar schools, according to the left, are bastions of privilege which ought to be destroyed.

And as for the rest, well what a fruity package of boys and girls: some of the best and most expensive schools in the world. No wonder they are 'socialists' – they know better than most of us exactly how the other half lives.

And so, before we even begin, it is abundantly clear that most of the Royal Court's leading lights were from the elite. Their ideology and their policy and decisions have to be seen in that light. This is in keeping with their own view: they regard private and grammar school education as elitist and unfair and damaging to society. They see that it creates an elite who automatically occupy the important positions in society, and that that is a bad and harmful thing. They do not think that such an elite can or should be trusted on their own to form our society, to form our thinking, to form our ideas and ideology. Neither do I.

And yet, surely, I thought, as I saw the results of my enquiries, it cannot be all that simple; surely the famous 'working class writers' of the Royal Court can't be a pure invention. I looked more closely and I found that indeed there were some writers of working class origin who had their plays on at the Royal Court, which gives some substance to the claims the Royal Court made. If you go to the *back* of the book, to the list of plays produced each year, that is where you will find the names of writers – obscure, maybe – whose social origins are other than public school and Oxford. What is hard to puzzle out is how they all manage to be at the back of the book, and how the elite manage to be in the front, in the main body of the text. You'd think they might like to present it the other way around to keep up the credentials of the theatre. But in fact, of course, the writers of the book had no such designs and merely honestly recorded the significant history of the theatre, as it was. It happened to be the truth that all the important and successful writers, who play a significant role in the running of the theatre and its development, were from the elite class.

How can this be? Is it a coincidence? Or is it simply that those born and bred to power know how to keep it? Or is it that only the writers who subscribed to the middle class left ideology were able to maintain the interest and support of the Royal Court? Is it that the writers who were working class but who didn't want to fit into the role of 'working class writer' and write within those expectations, quickly lost the interest and support of their masters? If you are a working class writer you pay your rent by being a Working Class Writer. Frank Norman was an orphan and jailbird and actually working class, but his writing didn't fit into the middle class political ideology: *Fings Aint Wot They Used t'Be*, though it might have pleased a working class audience, wasn't exactly what the middle class left mean by 'working class'. Stanley Eveling was working class, but he was no ideologue either. He was an erudite professor of ethics who was more interested in non-naturalistic forms of writing – not what they wanted from a working class writer at all! Keith Waterhouse and Willis Hall – both working class and from the slums, only one of whom could boast an inside toilet in the family home – didn't get beyond initial interest in one or two plays, for

they were too commercial and not left-wing; theirs was not the kind of view of life the Court wanted from working class writers. It's not, you see, a matter of class at all, but of ideology. Its not simply a matter of removing class barriers and making theatre available to the working classes to write whatever they see fit to write. It was more a matter of creating a new class, the *ideologically* working class. Now this was a class anyone could join: the Etonians, the Lancing boys, the Chichester High School students, the Trafalgar girls, the Queen Margarets girls, the Emmanuel School and Oundle boys, they could all join the ideological working class, it was all-inclusive, as long as you embraced the doctrine.

By the mid 1980s even Bond and Wesker (two of the actual working class writers) had become irrelevant to the masters. I remember when I was in the corridor of power, hearing Bond and Wesker talked of as being beyond the pale, sneered at in fact. One of them was not perhaps political enough, and the other had gone too far and was a Marxist. Not only did this make Bond an embarrassment to their new ideology, but it also meant that he rejected the middle class grip on power IN THE THEATRE, and God forbid, wanted to control things himself when it came to productions of his plays! He was and is a major figure in Europe, but an outsider here.

So it's not that there weren't any working class writers: there were some, though they certainly weren't anything like a majority, and in terms of the numbers of productions even less so. For it was the public schoolboys and girls who got play after play put on, who got to establish careers as professional writers, and who were able to develop their 'voice' and who got to say what they wanted to say, and to keep on saying it. They are still there now.

In the early days, in fact in the days of George Devine's conception of what the Royal Court should be, there were two strands: poetic drama (T S Eliot, Fry, Wedekind, Pirandello), and 'hard hitting, uncompromising drama' (John Whiting, Clifford Odets, Williams). He envisaged all of these being 'in advance of public taste'. Fate was to determine that the advent of *Look Back in Anger* occluded that vision. As Tony Richardson said:

immediately everyone realised that what they had been dream-
ing of, this European art theatre, was no longer the kind of
theatre that would be realised.

Or, to put it in the platitudinous cleverspeak of our own era:

by the post war, social and cultural change that quite empirically
shifted its remit and policy, made it conscientiously search for
new voices, new playwrights and new social worlds.

This was a significant turning point so early on; the Royal Court had just
got started when it narrowed its vision. It is the generally received view
that this was a great moment, that here was born the social realism that
was to be the British Theatre's distinctive quality, and that otherwise we
would have suffered the same fate as much European theatre, fanciful
absurdist plays with little meaning nor grounding in social realities, an
intellectualised theatre of sub-Beckettian copies. But I think that was
never likely. The poetic drama in Devine's mind was English and liter-
ary (not the abstractions of european intellectual absurdism). T S Eliot's
plays in particular are distinctly English in their form and their
content. Poetical they may be, but they are rooted in social manners,
just as social realism is. Their scope is achieved through verbal means,
not symbolic ones, and they are plays about the human heart depicted
naturalistically. In fact you might say that, had the gate remained open,
we might have produced more playwrights of the kind and ability and
refinement of Howard Barker. Indeed, writers like Caryl Churchill have
often had to move in that direction formally, to avoid a loss of scope for
meaning. It is hard for strict social realism to uphold meaning beyond
a certain level where everything can be expressed literally. Any writer
who wishes to go beyond that, even a little, usually has to expand the
form. Thus in British theatre by the late 1980s many writers began to
do this, and despite the suspicions of the critics, some were allowed to
get away with it, which is just as well or theatre would have ground
to a halt. Formal deviation is now commonplace and has now been
incorporated into the mainstream of playwriting. In other words, it is
used often, though not always very well and sometimes clumsily, but it

is accepted by the critics, who can always be trusted to move with the times as long as everyone else does.

Tellingly the foreigner, George Goethius, who was privy to many of the conversations surrounding its early days, called the Royal Court 'a theatre of middle class transition' (in his book *Ten Years at the Royal Court*), quietly hitting the nail right on the head, and this phrase is on page 28 of *Inside Out*. On page 11 is a facsimile of a letter for us all to laugh at, complaining that the national anthem isn't played, and on page 13, inserted into the time-line of the Royal Court, is the piece of information 'Churchill reveals that Britain has the atomic bomb'. In fact it was Churchill's predecessor Attlee, the Labour PM, who developed the bomb without Parliament's (or even his Cabinet's) approval or knowledge and lied to them about it.[1] It seems odd to mention this here, but then it seemed odd too to find it on page 13 of a book about the Royal Court, except that it illustrates the continuing presumption that the Royal Court's role is to oppose Conservative governments, however calumniously. It shows what Goethius meant: it shows that 'middle class transition' is the assertion of the middle class against the upper class establishment, and that even today manifestations of that struggle are still identical with the Royal Court's sense of itself. It is presented as if this struggle is widely accepted as a democratic and popular one, rather that of one elite group against another. This presumption litters the history of the Royal Court.

Devine did actually try to preserve the other type of play, and the plays of Ionesco were put on, which prompted the debate in the *Observer* in which Tynan said that kind of writing was 'a diversion from the main road of realism, in which characters and events have traceable roots in life'. Devine fought on Ionesco's behalf, but the outcome we know.

The Royal Court's own survey of notable productions conforms precisely to the predictable list of ideological targets and preferences.

The Making of Moo: Nigel Dennis, of Colonial background, makes a 'swinging attack on organised religion'.

1 Britain developed the *atom* bomb between 1946 and 1952 under Attlee, then the *hydrogen* bomb between 1955 and 1957, under Churchill and his successor Eden.

Boarding school girl Ann Jellicoe in *The Sport of My Mad Mother* made what Bill Gaskill called 'a strange projection of the lives of teenagers in an urban desert'. It wasn't a popular show, but the Royal Court knew it liked it. A scene is described where 'a group of writers and directors were cheering and stamping at the back of an almost empty house'. The show was hailed by Tynan, and Jellicoe claimed it was influenced by the 'mod and rocker culture'. We can wonder what, if anything, the boarding school girl knew about that.

The Flesh of a Tiger, by Barry Reckford, was the first play by a West Indian to be produced in London. (Barry was educated at the Kingston College, the best school in Jamaica, and at Cambridge.)

Live Like Pigs: this play was by John Arden, an architect educated in an all-boys boarding school called Sedberg School, founded in 1525 – a very beautiful building – and later a member of Sinn Fein. He wrote a play about 'the new working class with prim middle class souls, and the slum samurai from the backstreets'. A pretty good play this one, which exhibits the middle class writer's contempt for any feeble working class pretensions to bourgeois comfort and sophistication, and makes a big noise of supporting the neighbours from hell. I loved this one when I was thirteen. We now can see what has happened on the housing estates, where one family can easily terrorise a whole neighbourhood; where, just for an example, a family with 80 criminal convictions can pursue a campaign of terror against a whole community, and end up slaughtering and torturing to death two hapless students. (Not quite so fucking funny now, is it, Mr Architect?) The Royal Court has to accept its share in the blame for its role as architect of our modern society, but there is so far no sign of it doing so.

Arden referred to South Africa as a 'reminder of those historical grandfathers of ours who sent the legendary Sgt Musgrave and his men off to the wars', whereas in fact it was the creation of the Boers whom they fought *against*. But this rewriting of history is favourite gadget of the left and the theatre that supports it.

What is inspiring, though, is the management's militant evangelising support of a play like this, which was unpopular with the critics, to the point of going out onto the streets with leaflets. George Devine said they

had to support people especially if *they don't have critical approval.* How long ago all that seemed by 1988, when bad reviews meant you were a failure and wouldn't have another play on until the regime changed. The Right to Fail was no longer. In 1987 I was told that audience figures of 65 per cent was a failure, *upstairs.*

The Kitchen: Arnold Wesker, the Jewish plumber's mate, wrote a play about a hotel kitchen where he had worked. Jocelyn Herbert designed a set that cost apparently £80. I believe the set for the revival of this play under Stephen Daldry cost £80,000.

A Taste of Honey: Shelagh Delaney, of Broughton Grammar School, was almost as near to working class as the leading lights of the Royal Court ever got. Her first play, though, had already been done at Joan Littlewood's Theatre Royal Stratford East (which of course was the real working class theatre, and therefore much less known, less supported by the Arts Council). The Royal Court book interestingly quotes the *Daily Mail* review of that play for us to laugh at: 'once authors wrote good plays set in drawing rooms, now, under the welfare state, they write bad plays set in garrets'. If you swap 'garrets' for 'bedsits' it becomes wholly true: by the 1980s there was an ocean of bad plays set in bedsits about people who felt no requirement upon them to earn a living by work. (I know because I was one of them.) It is undeniable that that situation breeds a very particular dislocation from reality, particularly reality as it was for the working classes. It created, in fact, a new aristocracy, a lower middle class, penniless one: people like me hid under the shield of mass unemployment in the 1980s, and lived like down-at-heel penniless aristocrats. We rose at 11 am, breakfasted in a cafe, and either sat idle or, as in my case, wrote our plays, etc, as the fancy took us. Free to conjecture like characters from Chekhov, without the need for the conjecture to be either useful or grounded in any reality but our own. The danger this posed to good sense in writing is obvious. The aristocratic and parasitic nature of all this, this little class of amateur writers, was easily hidden under the popular cloak of poverty (self-induced). When writers in their awards acceptance speeches thanked the DHSS for funding, they weren't joking. And for every award-winning or talented writer there were a thousand who were neither of these. When I went to Sweden (the land

of socialism and equality), I found that only idiots expected to lounge unnecessarily on the dole, and that such behaviour immediately earned a humiliatingly probing interview and the end of 'funding'.

Already in 1961 George Devine was having to answer charges about the kind of programming, and to insist that it was not all 'liberal humanist' but was 'mixed in its political attitude'. Is it possible to imagine anyone today making such a charge, let alone the Royal Court feeling it had to answer it? (We'll see, perhaps.) He tried to deny 'the myth that we only do left-wing kitchen sink stuff'. And indeed, the image of the Royal Court still is connected with that sort of play, even though they have regularly departed formally – though very rarely politically – from that. Caryl Churchill and Martin Crimp could be examples of how the Royal Court has developed the form by which it delivers its old messages, both writers very close to the bosom of the Royal Court.

Inside Out describes how Ronald Duncan deplored plays 'bleating about some transitory and petty social ailment', and called for 'a drama which concerned itself with fundamentals and not welfare state values'. He is characterised by the Royal Court as some sort of interloper, and was ignored in its celebrations. In fact he started the English Stage Company. He was poet and a playwright; he wrote verse plays which became, of course, very unfashionable. He was a conscientious objector during the war; he wrote the libretto for Benjamin Britten's opera *The Rape of Lucretia*, and the screenplay of Jack Cardiff's film *Girl on a Motorcycle*. He represents the strand of writing that never made it to be part of the Royal Court.

We are also given a quotation from 1957 when Greville Poke wrote to Neville Blond: 'Wouldn't it be nice if the artistic committee came along with equal enthusiasm for some play praising some of the things old England stands for?' Again, I find it interesting to see how the use of quotes like these, naïve though they may be, demonstrate so clearly our own brand of complacency, which goes as yet unquestioned. How easy would the left like it to be? What kind of turkey-shoot do they need to still hit some targets? A quote like this produces all the ready-made responses in the brain of the average complacent middle class leftist, and gives the clear impression that the Royal Court must have been getting it

right to elicit this perfect kind of '*Daily Mail* response' (as it is known). Indeed, we read, with a cheer, that the response to it was for the artistic committee to demand even greater autonomy in programming; the next step in the ideological victory is assured.

Will there ever be a time when the march of progress towards the present will be treated with anything other than celebration? How bad does it have to get before the certainties that frame our minds can be called into question. So, Greville Poke seems silly when he asks for a different angle, when he asks for the writers to be constructive about England. Well, how silly was it? Of course his call was not heeded and the project of dismantling what we had of civilisation went ahead, baby and bathwater were thrown out into the posh square outside the theatre, and not a tear was shed for the loss of a peaceful society. (Orwell told us 60 years ago, about the way the deconstruction of the past is the method by which the dominant present orthodoxy makes itself seem inevitable and preferable.)

Devine gives the game away perhaps when he says:

> we knew that to be accepted by the middle, to be smiled upon by the top, is the first sweet kiss of death. So we carry on flirting with death in order to live.

Where is the famous integrity of St Devine in this speech? Doesn't it show the familiar positioning play of the Royal Court? Where does the truth come in, in all that? It is also the kind of self-consciousness inevitable in a bunch of public schoolboys playing games. Those thoughts wouldn't occur to anyone who didn't feel as if they had any choice but to speak the truth as they found it.

Skyvers by Barry Reckord, a play about a group of 'disaffected boys at a comprehensive school' (directed by boarding school girl Ann Jellicoe, and featuring Harriet Devine and public schoolboy David Hemmings) is included in the book and we are again treated to a Tory paper review (the *Daily Telegraph*) to laugh at: 'I am tempted to a rash use of the word authentic to describe the boys talk, but strictly speaking, I don't know if it is authentic or not, I never heard talk like this at my public school'. This is very funny. But the Royal Court book doesn't give us the punchline,

which was that if the critic didn't know if it was authentic or not, neither did the writer Barry Reckord, who went to a good school in Jamaica and then to Cambridge University, and neither did the public school boys running the Royal Court. At least the critic was honest, which makes a nice change. When they did a reading of this play recently critic Michael Billington said it was 'a piece that proves the best drama offers vital social evidence.' Some kind of evidence. Nothing much changes, it seems; just people get more gullible.

It is interesting to imagine the public school boys finding a play to explore their own schools and to delve into the way the old boy network operated in the left-wing arts establishment, just as for example the play *Another Country* does regarding the community of spying traitors. It might have been interesting, and they would have been writing about something they know.

The chapter on Bill Gaskill's tenure at the Royal Court literally begins and ends with two nice illustrations of the phenomenon at work. It opens with Gaskill arriving at the Royal Court as Tony Richardson's protégé to direct *A Resounding Tinkle* (the two had grown up in West Riding and both went to Oxford in 1948); and it closes with the appointment of a resident dramatist and assistant. Christopher Hampton became the Royal Court's first resident dramatist, and the first resident dramatist in London funded by the Arts Council under the Labour government's Minister for the Arts Jennie Lee (see the chapter on the Arts Council, page 60) from 1968-70, and supervised the script department. He brought David Hare in as his assistant.

> Bill Gaskill asked me what I planned to do after my finals [at Oxford], I replied truthfully that I hadn't the least idea, 'Well then you had better come here', and in this way I became the first Resident Dramatist in London.

Jobs for the boys eh? Christopher Hampton and David Hare were at Lancing School together. Its a pity they don't wear old school ties like they used to – at least then you knew what they were up to.

Now in case any readers are wondering why I bother mentioning this, I will remind them of the way the Royal Court has always identified

itself in terms of class politics, and that the period of the Royal Court's history in question is the one where working class writers were one of the main features. The fact that the writer's positions were handed out on the old school principle is not without significance – not when it is a question of whose version of socialism wins out, not just in the theatre, but in the country. It was around the same time that the Labour Party, newly in power with (at first) a tiny majority, was in one of its manifestations most similar to the one we have now.

The Labour Government showed itself to have the same approach to the working class share of the national wages bill as a 1930s conservative government, ie, to impose wages restraint (through the Prices and Incomes Board) – the same policy it would pursue when in power, right up until 1979, persistently frustrating the working class attempts to get a larger slice of the pie. At the same time, in the name of Modernisation and based on faked statistics, they abolished beat policing in 1965–66, which successfully ended a long era of highly successful policing (which had given us the most peaceful society, with the lowest crime rate, and the lowest imprisonment rates in Europe), and destroyed grammar schools, which served to cut off working class children aspiring to a better education – showing the Labour party to prefer ideology, and its own fake and laughable 'white heat of technology' modernising image, to actually serving the working classes. Staying in power under a wily and megalomaniac leader at any cost, and being dependable managers of capitalism, was each time the reality of a Labour government, and inevitably so when the parliamentary party is middle class to the extent that it increasingly had been since the war. The destiny of the left has in this country been determined by that very factor. A whole other outcome may have been possible if it had been a movement rooted fully and constantly in the working classes themselves. The level of equality achieved, say, in Sweden might not have been outside its reach; but that would mean a commitment to a redistribution of wealth through taxation and a proper legal support to comprehensive collective bargaining, neither of which any Labour government has been prepared to give.

So, while that redistribution of wealth was in full swing elsewhere,

here we had something else entirely: we had ideology – ie, priggish puritans telling us what to think and what to say, and tinkering with a largely unaffected capitalism, which has continued to operate chiefly in the interests of the middle classes.

If you see the Royal Court as the theatre of working class writing, in that light, it becomes more than a matter of arguing about their sincerity or otherwise. I do not need to show they were insincere; my point is about what their aims ever were. In the absence of any political manifestation of a working class movement based on a concrete redistribution of wealth, it was possible for a group of public schoolboys to think of themselves as socialists, or left-wing, or even as 'working class' in some odd way, without seeing any contradiction or insincerity in their politics. In a country without any real working class movement it is easy to understand that the left can consist of psychological and social types: middle class people with an emotional or psychological tendency to want to identify themselves with the less well off; those who are attracted to ideologies; and those who like to identify themselves as rebels. (A large group this one.) All in all, it amounts to a politics of gesture and 'ideas', tinkering and posturing combined.

Only in those circumstances can a play like Bond's *Saved*, whose only achievement is to show how vile and horrid the working class has become, be seen by the middle classes as politically significant and interesting to the degree it was. Bond is a Marxist, I think; the analysis behind the play is a teleological one, with its sights fixed in the far future in a sort of neverland; it is in its essentials a theoretical way of looking at things. To the Marxist, the details of hardship and suffering point to the need for a belief, for a faith; and only when this faith has been achieved will the ills be removed. Many people like *Saved* because, while it doesn't pull any punches with its analysis and description, it doesn't offer any moral and solution. This gives it the appearance of good art to people, not necessarily Marxists, who prefer not to be told anything too concrete, and who think art is above morality. But in fact Marxism does have a morality, the play does have a moral to its tale, but it is simply set so far in the future (a bit like a religious one) that it is not worth mentioning. Nothing is more moralistic, in the story-telling sense of the

word, than Marxism. There is only one good outcome, one big message; it just doesn't have to do with morals but economics.

So, a play like *Saved*, with its meaning set off in an ideological nirvana, is the ideal play for a class of middle class leftists running a theatre in a country where there is no practical or concrete solution either expected or looked for. The left-wing one is too far off and the conservative one is simply not wanted. *Saved* characterised the position of the left at that time (and even now, insofar as they have any position at all).

It is fascinating in a sense to behold the strange spell *Saved* casts by its inertia. It was speaking to people to whom, in a sense, reality is so alien that they are in a state of paralysis, and cannot even imagine anything else. It has the effect to make them want to Do Something, to 'be political', though what they mean by it has no connection to the perceived problem. To attack the 'establishment' to say something about Suez or Vietnam or the Queen or the Lord Chamberlain's censorship or God knows what else, is their idea of being political – that's about as concrete as it gets, because they live in a country where the working classes are like animals in a zoo, who need to be better fed but who of course cannot be given an equal share of power or property; a country where if tax goes up a penny it is the end of the world and a brain drain starts, and if the working class gets a slightly bigger share of the cake inflation will destroy us all. In that context you can say and think anything you like, it's perfectly safe. In that context Howard Brenton can toy with violent revolution and virtually any small issue, or an aspect of foreign policy, can be made into a defining moment or a defining aspect of a person's thinking. This has progressed since then into a linguistic and bureaucratic little hell of pettiness, where ideology has been overtaken by events so that the left have to put electric gates up to stop their children being murdered by street gangs.

Some of those whom we consider to be political writers, David Hare and others, have said that the Royal Court was not political. The typical Royal Court view has been described as liberal humanist; while I have been arguing that the Royal Court saw itself as indeed political and that it has always claimed to be. David Hare has said that there was even an explicit struggle between those who wanted the Royal Court to be more

political, and the humanists under the influence of Lindsay Anderson, and that the latter won. But in that case the liberal humanists were not greatly different from the left-wing politicals; their essential bias is the same, ie left-wing. At the time Hare is talking about, the resistance to an overtly political message had still something to do with Devine's persistent, though from the start reduced, interest in what could be called absurdist or ethical writing, that is, writing not rooted in social issues or in realistic depiction of social realities. But by the 1990s this interest had more or less gone, and what had triumphed was in fact a set of political presumptions but usually set into a narrative individualistic enough to be mistaken for humanistic, rather than political. In truth, by the 1990s, much of the work was neither political nor humanist, in that it had no realistic view of political realities informing it, and was so nihilistic as to make the word humanist hard to apply.

One must wonder what a humanistic view would look like if such a thing had really triumphed over the political. It is a word which can be used to many purposes. In connection with the Royal Court I think it is meant to denote something 'progressive', but not connected with any political philosophy. I hope that is a fair definition. At any rate, whatever words used to describe it, their humanist view is hard to separate, in practice, especially now, from a left-wing view; in fact, if we consider that the left are more ideological than concrete in their position, being as they are more and more divorced from working class life, then the distinction is slender.

It would be nice to think that there could be humanism that managed to be separate from mere left-wingism, enough to be able to include ideas which were antithetical to the left; but such a humanism is not, I think, yet to be found at the Royal Court. The humanism to be found there is more of a half-baked left-wingism, which in later years has become not so much even half baked as distorted ; its attitude to violence in particular, and perhaps its failure to resist the values of capitalism which seeks to shape our idea of the individual, undermines any claims to humanism.

A little example of the political presumptions and prejudices or biases in Royal Court humanism between the 1970s and 1990s can be seen in

the Royal Court's Young Peoples Theatre. Set up in 1970 because they had noticed that

> theatre [in general, he means] was middle class men, Oxbridge and RADA educated exploring the endlessly fascinating world of the working classes. The Royal Court was instinctively different [sic], it has always sought out embryonic talent – the rawer the better.
>
> <div align="right">David Sulkin</div>

It was later described as a 'proactive initiative' to get young West Indians who didn't go to the theatre to come in and 'get involved'. We might wonder what gave them the impression that young West Indians ought to go to the theatre and 'get involved' with the left-wing middle class men there. As one of the organisers put it:

> I brought my pupils, mostly girls aged 13–14 from the West Indian community in South London. Beryl and the Perils did a show which referred to the clitoris and the girls all went home asking what a clitoris was. Gerald [the YPT leader] went on to talk about homosexuality and said there were a lot of ways to have sex. Of course I got a load of complaints from parents.
>
> Hanif would start workshops by asking young people to go to one side of the room if they had had sex that week.
>
> I wanted to change people's lives... I got the job on a very specific agenda about race, gender and class.

And so by that time 'humanism' meant one class of people, the liberal progressive middle class, imposing their view of life on the *children* of the working class immigrants, including their views about sex; and it seems, all under the specific instructions of their employer, the Royal Court, which now saw its mission as imposing its views on race, gender and class on the young people (ie, children) in its temporary care. I can imagine if any parent objected it would have been easy to have them escorted from the building by the police, they were after all only black and working class, and their views didn't actually matter, it seems.

(The Humanists will no doubt be pleased to know that 13 year-old

West Indian girls probably know all about the clitoris by now. It is interesting to see this in the context of the left's current 'multiculturalism'; the constant factor is that their own liberalised version of our culture should prevail over a less progressive one, no matter what means are employed, at whose cost.)

By the 1980s and 1990s, 'humanism', used in this way, once we get down to grass roots level, is just another word for the class ideology of the middle class left, and one which regards other views as old fashioned, regressive, repressive and eventually seeks to make them illegal.

There was, then, a rift between the new generation who wanted a more overtly political approach, and the older guard who didn't. By the time of *Layby*, a play about a controversial rape case, co-authored by 'playwrights from the generation that are considered a threat' (Brenton, Hare, Clarke, Griffiths, Poliakoff, Stoddart, Wilson), the fact of public schoolboys playing at politics was frankly admitted. 'I don't recall any of us being much interested in whether justice was served afterwards' (Snoo Wilson). Nicholas Wright remarks of the controversy in the building: 'I did notice that all the people in one side had been to Cambridge, and the others to Oxford'.

The younger group wrote an irresponsible play which came out of a meeting to discuss the theatre's policy and, according to David Hare, 'to get people who felt out of touch with the Royal Court into the place'. The Royal Court now already had a new group of outsiders knocking on the door. A lot had changed since 1956, many other theatres were doing new plays and the Royal Court was not even the sole natural focus of political theatre.

Lindsay Anderson was angry. 'The Royal Court,' says Hare, 'was terribly angry about the script, – a lot of people were.' The idea of a play being a *succès de scandale* but without any actual merit was being established, the schoolboy prank idea being raised to the dignity of 'art' or 'politics', a puerile attitude to authority which had disastrous consequences for society. Once again, it is public school games applied to society as a whole where no-one remembers to count the cost to ordinary people. Anarchy is fun when it's kept in the drawing room or the JCR or the dorm. But on the streets it's not quite the same. Take a look at

If by Lindsay Anderson, public school boys with machine guns mowing down the parents and teachers and other pupils; an iconic film for the 1960s and '70s. But er…not so jolly when 30 years later it's not public school boys machine-gunning the lampooned 'establishment' (who in the film somehow represent an evil-minded military regime who kill foetuses), but now it is real life working class thugs going around with machine guns, and children store them under their beds for older ones, and where children *are* regularly murdered and when 60 per cent of teachers have been assaulted. It's not a game any more, it's not sexy any more – it's not interesting to the middle classes any more.

So maybe they should ask themselves why they were so bloody interested in it in the first place.

By this time too, according to Bill Gaskill, 'the whole class thing had become a joke. Actors of good background [sic] pretending to be working class and left school at 14 when they had been to Oxford or Cambridge.' At the same time it was noticed by staff that casting was increasingly done with an eye to West End transfers. When they put up opposition to this, the establishment figures like John Osborne (remember him?), who had made a lot of money from transfers, stamped on it very harshly. There is always a danger that public money can be used in this way to essentially subsidise commercial ventures and thereby line people's pockets. Also, once casting is thought of in this way, then it isn't a long step to the choice of plays being made in the same way.

Oscar Lewenstein took over the Royal Court in 1972: the outsider, the name you never remember despite the fact that he was in it from the start, an episode very interestingly handled in *Inside Out*. He was 'never accepted by the Court fraternity,' Nicholas Wright says. 'He was treated like a money grubbing producer…' He was the son of a shopkeeper and a Jew, whose parents had fled Soviet Russian anti-semitism. He was a life-long Marxist nevertheless. But despite his strong convictions he didn't fit in with the Royal Court politics. 'With my personal history as a Jew,' he once said to David Hare, 'who came to Britain in the 1930s, I am not going to put on work which is so savagely critical; this country is a haven to me… I just don't accept the version of England that you have.'

Which maybe explains why he didn't fit in.

On another occasion he asked Nicholas Wright: 'But do these people Brenton, Hare, Bond really want people's ownership of the means of production, distribution and exchange?' To which Wright answered, 'No, I don't think it's like that Oscar'.

This does actually reveal something about the left-wingism at the Royal Court. Of course the writers there didn't advocate state ownership; the Labour party had abandoned nationalisation already. Left-wingism for those public schoolboys wasn't as literal as it was for the Jewish son of a shopkeeper. For them it had nothing to do with interfering with their worldly goods exactly, no, no. Their frustrations were about power and influence in their own chosen spheres. For example, they didn't like the office of Chamberlain, associated so closely with the Royal household and the upper classes, telling them what they could and couldn't write in their plays. It was about who had control of the ideological wheel in the capitalist society. Of course Lewenstein's Marxism was also of a kind which merged pretty well with the West End transfer system; he knew well how to find financial success, but he had been operating working class theatre while the Royal Court establishment were still fagging in the dorms.

This is how a group of writers devised a system of not taking responsibility for what they wrote: As part of a group who created *England's Ireland*, about a subject which really needed the input of some ill-informed English public schoolboys to stir the shit. Of course, not being Irish or Catholic, they had little idea what it felt like to live under the heel of the kneecapping, authoritarian thugs, those lovers of freedom who ruled the roost, their beloved IRA.

David Edgar: 'On the same principle as a firing squad in which one rifle is armed with a blank, each individual writer could deny authorship of the most outrageous scenes'. The marvellous result of this was a scene (in *England's Ireland*) in which 'the story of internment was analogised with the arrest, trial and persecution of Christ', written by Howard Brenton and David Edgar. No idea that equating a cowardly murderer of innocent people with Christ might be offensive. But of course Irish Catholics are only interesting to the left insofar as they seem to be a stick to beat the British Establishment with, otherwise they are just superstitious papists. The Irish problem was just a weapon in their cheap game.

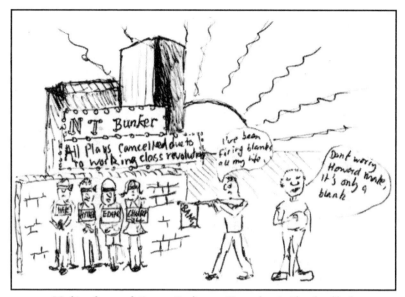

Working class revolutionary: Don't worry Howard mate, it's only a blank
Brenton: I've been firing blanks all my life

Again, *Magnificence* by Howard Brenton exhibits the so-called left in its now familiar guise of self-reflection: a puerile fantasy about squatters taking conservative MPs hostage, and trying to blow them up. This gives Brenton the chance to examine the question, as he puts it: 'Would you have the courage to lift the gun?' Interesting to note that it seemed to be a matter of lack of *courage* which might prevent the use by a playwright of violence against unarmed people; violent revolution with the Angry Brigade. Radical politics for the middle class left is a school boy fantasy: they just weren't sure how nasty they wanted the game to get.

Apparently Lindsay Anderson, who himself had made *If*, was climbing over the seats to get out: 'I've had enough of this shit,' he said, apparently.

Meanwhile the real consequences of squatters developed apace, and by the early 1980s the norm was that young, fit, healthy people, usually middle class, and almost definitely 'left-wing', languished on the dole and took their drugs, and developed their talents, in flats that ought to have gone to working class families with children. This

I witnessed at first hand many times. Apparently Howard Brenton wasn't aware of it.

Nick Hytner made a public statement, a few years ago, to the effect that he actively *wanted* non-left plays. I presumed, as I told him too, he was going to get someone from the left to play devil's advocate instead; and sure enough, we have Howard Brenton, rearing his head as the more or less sympathetic dramatic biographer of Harold Macmillan. I wonder if we might see a timely conversion to Conservatism in time for the new regime? Or maybe he fears a working class revolution may be on the way...??

Bent is another example of the left rewriting history to suit their doctrine. The play depicted homosexuals in Dachau being given the punishment of carrying rocks until they died of exhaustion. A survivor of Dachau wrote to the Royal Court and pointed out that it was Jehovah's Witnesses who were given that punishment, not homosexuals. Of course the Royal Court could never have felt sufficient sympathy for Jehovah's Witnesses to bother with a whole play about that. And in fact the play about Jews in concentration camps, a bit later, was *Perdition*, which blamed Jews for acquiescence in the ghettos. A piece of deliberate Jew-baiting from the hard left, which the Royal Court had to take off before it was even put on, for fear of never seeing another Jewish dollar.

Max Stafford-Clark (Artistic Director 1979–93), the stylish head prefect who drove a Jensen Interceptor, introduced the dead hand of 'play development' to the Royal Court, and it might be fair to say that his tenure marks a low point in the status of the writer at 'the writers' theatre'.

'The Joint Stock process of building up a play from ground level had a lot to do with empowering the director and the actors,' he said. In other words it subjugated the writer. My personal impression of the position of the writer at that time was as a sort of confused infant who left his mess in the corridor for the director to clear up for him. The joint stock process was used sometimes with young and inexperienced writers, drawn from the new constituency who were firmly under the director's controlling hand, the writer being more or less a pupil. As Stafford-

Clark put it, 'very few writers are stars'. And being a star was increasingly important.

In 1982 the Theatre Upstairs had to close due to lack of money. In 1975 the Royal Court did eighteen plays; in 1982 it did eight. Tory Cuts.

Max Stafford-Clark's tenure was marked by a further politicisation of the programming which was now more overtly left-wing biased than ever. Stafford-Clark explained this by pointing out that his regime coincided with Mrs Thatcher's. Forced by circumstances, he also laid a new emphasis on good box office; the right to fail was not something the Royal Court felt it could afford.

To Max Stafford-Clark's great credit, *The Rat in the Skull* was an occasion where there was not the predictable bias, and both sides of the argument were allowed. The play was presented to the GLC for £30,000 funding and they were told 'Irish play, Royal Court, no problem' since the GLC presumed it was a pro-IRA play. As Max Stafford-Clark pointed out, if they had known the real content they would have fined them £30,000.

It has been said, at the time it was said, that *Serious Money* backfired and that the city types who were the plays satirical target actually enjoyed seeing themselves and flocked to see it, making the play a huge commercial success. Of course this was unintentional, and is perhaps always a danger with satire. But in a broader sense it wasn't just an incident, it was how things felt at the Royal Court at the time. It was unmistakable that the success ethic had infiltrated the building, as well as a domineering atmosphere, and the narrow-mindedness that comes from polarised politics. The Government's robust scepticism about art was matched by that of the management of the Royal Court.

Max Stafford-Clark's view of the writers' theatre was this:

> Any vision of the writers theatre must come from the writers themselves, but what the Artistic Director can do is to point the areas of experience which will respond to creative commissioning.

In other words, he can tell them what to write about. This vision of theatre is one where writers are the Artistic Director's employees to help

him in the Zeitgeist hunt. In this case it was also a hunt for something else; '...as a political solution to the left's problems seem more remote, so the voice of theatre becomes more important.' As a writer, I found it rather too paradoxical to be helping the Jensen-driving upper classes to find the answer to why no-one wanted to elect them as socialists. You could find yourself berated by the bourgeois *Time Out*, and their hard line chums at *City Limits*, and ultimately shown the door by the Royal Court itself, for not buckling down to fight the good fight in the most obvious way. The Royal Court was the writers' theatre, on its own terms only – essentially this meant the Artistic Director's terms; by now no-one wielded any power but the Artistic Director. It wasn't a place where a writer was supported as a writer, but as a potential part of a political movement – or dropped.

It wasn't only the Royal Court where the left was using public money to examine itself. At the National Theatre too, the left-wing writers such as David Hare and Howard Brenton, and David Hare and Howard Brenton and David Hare and Howard Brenton, were given unlimited access to the stages to try to find the solution. We even had a play where the Church of England itself was used as a metaphor for the Labour Party.

By the end of the 1980s the Royal Court had lost any pretence of an independent political standpoint. If it had ever had one it had been subsumed in the polarised party politics of the day. Somewhere along the way it seemed also to lose the ability to look closely at the shape society was taking. Already by this time, the left/right party lines were forming nothing more than a distraction from actually looking to see what was happening, what changes were taking place. Crucially, the strong left-wing bias, and the particular ideas which formed it, were pushing the Royal Court towards the complacent end of things. George Devine had feared it: 'we knew that to be accepted by the middle, to be smiled upon by the top was the kiss of death'. The middle and the top now looked somewhat different from how they did in the 1960s, and the Royal Court were incapable of spotting them, even though they were now rubbing noses with them. I expect their breath on the mirror clouded their view.

6 THE OZ TRIAL

A Landmark in the Progress of Freedom from Censorship

This case stands at the crossroads of our liberty, at the boundaries of our freedom to think and draw and write what we please.
(*The Times*, 1971: *John Mortimer QC*, lawyer for the defence in the *Oz* trial, Chairman of the Board at the Royal Court, playwright, television writer, etc)

SINCE THE EVENT IN 1970, the story of this trial has resurfaced a few times to be celebrated as a blow struck against a repressive or uptight establishment. The arguments used at the trial and around it and after it, as we congratulate ourselves on the path we took, are now the presumptions that form conventional wisdom on the kind of society we have built and want to have.

In the light of the outcome, maybe it is time to look again.

In 1970 the stylishly produced, self-styled 'underground' magazine *Oz* had already a proud history of getting up the establishment's nose and had even had its offices raided by police. In their native Australia the editors had been found guilty of obscenity twice and had been sentenced to prison with hard labour (sentences quashed on appeal). They had, after getting a little too close to gang warfare in Sydney, moved to Britain and pursued the magazine here with the help of Londoner Felix Dennis.

By 1970 the magazine was highly successful and was already being accused of losing touch with young people. The editors' response was to place an advertisement, rather disingenuously stating that 'some of us are feeling rather old and boring' and appealing to school children to apply to produce one issue of the magazine. This resulted in 25 school age (fifteen to eighteen year-olds) children assembling in the London flat of the 'charmingly louche 30 years old' Richard Neville.

Here it seems the editors (the other two young men in their 20s) were not shy about giving a discreet lead in the direction they expected the spontaneous school kids issue to go. According to one such 'school kid' present (Charles Shaar Murray, whose account was published in the *Guardian* in August 2000): 'we were interrogated for our opinions on education, politics, society [...] as well as sex, drugs, and rock and roll. Given access to the magazine, what would we want to say?' A nice open question.

These were not just any school kids though, they were predominantly public school pupils (surprise, surprise) and had great careers ahead of them: Peter Popham, subsequently a foreign correpondent for the *Independent*; Dedyan Sudjic, founder of *Blueprint*, editor of *Architectural Digest* and a commentator on architectural issues; Colin Thomas, a successful photographer; Trudi Braun, who became a senior editor at *Harper's*; Steve Havers, cultural commentator turned web designer. And at least one of them was already 18 by his own admission.

Needless to say, although much of it was puerile, the content was sufficiently talented and articulate to fit in to the best underground magazine of the time, and had virtually nothing to do with the disaffections or complaints of working class youths. After a few weeks with the guiding hands of the editors, the (public) school kids' issue, no 28 of *Oz*, was produced. The content included a cartoon montage by a fifteen year-old, Vivian Berger, which used a cartoon by Robert Crumb, upon which he pasted the head of Rupert Bear, the children's cartoon figure, to give us the image of Rupert Bear raping an unconscious woman. This liberating piece was the subject of an obscenity charge, as well as a charge of conspiracy to corrupt. In the event the editors were acquitted of the latter charge, which carried the sterner penalty. The conspiracy charge was:

> conspiring with certain young persons to produce a magazine containing obscene, lewd, indecent and sexually perverted articles, cartoons and drawings with intent to debauch and corrupt the morals of children and other young persons, and to arouse and implant in their minds lustful and perverted ideas.

It is hard to see, given that this was the charge, how they could logically be acquitted. The real explanation is probably that the subsequent appeal trial drew such attention, and that the defendants received such vociferous support from a vigorous and confident new wave amongst society (John Lennon, Yoko Ono, George Melly, Edward de Bono, Caroline Coon): the tide of feeling was flowing in favour of *Oz*. They were the long-term and clear winners; and that is why I am writing about it.

For of course there was nothing accidental about the actions of the magazine. It was serious and concerted; they were sincere and determined, and knew what they were doing. In their sometimes maudlin and self-righteous remarks in the trial, they tried to depict themselves as the honest victims, intent on improving society and 'offering a platform to the socially impotent' (referring to the public schoolchildren).

They also claimed that the trial had a broader significance. Neville: 'It is not really only us who are on trial today, but all of you, and the right of all of you to freely discuss the issues which concern you.' (Which in this case meant the freedom of the schoolchildren to discuss the issues the editors suggested might concern them).

Away from the pressure of the court room, the editors expressed themselves more clearly, in the final edition of *Oz*. Here they remarked that Inspector Luff at the trial had said, 'it is an attack on family life'. 'Quite rightly,' they said. They went on:

> the popularity of *Oz*'s atmosphere was especially to working class kids...an index of the end of decades of post war deference, evidence of a new refusal to any longer pretend loyalty to the Queen, the Law and the Empire.

The Australian guest spoke up nobly on behalf of his down-trodden British hosts, but it is interesting how he includes the law in his list of pet hates, without apparently any thought for what that really meant. He went on to outline his vision, describing how the 'underground' had made incursions into what he called, in a derivative 'Marxist' cliché, 'capitalism's real estate', the family, school, work, discipline, 'impartial' law courts, and the BBC. (The impartial law courts and the BBC being the only items they didn't also have in Soviet Russia at the time, though

perhaps he wasn't aware of that.) His perhaps fanciful idea of *Oz* as a working class favourite can be forgiven since he was using a shorthand, perhaps, to take into account that over the next 30 years his ideas would permeate down into the classes whom he had so little knowledge of. 'Unlike previous movements of radical "artys", he boasted, 'it actually transmitted its mood of indiscipline to young people of all classes'. This was his claim in 1971, and indeed it was a considerable achievement. 'Indiscipline', from the perspective of 1971, probably still seemed like fun, especially to a successful 30 year-old publisher; a lot more fun than it seems to anyone beset by gangs of violent, predatory youths on a housing estate in contemporary Britain. No doubt it is a bit harsh to lay the logical conclusion of his own hatred of law at his door. Neville's capacity for foresight was at any rate rather limited, and somewhat rosy, and a product of the hopeful mood of the times. But there were others with a more realistic insight: *Clockwork Orange* is of that era and told a truer tale of the future to come.

One can perhaps be forgiven for wondering why exactly Neville had it in for the British Establishment so much as he did, as by 1970 he had barely been here two years. Was it simply that he found it an easier 'oppressor' to attack, after his own society – that well known bastion of conservative values, Australia – had sentenced him to six months hard labour for the same offence of obscenity? He certainly knew nothing about going to school in Britain, except perhaps what his public schoolboy apprentices had told him, and yet it was there on his list of capitalist real estate. One cannot help seeing in his statements the flush of excitement of the indoctrinated, almost all his ideas being the fashionable Marxist ones of the time, though they bear little relationship to the realities of a socialist society. They are just a way of saying how much you dislike your own one. (Or your new-found one, as in Neville's case) The vision is therefore a negative one, unless you count the frivolous and the fantasy, the free love and sex in the streets vision which *Oz* had, which was an attractive counterpart to the dull, straight-laced Britain of the near past; However it was never a very golden reality.

Oz itself contained within itself the seeds of its own demise – at the hands not of the 'legal viciousness' of the establishment (or of a society

trying to defend itself), but from the disgruntled feminists who could no longer overlook the fact that much of what lay at the heart of the radical dissent in *Oz* and similar parts of *the movement*, was a puerile, though vicious, rape fantasy. It wasn't possible to ignore the fact that, all too often, the way to confront the older generation was through images of sex, which had, early on, lost any connection to love, and by the 1970s were more and more brutal and sadistic; the free love fantasy was largely a male one.

'What knackered the underground was its complete inability to deal with women's liberation,' was Neville's rather telling, chastised attempt at self-examination, after the Sisters had got to him;

> Men defined themselves as rebels against society in ways limited to their own sex [...] because the underground remained so utterly dominated by men, sex and liberation was framed in terms saturated with male assumptions, right down to the rape fantasy of dope, rock and roll, and fucking in the streets.

According to Neville '*Oz* was trying to redefine love, to broaden it, extend it and revitalise it, so it could be a force of release and not one of entrapment. *Oz* was against the guilt and oppression of repressed sexuality,' he said, airing the bogus Freudian ideas which were the received thinking of his community.

Neville could not conceal the simpler truth. As Marsha Rowe, writing in *Spare Rib*, put it:

> The underground press used sex-objectifying images which had developed from being fairly romantic to stridently sadistic... After a time on *Oz* I had worked for the defence in the *Oz* trial, and the cover of that issue was a montage of pictures of naked women on erotic display. In November 1971, three months after the trial, I went to the Women's Lib demonstration outside the Albert Hall against the Miss World Competition, and was beginning to feel contradictions exploding inside my head.

As well she might.

Neville's admission, prompted by the complaints of the women in the

movement, is interesting not just in relation to the feminism it attempts to 'deal with'. For while *Oz* seems to have been sufficiently castigated by the feminists in the movement to attempt this recanting of previous use of sexual aggression, doubts over its use don't seem to have extended in his mind to any other areas, such as its use in connection with children or society in general. It isn't only feminists who are offended by rape. A few more of Neville's capitalist real estate pet hates are also offended by it, and afraid of it – afraid of it being done to them. Parents don't like their children to be raped (family); the law attempts to protect people from being raped (the law); and this would bring us back to the trial, and to the idea of corrupting morals (exactly the same charge the feminists brought against them). For *Oz* had chosen, not at all for the first time, to express rebellion, as they freely admit, in terms of sex. Sex as a weapon, sex as a means of offending and of hurting. And that is what they were on trial for. 'Corrupting the morals' didn't mean (though *Oz* would have liked it to) promoting free love; indeed the prosecuting lawyer accused him of being without love. Remember at the centre of the trial was the montage of a children's character raping an unconscious woman, a virgin apparently. *This* was the image of a liberated society, not any other.

The boy who did the offending cartoon confirmed in court that he, for example, would be likely to leave the magazine around the house where his 10 year old sister would be likely to pick it up; the magazine, by its editors' own claims, was popular with children

And how accurate was *Oz*'s vision of a liberated society? Recently a group of teenage boys were convicted of gang-raping a retarded girl and, not content with that, pouring acid over her genitals to remove the DNA evidence of their deed. This is the reality of rape, and of the society liberated from moral restraints, which the little public schoolboy and his 'Marxist' friends were, it seems, unaware of the possibility of. But it is not just that the reality of rape sits uneasily with the schoolboy fantasy of it, it's that the trial was about society trying to decide, albeit clumsily, what its future was to be. The defence lawyer and Neville were both clear about that, as of course were the prosecution.

The prosecution argument, the argument for repressing such items,

is that depictions of such acts, especially in certain contexts, promote their occurrence in reality. That is what 'corrupting the morals' means. Morals is about behaviour, about each individual's judgement about what he will do, what is acceptable to do. On a public scale it means the morals of everyone, the *general standard* of what is deemed acceptable. Attempts by whomsoever – the state, the church or individuals or organisations – to 'protect' public morals are attempts to try to influence what is generally considered to be morally acceptable. I say this because 'corrupting the public morals' seems to sound, to many people, as if it has something to do with outraging narrow-minded people who want to repress freedom of expression, especially sex. In fact public morals (regarding violence) have been continually corrupted in the last few decades, so that morality has so weak an influence over people's minds that terrible cruelty is now commonplace. This is one of the most tangible changes in society during the past decades, and the *Oz* trial is one of the many points along the way.

It is also one of the aspects of our society we most need to change: to do so we have to look again at our attitudes to such things as censorship and morality; we have to free ourselves of the bias we have developed, and of our prejudice *against the repression* of bad aspects of human nature.

Some people claim that depiction in itself does not affect whether something will become morally acceptable or not. This is the one you hear most often, the view for a long time vociferously made by broadcasters, theatres, writers, individuals, who want to defend their freedom to graphically depict immoral acts in their entertainments or works of art.

The doubt concerning the actual effects of depiction paralyse the whole argument, and of course can do forever, as nothing can be called proven, unless people want it to be. No sooner is the idea of the bad effects of depictions of violence raised, then this argument pops up to silence it. It works not because it is a good argument but because it has so many degrees and aspects that it is almost impossible to handle fairly or accurately. Also because any attempt to be precise is immediately perceived as being weakness in the argument against depiction. This is

largely because to distinguish between one thing and another is seen as fudge, whereas it is the opposite.

One counter-argument is to say that it is impossible to restrict depiction because it would be 'unfair'. 'Why should professors be allowed to read old poems about rape and it not be allowed on television?' Also, it is argued that there is no distinction between styles and modes of depiction, and that attempts to distinguish differences is bogus and unfair.

But let us say, to use extremes to clarify the case, that there is a piece of Roman pottery depicting a violent rape which can be seen on application to the curator of the British Museum, and there is also a nightly screening at 8pm of a graphic depictions of violent rape, made by young film-makers, fifteen to eighteen. It is conceived as part of a youth strand, and sees it self as 'addressing head-on a live issue amongst certain communities of urban youngsters'. There was originally a post-show discussion of the 'issues involved', but after low ratings the rather dull though responsible presenter was ditched for a more lively, though morally dubious, more voyeuristically-minded one. He livens up the after show section by lightening it, and being a bit naughty about it, that's how he gets his good ratings, he's confrontational, even towards the women, and lets the boys give their point of view, which tends to be that rape doesn't really matter. It includes a competition where you vote for your 'favourite' (best made film, of course).

But the newspapers each morning open a hotline to vote on the 'raunchiest' rape so far (nothing to stop the tabloids calling it that since they are only fiction on TV), it becomes a fashion for fifteen year-old girls to audition for the nightly part of the raped girl, and it becomes like a national hobby and the violence gets more and more extreme as viewing figures go down. There are disputed figures showing an increase of rape; some say it's only an increase in reports to the police, which is a good thing, it shows the programme is encouraging girls to go to the police. There have been a few culprits who claimed only to be copying what was done on the TV, but these are dismissed as not typical...

The rather fake worthiness used to ameliorate the original idea is abandoned, ratings climb while letters to the *Daily Mail* increase. The

Guardian readers studiously avoid 'falling into the moral panic trap'. If cornered they say it's 'hypocritical to make a fuss about this stupid TV programme, what about the real issue of rape… etc'.

You can get ringtones on the internet (illegally) for your mobile of one of the girls crying as she is raped and beaten…need I go on?

Which sort of depiction and exposure would have the most effect on public morals? – that is, which one would make rape more acceptable and likely to happen more? The pottery or the TV series? And at what point does it stop being laughable or hypocritical or old-fashioned or capitalist intellectual real estate to object and want it to stop – or be stopped, ie censored? And at what point does the producer of the series no longer get away with saying, 'We are only reflecting the real world' (which is the other argument), or saying, 'We are only allowing the issue of rape to be openly discussed'? How long is it before the two extremes of society meet each other, where western permissiveness and Somalian religious fanaticism end up with the same results: girls being raped or stoned in football stadiums for entertainment?

I hope this example shows that there might be circumstances easily imaginable, by now, where even the most determined liberal might concede that depicted violence may have an effect? Or maybe not? In fact we almost have the situation I was describing already, except that it is spread across hundreds of different programmes over the years, and video games and so the effect is harder to trace; we also have a spectacular increase in violence committed by the young – and yet the average bourgeois dinner table is unlikely to yield censure or proscription, more likely just a smug laugh at the very idea.

John Mortimer thought 'our freedom to say and draw what we like' was at stake. There was more at stake than that.

We are *not* free to say or depict what we like, and neither are citizens in any other part of the world; the law always restricts freedom. What is at issue is the decision about what is proscribed, not the principle of whether *anything* is proscribed. Take this for example: In the 1960s it was illegal to depict as well as to practise homosexuality; in 2000 a writer on child-rearing was investigated by police under new laws against homo-

phobia (sic) for saying on radio, when asked, that in her opinion homo-
sexual couples should not be allowed to adopt children. Both positions
of the law seem absurd, but both have been real.

Both are based on a presumption that there *are* effects caused by the
proscribed behaviour (including speech) beyond themselves in society.
Strangely, it is precisely that effect which is denied whenever liberals
argue against censorship, but it is precisely that which motivates govern-
ment censorship of left, and their own censorship of words, and right.
People who work in the arts habitually put themselves plainly *against*
censorship – unless that censorship coincides with their opinions. A
theatre for example, pretending to be against *censorship* is really indulg-
ing in self-deception. Not only is there state censorship through public
law, such as blasphemy and obscenity laws, but it has always been illegal,
for example, to incite murder. Civil law can also provide for legal action
against libel and slander, as well as insult; these are normal laws which
only the immature or naïve would pretend we should be without. And
similar laws are to be found in every country. We have *lèse-majesté*;
other countries have strict laws about insulting the flag, etc, which we
are generally spared. We are not unique in setting limitations, even
though to judge from the hysterical self-righteousness of the so-called
anti-establishment (except when it comes to the proscriptions of their
own government), you would think we were.

We can see how it is now that the ex-anti-establishment are left
to frame the laws. On top of the above mentioned we have new laws
against incitement to hatred, which involved a considerable abandon-
ment of some of the areas reserved for free speech since it is a law which
can be, and is, used to silence opinion of all kinds. But that is a choice
the government has made. It has to be acknowledged that the left in
government is at least as proscriptive in terms of censorship as the old
establishment ever was. In their defence it can be said that some of the
laws are in response to a situation where there was an unusually violent
source of hatred which they felt had to be acted against. That is where
government differs from the so-called artistic community, in that they
have responsibility on their shoulders.

There are other forms of what could be called censorship which

doesn't even need the operation of the law to make it work. In an open society such as ours there is a special area of public institutions which have large degrees of independence, such as the BBC, and it is always a matter of contention, as it should be, whether or not they are behaving impartially. This is because censorship can of course work through the simple means of preference – the preference of those with the power to decide. There has long been a battle over the perceived left-wing bias of the BBC, which nevertheless is never enough for the left who crave more consistent bias. It is really a battle for what can be called 'neutral'. One man's neutral is another man's bias. But how does such an institution decide what is the exact equilibrium of a whole country's opinion (which they ought to reflect), while navigating the inclination of the journalistic class? It is always bound to be a battleground. Interestingly, there is no such pressure to be unbiased upon state-funded theatres, whose left-wing bias is open and unquestioned. That is a situation which ought to end, not by insisting on neutrality, but by ensuring, in general terms, that two sides of the argument are heard.

The 'censorship' which operates through preference is not always simply political but of course covers all sorts of opinion. Paradoxically the more open a society is (the smaller the direct role of government in these matters), the easier it is for these effects to go unnoticed and unchecked.

A few years ago I was in the Royal Court, witnessing the International Writers Festival, and I was talking to a Chinese girl who I knew had been invited largely on the grounds that she was censored ('banned') in her own country. Lazily enough, in the conversation I asked her about this and she told me how it worked. She said she was not actually 'banned' as such, her plays were not illegal, but that it operated in a more subtle way. If theatres put on her work, critics would say bad things about her plays and about the theatres for putting them on, and the managements would be afraid they would affect audience numbers and even their own careers; but luckily enough her plays still went on…

This sounds familiar! I thought. I hadn't had a play on for fifteen years at that time, for much the same reason. I began to wonder if I might manage a ban, then I might get invited to China…

Because our state doesn't usually use threats or coercion against mere playwrights, we don't notice how quiet someone can be kept. Civil servants, though, who leaked information which upset the Tories, have gone to prison (like Sarah Tisdall), or been prosecuted (like Clive Ponting), and academics like David Kelly who leaked information that upset New Labour, died in mysterious circumstances.

Consensus-ship might be a word for the process as it operates here. All the theatres seem, by chance, to have the same taste. I don't like how it operates against me, but I might secretly enjoy the way it operates against what *I* consider to be beyond the pale. (I am glad not to see loads of plays favouring Nazism, for example.) But to pretend the system doesn't exist is foolish.

It is not a magical process of natural selection that determines which plays go on and which don't. It is the operation of all the forces, political and otherwise, that keep things the way they are. Selection is a form of censorship, especially an open society, and it is *very* effective.

Consensus-ship is a lot harder to protest against than legal or state censorship. Interestingly the louder one were to protest against it the more easily one can be branded a crank. In that way or course, it is not so dissimilar to state censorship in totalitarian regimes, including the voluntary silence aspect. Because, of course, when you are a dissident in such a society it is not a *good* thing to be, it doesn't have the same heroic clang as it does to us. There it is like being a traitor or a collaborator or a child molester; a sinister villain with an obscene agenda, a real enemy of good society, an enemy of the people, a failure seeking to aggrandise himself, a reject with personal problems, deluded, megalomaniac. You can easily be called some of that here, if you complain. Being a dissident always means being called the worst names, not the best. You aren't branded as a 'rebel' (that's what they call you if you are a successful conformist). In fact, you get called the same names as the ones who deserve them. It's never simple. All you can say is: 'No, I'm not.' It becomes embarrassing to know you – the less courageous or the less strong-minded among your friends start to feel that maybe what people say about you is right – and if you're not careful it *becomes* true. It becomes easier for your friends to think that you may be deluded or

mistaken, than to have to think that a whole community is mistaken in some way, especially if they are a part of it. The mechanics of the group against the isolated one is that the single one is in a position very close to delusion or insanity. Keeping a firm grip on the facts is the only guard against it – and it is the facts that are in dispute. The dissident has to stick to the facts – the target of dissent has to avoid them. The best tactic for those who would quell dissent is to stick to insults – most often it is the insults which will be believed. It is only by determination, allied to some forces of history, that the dissident can finally triumph.

In these matters it counts very much *who* says *what*. Sometimes being the dissident can be the weakest position, sometimes it can be the strongest. It depends really which way the wind is blowing. Seeming to be isolated is not good; seeming to be part of a new trend, rather than an old tradition, is good. In the *Oz* controversy, the magazine was on the right side; they couldn't, ultimately lose. The actual debate didn't matter, because it if had the prosecution would have fared better, for its main points were shared by doubters within 'the movement'. The establishment lost by being just that, the establishment. Society, and those most vulnerable in it, are still paying the cost, for the many victories of that kind, subsequently, in the courtrooms and boardrooms and offices in all spheres of business and the media and the arts.

Another feminist who was asked to take the stand decided she couldn't. She gave the very same reasons the state gave for prosecuting. 'Rupert,' she said, 'was one of my childhood *heroes*. I think in many ways my character was partly shaped by Rupert Bear. My memories are being violated.' Corrupted, as in the actual charge in court. If she had thought about it a bit longer and could have stepped outside the battle-lines, maybe she could have appeared for the prosecution.

If we frame this argument to be not about censorship but about choosing the kind of behaviour we praise and celebrate, the issue looks different, maybe.

It was the sadistic vision of society and sex in society deplored by *Spare Rib* which finally won the day, so that now pornography is an active part of our lives. While supporters of *Oz* have always pointed out that pornography was flourishing with the nod of a corrupt police force,

the widening of interest in and availability of pornography did not come chiefly from the under-the-counter brigade, but through the loosening of public morality standards through the '60s revolution, which eventually became indistinct from it, and of which *Oz* was a proponent. The loosening of standards which made sex ever more visible on TV and then later on video games comes not from the pornography lobby but from permissiveness. But in the end permissiveness and old-style porn became indistinct. The regular injections of violence, to which sex is sadly often attached, through the internet and video games and music lyrics and extreme pornography into the minds of the young is now a *fait accompli* which is hard to see as anything but a result of permissiveness, as we have seen it increase by gradual increments over the past 35 years.

The results of the actual situation we have created, let us be clear, are catastrophic; young girls are now expected to satisfy not the normal expectations of young boys, but the expectations fed by an endless stream of violent or extreme hardcore pornography which is easily available to anyone.

If any readers want to risk standing close enough to any teenage males in London they will hear these expectations for themselves.

The countless and gruesome accounts of rapes and sexual assaults on young girls by men/boys is clear and unquestionable evidence to any who are brave enough to face facts. Again, I have to say, this is something the left turn away from (except feminists) but it remains a quiet issue because it doesn't suit the ideology. (The conviction rate for prosecuted rape cases in Britain is six per cent, more or less the lowest rate in Europe. Not very encouraging for anyone thinking of going to the police.)

Any acceptable ideal of a sexually liberated society ought to lessen the incidence of sexual violence, not increase it. It would include the idea of the sensible regulating and control of availablity of images of sex, as well as the separation of violence from sex – unless of course the liberation is for men only?

A few last words to show that nothing has been realised from the

experience of 40 years of mayhem. This from former headmaster of the 'progressive' comprehensive at Rising Hill:

> [*Oz*] is simply an attempt to shock those of the older generation like myself who have been brought up on the nauseous fact [sic] that Rupert and Enid Blyton books and all this kind of rubbishy sentimentality, are suitable for children. The cartoon, therefore, brings together the notion of Rupert, a horrible sentimental little bear, with the more realistic activities of a male human being in such a way as to cause an element of shock. This can only be to the good if it helps people to realise just how bad, how destructive in the long run, such mush as Rupert is.

Now, after a few decades' experience, we can perhaps begin to see the difference between perversely *calling* something perfectly innocuous 'destructive in the long term' (which depends on a strange contorting ideology), and being able to see the *real* destruction of even the possibility of childhood in many areas of Britain, caused by the kind of 'progressive' attacks on childhood sponsored by the left, and their progressive capitalist counterparts.

The orthodoxy is still churning out the usual clichés. Charles Shaar Murray, one of the original *Oz* school kids, said in the *Guardian*:

> Depictions of sexuality and violence do not, in themselves, offer any threat....we have seen those who are threatened by ideas demand censorship in order to win cultural wars when they know, in their heart of hearts, that they have already lost the argument.

There speaks the winning side.

But it wasn't the argument that was lost, the struggle was lost. That's not the same thing. Unless we presume that right always wins? I suppose the new Whig version of history does rely on that belief. And right is always on the side of the self-styled 'progressives'. They will keep believing that, until they start to look at the cost to everyone else, and find it in themselves to care about it.

7 A REVOLUTION IN COMEDY
Public schoolboys having a laugh

JONATHAN MILLER SAID RECENTLY that he felt afraid to look at teen-agers on the street, for fear of violence. Maybe if he sticks around for another 30 years he might begin to wonder how that came about.

The Goons, though much revered by their inheritors, were the end of an era; the era of music hall, radio and seaside-town comedy. Milligan and Secombe started their careers in the concert party during the war. In the era that followed the officer class took over with *Beyond the Fringe*, and what grew out of it. In a way it became more subversive, not less, because it had built into it a narrower and precise political focus. The satire had a single-mindedness about it which gave it a sharper edge. When Peter Cook named his club in the West End 'The Establishment' it left no doubt what was foremost in his satirical mind at the moment, and gave a self-consciously class-activist flavour quite alien to the more anarchical Goons.

Within a few years it could have renamed itself 'The New Establishment' in a quite literal sense.

The 'I look up to him and down on him' sketch[1] shows, in a rather lugu-brious way, the class consciousness that forms the content of so much of their humour. They can be forgiven perhaps if for the neatness of the thing they ignored two classes; the lower middle class, to which the Goons belonged, and the upper middle class to which they themselves belonged. In their world there was the working class with cloth cap, the middle class with city bowler, and the upper class aristocratic type. But it was their own upper middle class who were in the ascendant and

1 From *The Frost Report* (BBC, 1967), written by Marty Feldman and John Law, and starring John Cleese, Ronnie Barker and Ronnie Corbett.

were the most culturally active and potent class, the ones redefining the nation's sense of itself through its control of comedy, broadcasting, literature, publishing, fashion, politics and music publishing. How did these keen-eyed social satirists miss out on such an important class? Strange perhaps, but not so strange when we remember that the machinations of that class remain even today strangely invisible, failing to appear on most radar screens, at least not in the form of a target; their revolution still escapes definition. And it was possible to watch several series of Monty Python without seeing them except in the guise of interviewers on TV.

Why were their own class were so invisible to themselves? Why were *Beyond the Fringe* and Monty Python so unaware, despite their keen sense of class? One can only imagine that as with most revolutionaries they saw themselves not as a class but as instruments only, agents of change – in some way neutral. It is one of those anomalies of revolution that the beneficiaries and originators of the ideas and the action and the resettlement tend to see themselves either as acting on the behalf of another class entirely, or as being so purely formed that their existence is a mere abstraction. The French Revolution doesn't generally conjure an image of a lawyers' tyranny. (Neither does the EU, which incidentally is owned and controlled by that self-same class, the direct descendants of Robespierre.)

Comedians share with revolutionaries that sense of their own non-participating, non-culpable existence, the inheritance of the immunity of the jester. But while the lowly jester was given immunity to pull the king's beard and call him a fool, it's a long step from that to an array of public school Oxbridge elites managing to grant themselves the same too-low-to-be-suspect status. Did they never take a look at themselves? Did they never line themselves up with their education or qualifications and their elite position in society and their remoteness from the mass of people, and their rebel status, and think there might be a gag in there somewhere? Didn't the JCR atmosphere give them any stray emotions?[1]

1 Yes, I know Dudley Moore was working class; Alan Bennett was a grammar school boy – more of that later.

It's possible that when they targeted the crusty old Macmillan-style conservative establishment type, they felt as if they were already hitting at their own origins. If this is true, then they were simultaneously granting themselves exemption, presumably on the grounds that they didn't feel as if they were part of all that, on account of their youth. It is indeed typical of that class that they are capable of deriding privilege and elitism while refusing to acknowledge that they are beneficiaries from it: it is a very strange paradox. After all, if it isn't important then why attack it so keenly?

Beyond the Fringe and Monty Python were certainly funny and Monty Python at least amounted to a lot more than a class phenomenon. Not only were they funny, but they liberated the imagination, they even transcended mere social and political satire and created, not least in their films, a broad satire of humanness: *The Life of Brian* is possibly second only to Zeffirelli's *Jesus of Nazareth* as a life of Christ, and the *Holy Grail* is a more or less perfect embodiment of *Sir Gawain and the Green Knight*. As a schoolboy in a London comprehensive in the 1970s I witnessed first-hand the way Monty Python's humour transcended class, to an extent – though of course the lower down the social scale you went the less likely, thankfully, you were to find boys reciting sketches. You could never say their appeal was universal.

Monty Python contains many lessons about satire and humour, which a mere fortnight on the continent (to witness their complete misunderstanding of it) can make one eternally grateful for. The combination of precision and excess is something Europeans have difficulty getting right, and they veer easily into stupid slapstick and exaggeration: Monty Python contains many moments of real originality, and they created their own version of surrealism. The talents and mere acting ability of the crew were unquestionable and they made an irreplaceable contribution to our culture. It exemplifies an aspect of the British psyche so fundamental that it seems as if Monty Python must always have existed (the same is true of the Goons) – and none of it is of course divorceable from the personal and social backgrounds of the participants. In other words, the upper middle class view of things then was generally funny and did allow individuals to generate real meaning and accuracy.

It is obvious too, though, that *Beyond the Fringe* and Monty Python were part of a general class movement to which they contributed in no small degree, and their victory was and is undeniable. By the time the poor Bishop of Southwark encountered a conspicuously relaxed Michael Palin in a TV studio in 1979 and tried to object to *The Life of Brian* as blasphemous, the evidence of who held the upper hand by then in British society was so clear as to be unseemly. It was almost unbecoming for a comic (or jester) to be in such a superior position: the brute force of his upper hand was so much that one almost hoped the Bishop would leap up and pull Palin's beardless chin. And of course the Bishop was right: the final scene in the film, where Brian is singing along with 'Always look on the bright side of Life' *is* blasphemous because it belittles the suffering of Christ on the Cross which is the central aspect of Christianity. But an establishment which could no longer defend itself against that was no longer an establishment: the war was won. The 'Established' church now struggles to just about hold its own as one of many religions; blasphemy laws are now nothing to do with defending Christianity from insult, but with defending other religions from criticism. The relegation of Christianity is of course a source of delight to the new middle class left-wing establishment: for anyone else, developments have the scant consolation of seeing the new establishment caught on the real horns of a dilemma: to decide between their distaste for religion, and their dread of being 'racist' (sic – they mean 'culturalist').

Terry Jones recently said, rather smugly, that, 'although it was like kicking a dead donkey at the time, the film is now more relevant than ever because religion has come back on the political agenda' – disingenuously ignoring the fact that it is not the easily-kicked established church that is 'on the political agenda'. I don't think we'll be seeing the Pythons having a go at Islam.

Readers will notice that I am taking the unusual position of presuming that there is nothing wrong with Anglicanism being the established religion, and being afforded legal protection not given to other religions. This seems like anathema or racism (sic) to the new establishment, but is normal in many other countries – especially Muslim countries. The point is, of course, that the position of the Establishment Church has

been weakened, not because of Islam (to whom its existence is taken for granted and a well understood, even approved of, fact), but by its collision with the middle class left, who saw it as an impingement on their humanist values and, more importantly on their religion of personal freedom to do as they like and make as much of themselves as they can. Readers will remember Michael Palin's attack on Catholicism (a minority faith in Britain) in *The Meaning of Life*, a scene which involves a hundred children singing about sperm. The poor feller would be arrested if he shot such a scene in today's Britain, notwithstanding the 'benefits' of the sexualisation of children, brought to us by the operation of the very same agencies of freedom and humanism, ie capitalism and the middle class left. The paradoxes go around so fast it is hard to keep up. No sooner has something been called a paradox than it becomes a plain fact.

Hey they weren't all public school y'know!

At the height of the Labour Government's pogrom against grammar schools in the late 1960s, on the set of the *Today* programme, a timid, mild-mannered Yorkshireman was wheeled on to denounce elitism and to explain what a terrible social ill grammar schools were. That man was Alan Bennett. Yes, the very same, the grammar school and Oxford-educated author of *History Boys*, that heart-warming trip down Nostalgia Lane, to the days of chalk and talk and, yes, grammar schools. Long may his bank account flourish. See you on the barricades Alan!

Anything goes.

8 WHERE IS MARXISM?

ONE MIGHT WONDER WHERE Marxism lives these days. Largely it lives in the universities where discussion over its definition is on a sufficiently high plain to make the outcome of the discussion beyond the reach of most, including academics if they are not trained philosophers. The result is that theory and practice get separated, that is; Marxism's contribution to socialism grows less.

Marx was suspicious of philosophy and found that 'the dispute over reality and non-reality of thinking that is isolated from practice is a purely scholastic question.' Furthermore, he saw the activity of philosophising to be a result of the division itself between manual and non-manual labour which society would eventually abolish.

What indeed is the use of any discussion of socialist philosophy which doesn't translate into better housing, better social conditions, including their freedom and well-being, and better pay, for the working classes? The middle class academic answer is, 'Yes, but how do you define those things?' – but then he's getting paid £40,000 per year to discuss it.

Another argument might be that philosophy has supplied the impetus for revolutions, the French Revolution and the Russian Revolution being obvious examples. We are certainly very used to that idea. It is the view of history given to us by some historians and by the powerful political classes who were the inheritors of those revolutions, the lawyer class of France and the elite totalitarian class of Communist party-members of the Soviet Union. But it might also be argued that what the philosophers, including Marx, provided was the derailment and usurpation of the revolutions by the middle classes. Both revolutions occurred when oppression had reached the stomachs of the oppressed.

Marx and Lenin are two of the best writers on political economy the world has seen: their inventiveness and knowledge alone were phenomenal, their grasp of the situation was *almost* exhaustive. But do we really believe that it takes thousands of pages of brilliance to make a revolution

good enough to seize some food, some land and some peace? Are the mass of people so stupid that they cannot feed themselves? The Russian revolution was in *February* 1917; it was not led by the communists, or by anyone at all for that matter, and established a Diet elected by universal suffrage (which the Bolsheviks later destroyed – and that was the last the Russians were to see of democracy for the next 60 years).

What the writings of Marx and Lenin provided most was the means by which *after* the revolution, the freedom of the people could be abolished and the truth so tied up in knots that it was possible to murder millions of people, to abolish normal freedom and common sense, to enslave and terrify millions, and for the middle classes once again to hold the people by the throat; that's what the actual pages of Marx and Lenin were used for in the little offices along the long corridors of power in the Soviet Union and in Eastern Europe; *not* to remove the Tsar's government. That was done by other means.

And in Britain, how many bathrooms, council houses and pay rises have the writings of Marx and Lenin added? The improvement in conditions of the working classes in Britain had little to do with Marx. Socialism itself of course predates him, as do the working class movements here. And as far as theory is concerned, Ruskin expressed the idea of alienation in far simpler terms without reference to Marx's recondite theories. He said the division of labour (*Adam Smith*) was the cause of working class misery by reducing a man to a function, by not using the whole man. The alienation idea in Marxism is the same idea only expressed more convolutedly and extending its meaning to such a degree that it seems to be a general observation about the human condition rather than about modes of employment. After all, pointless work is a drag to anyone, and it would be nice to get rid of it when possible.

They are still discussing it in universities now where it meets structuralism and existentialism. All very interesting for the middle class academics but not so much of an advance on the idea that boring work is boring, and prevents men from developing as individuals largely because it takes up all their time on something unrelated to themselves. It's a fact of life which hardly needs to be dug into a structuralist Marxist conspiracy theory in order to ring true; and there wasn't any shortage of

alienation in the Marxist-Leninist society of industrial state capitalism in the USSR. On the contrary, so bad was the effect of alienation there that the simple distribution of food eluded them for sixty years because people felt so little interest in their work.

If Marx had never written a word, nor Lenin, the condition of the working classes in Britain would be no worse before 1960 and would certainly have been better without it since then. British political development gave us a successful revolution in 1688 (which only now has been defeated by the Labour Government's attack on Habeas Corpus). Liberalism, Toryism and feminism gave the extension of franchise to universal suffrage; Victorian know-how, utilitarianism and Benthamism gave us drains and libraries and schools (religion had, unfashionably, a big hand in this). Capitalism gave us cheaper bathrooms; medical science gave us antibiotics; Florence Nightingale gave us clean hospitals; trade unionism gave slightly better wages and conditions (until it was met with Labour Government betrayal); and a Labour Government gave us the Health Service and the Welfare State, which are ideas which grew out of Poor Law provision and workers' friendly societies and the Beveridge Report of the wartime government. It was growing in the 1930s; they had it in Germany under Bismarck (no Marxist he!).

Socialism, we should remember, is not a version of Marxism, rather the other way around. Socialism is the working classes helping themselves and fighting for their interests; it is a practical movement or it is nothing at all. In the minds of contemporary middle classes who call themselves socialists but who are in fact Marxist theorists (with high paying jobs), it means nothing at all. Under them, Marxist theory, not just Marx himself but the legions of academics who have fed on his work, has infected the practical movement of socialism and even replaced it. The two strands can be seen in the current Labour government: the family tax credits which hand out large monthly payments to low-income families is socialism; the use of the Arts Council funding to implement its social engineering, and impose its ideology, is Marxism; the education system is Marxist-Maoist. These last two bring no benefits to the working classes, and in fact leave them worse off.

9 INTERVAL AT LAST!!!!!

A little drink with Rousseau and Althusser

JUST TIME TO RUN down to the bar. And who should be there but our old friends Althusser and Jean-Jacques Rousseau, released on a day trip from the École nationale supérieure. Althusser is wearing a police helmet, and for some reason he hails Rousseau thus: *Hey you!*

Who, him? Rousseau replies (pointing to the space alongside him)…

(Illustration by Hedvig Kjellberg-Motton)

A positive view of mankind

'Man is born free but everywhere he is in chains.' These words are to found somewhere near the heart of the left-wing way of thinking; it

expresses the positive and optimistic view of human nature upon which can be built an idea of a society which has released men from chains and returns us to the point where man with his basically good nature can thrive, if only law were framed in such a way to enable it; the outlook is good if we can only undo the wrong turning, which has resulted in man being enchained by bad systems.

In this view, man's basic good nature can be relied upon to respond well to good laws; it implies that what we need is certainly not more laws, but rather to be liberated; if we can liberate ourselves then all will be well once again; the iniquities of inequality and bad government and bad economic systems will be removed, because man in his natural state – is free.

His natural state is to live in liberty and the equality that that implies. This is what is to be understood, broadly speaking, from this basic tenet of Rousseau's thinking.

Or is it?

If man was born free but everywhere he is in chains, who is it that put him in chains? If man is basically good by nature, then who is it that has come along and enslaved him? Spacemen? If man's natural state is indeed a state of nature, where there is harmony and equality, then who are the ones who were not in that state of nature and who sought to exploit and enslave his fellow man?

Here we find at the centre of Rousseau's thinking his essentially ruptured mind and his paranoia. It is someone *else* who is the exploiter. Not me. Not us. The paranoid mind is essentially one who seeks to put all the bad outside of itself. Unable to face its own faults it projects them onto others, another person, all other people, or another group, another race, etc. In this simple phrase of Rousseau's we can see *built in* this strange and contradictory and in fact impossible view. 'Man is born free and yet everywhere he is in chains' is an impossible statement; it is impossible whether or not the state of nature is intended to be an historical time or just a metaphor. The fault for the chains must be in man himself, his own nature, all our natures; so that the best we can say of man is that he has a tendency to want to enslave his brother. Certainly anthropology gives us no reason to think there was ever a state of nature *before* this sort of thing went on; all human arrangements involve some sort of hierarchy; no-one is free; no-one is free

from fear, superstition and from the peculiar displacements we enter into to deal with them. We voluntarily enslave ourselves to systems because the alternative is even worse. Religion, and the power of the religious man, wise man, shaman, medicine man, etc, has been with us since the earliest times.

Agricultural settlements, the food surplus and profit and wealth that came with it, was certainly a step in enslavement, as it was a step in civilisation. In Rousseau's social contract however, the enslavement comes before the contract: the social contract is an arrangement man enters into to deal with the criminal activity of the enslavers, those who are not in the state of nature; society, by this idea, was begun as a response to human nature (even though Rousseau curiously puts human nature in a place other than the breast of each one of us).

This essential aspect of Rousseau's thinking can be seen in the attitude of the left whose view consists of the same two elements: an idea of a state of nature where man is essentially innocent and trustworthy; and a group of 'others' who seek to exploit the people. This false duality is the root of many falsehoods in their positions. The ungrounded optimism regarding human nature (and their consequent failure to make proper provision to counter its worst aspects), and the projection of all bad onto an imagined enemy who are unlike the rest of mankind. This view also, by the way, makes them particularly good at hypocrisy, able to be in fact capitalists while claiming that it's always someone *else* who is the capitalist. It is amusing to read Rousseau's *Confessions* and see the quite spectacular extent of his insanity, his paranoia and outright hypocrisy, and to have in mind the traces of it in his followers.

Another inherent trait of Rousseau's thinking is the ultimately tyrannical aspect of his vision of the state. This he shares with Althusser whose special charm as a hard-line Marxist is that he writes in the post-Stalinist era but fought bravely to oppose the new Marxist humanism and to probe Stalinist Marxism into areas of humanity where it hadn't colonised yet[1] (as well as asserting that Marx's philosophy was not the

1 'We can see the emergence of Althusserianism', E P Thompson wrote, 'as a manifestation of a general police action within ideology, as the attempt to reconstruct Stalinism at the level of theory'.

kind which referred to actual objects or phenomena but one which 'as a science [...] contains its own internal methods of proof'. In other words it made best sense if you didn't check it against reality.[1]

E P Thompson, the British Marxist, did find this kind of Marxism suspicious, and saw it as an idle game for an intellectual elite.

This group, 'indoctrinated by selective educational procedures to believe that their own specialised talents are a guarantee of superior worth and wisdom, are only too willing to accept the role offered to them by Althusser'– that of philosophical guardians of proletarian science. 'Isolated within intellectual enclaves,' Thompson writes,

> the drama of 'theoretical practice' may become a substitute for more difficult practical engagements [...] It allows the aspirant academic to engage in a harmless revolutionary psycho-drama, while at the same time pursuing a reputable and conventional intellectual career.

Althusser described the Ideological State Apparatus which defines and controls humans. In brief, we see ourselves as whatever others treat us as; and it is the powerful agencies of social control (the family, the media, the law, and ideologies) that influence us most (despite men thinking that they are free agents). This is why, according to Althusser's famous example, when a policeman calls you across the street, 'Hey you', you are defined by him. It's a good theory, if you refrain, as Althusser would have us refrain with Marx, from checking it against reality. At best it is only part of the truth. But being an ideology which is born in universities, it requires to be the whole truth, exclusive of any others, all of which it subsumes. It is a theory of everything, just as Althusser claims to have revealed that Marx was not economics, but philosophy, a theory of being. Out of Althusser's rarified abstractions have been built theories of social control and of exploitations of one group by another. His ideas

1 In Althusser's view, Marx did not simply argue that people's needs are largely created by their social environment and thus vary with time and place; rather, he abandoned the very idea that there could be a theory about what people are like which was prior to any theory about how they come to be that way.

have filtered from the high place of his Paris hide-out, to the universities and colleges of Europe and America, through followers such as Foucault and Derrida, until they reach local councils, the Arts Council, drama teachers and finally directors where they are in the form of a theory of victimology, where life and society is explained in terms of groups in the Marxist superstructure where it is just a matter of working out who is exploiting whom, and by what means. In effect, though, not in intention, these ideas bring about a move away from the economic base of Marxism, so that the mere issue of workers' wages and conditions can be put to one side. It means, for example, that the working classes are not the necessary focus of the modern Marxist; for indeed they are only one group among many and can be divided into smaller groups at different times in different circumstances. The working classes may at times be found to be the oppressors; of women or homosexuals or immigrants, for example. All very true, no doubt; and it works so very well to keep things exactly as they are when it comes to who has what.

The Ideological State Apparatus confers upon us all different roles in different situations. The 'terms of control', as they might put it, are defined out of the Marxist analysis: like a sort of all-embracing conspiracy theory. Our relationships with one another are depicted in clusters of two, where one is a victim and the other is an exploiter. The beauty of it is that anyone can be a victim and, by extension, anyone can be an exploiter; it depends, really, who has sufficient power to insist on their own interpretation. Let us take, for example, a middle class public schoolgirl: if she is versed in Marxist method, and if she is well enough connected with theatres and if for example she is a playwright, she can ensure that she is always the victim. She can be the victim of men, or of Jews, or religion, and of the working classes, and still be socialist; can be the prime socialist, the top socialist, if you like; not because there wouldn't have been other ways to interpret those relationships within the Marxist framework, but because she has the ownership, let us say, of the means of production of these definitions. It soon becomes obvious that once the definitions are up for grabs in this way, it is inevitably a matter of raw power as to whose definition gets to be the definitive one, the one which is believed. Let us say there was a working class revo-

lution: we might find that this fictional woman playwright might find herself cast in the role of an exploiter, and might find herself stripped of her fortune and her power and her status. So it goes, as Vonnegut used to say.

Althusser was mentally ill and lived in the safety of the École nationale supérieure. Here it was he strangled his wife to death in 1980 whilst giving her a massage. He was committed to an insane asylum and never charged with her murder and continued to write –

Oops, there goes the bell.

10 a lITTLE cOCKTAIL iN sTEPHEN'S bAR

After the controlled and manipulated left-wingism of the 1980s, Stephen Daldry, the new incumbent at the Royal Court, realised that the best way to be receptive to the Zeitgeist was to allow it to be determined more by what came in though the door; a position of admirable logic which allowed a diverse reaction from a number of different sources; this was more appropriate to a theatre which claimed to be a writers' theatre.

However, by then, writing had turned itself into something which had unquestioningly absorbed much of the ethic of the 1980s, so that it was now a mixture of left-wingism and an obsession with success. And success was measured by how completely the predominant values of the present were manifested; that is, non-analytically, without comment, without criticism, without much thought or judgement.

And if a play could manifest the very newest and the very worst of current trends of behaviour and attitudes, then the play was a success. In this way, theatre's ambition was now to participate, to take part passively in whatever was going on. This tendency registered itself in the smallest details in the plays and productions, and still does. It registers in small details because that is how absorption and imitation take their effect; through language and through attitudes expressed indirectly. We are no longer talking about a theatre of ideas.

This coincides with the popular view of language as a positive register of *development*; to playwrights who subscribed to this it was natural to allow as much of what might be called 'trends in language' to seep into their plays. For them, if the process is conscious at all, it is evidence of life and vitality in their work; where it is not conscious, it occurs merely because it reflects the uncritical identification of the playwright with the society he finds himself in.

Since what registers first are notions formed by the broadcast media, it is likely that what is being so hungrily absorbed is precisely that. In

this way playwrights became yet another outlet for so-called 'popular culture' which is of course anything but. It made itself an outlet for received ideas.

In an era where the understandable left-wing interest in the working classes had degenerated to a search for 'authenticity' – as if that might validate their increasingly wayward, disconnected ideology – this so-called authenticity came inevitably to be measured by how passively the imprint of the media had made its mark, since there was now little distinction between the powerful, corporate media, and popular culture.

The more manipulated and thoughtless a play, the more authentic it appeared to be. Theatres such as the Royal Court and many others didn't shy away from manipulating these 'authentic voices' themselves of course, but that hardly mattered, since their manipulation was essentially no different from that of marketing, government, music industry, advertising, TV, video, etc, precisely because they didn't think any differently from any of these agencies. Theatre had gradually absorbed the values of the vigorous money culture of 'youth' that it had converged with to the point of becoming indistinguishable.

This abject position has been hidden by the very success of the collaboration. It has allowed the theatre to share and use for itself the energetic-sounding language which belongs to the politics of marketing. The fake populist ring of the language in much of the theatre in the 1990s, for example, is an example of this; the brash tone of the plays and their begging-for-attention titles show a theatre trying to identify itself with the fashionable version of the working classes. An almost comical preoccupation with plays involving London's gangland (a very out-of-date version of this, based in the 1950s and '60s), populated with tough diamond geezers, thrilled the audiences, and no doubt the writers – the flirtations with violence still give energy to a theatre intent on aping anything that can make them seem half-awake, no matter how bad it is. The same happened on television where middle class producers served up, and still do, 'authentic' versions of an increasingly violent society, with no more thought for the consequences than what the accountants tell them. There has been created a culture of grossness that now holds the BBC hostage, and like a latter-day Patty Hearst, the BBC can't sell

itself quick enough… Social conscience is a joke, and the BBC has been in contravention of its charter for a good two decades. Conveniently the middle classes have denied any link between broadcasting and changes in social values (except where TV has taken to 'reflecting' them – the interaction only ever goes one way, apparently) and have thus happily allowed the well paid producers to mine the violent vein with impunity.

Theatre no longer expects itself to have any analysis, so there is virtually nothing to impede their triumphant pageant of tinselled degradation of body and soul, and mind, that has beset the generations, and against which the theatre has no word to say of opposition or dissent.

The language and gesture of manipulated robots produced by the machinations and/or failure of modern capitalism, and its associate left-wingism, and the disastrous results of moral collapse, find only approbation and approval from the playwrights of today, and this was pretty well the established pattern by the 1990s. Satire is a thing of the past because language is seen as non-problematic.

The other view, the negative view, the pessimistic view (which should form a more conservative outlook), is that language is a register of lies and mistakes: the more fresh and current the idioms are the more fresh and active are the misconceptions that gave birth to them; upon that view of language is built the language of satire, and it is very significant that satire hardly exists in theatre (while it does continue to flourish on TV). It shows that theatre has accepted language at face value, which means that folly is being approved, mistakes and misconceptions taken for genuine expressions and ideas; folly and pretence are taken for what they pretend to be.

We can be thankful that in recent years Royal Court managements have chosen the eclectic path and sought to allow more of the impetus to come from writers.

But inevitably the dominant orthodoxy remains the default position in theatres and in writers' own minds. It is the job of writers, when given the opportunity, to break out of the prison of their presumptions; so far only very few have been able or willing to do so.

It is not until writers take that step that theatre can have the critical relationship to society that it expects itself to have, but doesn't.

11 C...C...C...CRITICS!

YOU CAN TELL HOW emotional a *subject* the critics are by the degree to which people pretend to be not one bit bothered by them. From the way people speak you would think no-one is in the least affected by what the critics write, and that in fact no-one reads them.

At the same time each production has a special night or nights when the critics are all invited: staff are employed to send out the invitations and to book them in and to welcome them when they arrive. The opening dates of shows are scheduled around the logistics of not clashing with others and losing the opportunity of getting the right critics to come along (because even critics cannot be in two places at the same time). In other words the critics' importance is built into the subsidised theatre system.

Pretending that critics are of no importance is and has long been the fashionable posture to take. To present a dignified exterior to the scurrilous enemy and to sympathetic friends alike is the norm. In theatre corridors I have seen many a dignified face, many writers, actors and directors upon whose visages 'unconcern' could not have been more largely writ and in whose words 'light-hearted unawareness and haughty contempt' have reached a mixture of cement-grinding gravity.

No, no-one reads the critics, no-one cares what they say. No-one, that is, except audiences and theatre managements. Especially the latter.

Because there has been a widespread reluctance to address the poor quality of the work of the critics over the past, it is an area of theatre which has hardly changed for decades. Criticism *is* very important, including criticism of critics. It is ironic that they are the only ones to escape criticism; it is time for that to end. The absence of criticism leads to stagnation and self-deception and delusion. Poor quality criticism is similar to no criticism at all. My argument is not against criticism, it is a plea *for* criticism.

Theatre critics are apparently pretty well paid, but the standard of criticism in theatre is probably lower than in any other art form. In fact no-one expects theatre critics to be on the same level or to perform the same functions as other writers about the arts. Very few theatre critics have made the step of writing anything longer than a review, and it is hard to imagine that many of the main newspaper critics would be capable of it. And if they do produce a summary of plays over the years with one or two observations they are raised head and shoulders above their colleagues and earn the grateful acknowledgement of a starved readership.

It would be a good idea to review the reviewers. To subject the work of the critics not to the lazy scurrilous attacks they favour, but to reasonable scrutiny, if only to ensure that minimum standards are met: the natural standards of honesty, fairness and logic. I think there is now somewhere on the internet where this does actually happen, and if there isn't it could perhaps be arranged. Maybe one of the leading newspapers could play host to it. It might just sow the seeds of a rebirth of standards in criticism. The critics of the critics could provide the newspapers with a pool of recruits to replace their old critics when their usefulness has been worn away. The upward pressure of able minds, who would be tested by the very process every time they wrote, would be a sure spur to the improvement even of the existing critics; failing that, they could be replaced. Within a short time it would be evident that there was more talent off the newspaper critic staff than on it. I am sure this idea would be welcomed by the critics, being as they are, men who believe in the beneficial action of disinterested criticism. It would without doubt be beneficial for our present critics to have to look over their shoulders at *their* critics while they work. I hope they get a fair hearing.

Bad criticism often fails in a few basic ways. (These remarks are all elementary, but we are I think, as far as criticism goes, in the elementary class still.) Judging a piece by the wrong standards is one of them. To state what ought to be obvious, a comedy should be judged for by its ability to make us laugh, a thriller to thrill, a drama to represent the human psyche, a play of ideas to elucidate ideas, and so on. Combinations of

these are of course allowed. If critics would remember this rather than wishing they were at a different play, we would be better off.

What impedes critics from remembering this basic standard is that they have suspicious minds and don't even trust the motives of the writer. If critics did not always presume that anything they don't understand is intended as an insult to them or as a dirty trick, there would be a lot more room for variety in the theatre.

Sadly not many critics seem to even know the difference between their *taste* and their *judgement*.

To treat goodness as hypocrisy, to treat virtue with cynicism, to answer intelligence with stupidity, is the work of a villain; it is dangerous to truth and to civilisation and the general good. To fawn upon the fashionable and the proud, and to praise the herd and cast stones in a rabble against the unorthodox, are similarly the actions which lead to a vulgar and stupid society. The critic, in his role, has to avoid all these – not just to be a good journalist, but to be a decent person.

Critics, like all of us, have their problems. Being an alcoholic, for example, is not a good qualification for a critic. Not just because an alcoholic is often drunk on the job (there is a certain kind of mind which cannot be worsened by alcohol), but because alcoholics are liars. They lie to themselves and to others; it is one of the characteristics of the condition.

The difficulty facing the honest critic is the same as faces all of us: to be able to tell the difference between the real and the fake. That is the crux of the critic's job, and that is why his judgement and discernment ought to be his stock in trade; that is why he ought to be a man of honesty and courage and patience and modesty. It is a very demanding job, in a way. Sadly there are very few who measure up. Or to be fairer, there are few occasions when the critics we have measure up to those standards. That is not to say they could not.

Considering the impact critics have on the fate of theatre productions, it is surprising there isn't more of a dialogue between theatres and newspapers about the fairness or otherwise of their comments. The reason there isn't, is fear. Theatres rarely start a dialogue because they prefer not to upset the critics, on whose reviews they partly depend to get a decent

audience for their shows. This is a shame because an improvement in the critical environment for plays is long, long overdue.

The problem is not just the negative aspect of bad criticism, but the lack of developed intelligent criticism. It is surprising that critics aren't more eager to play a fuller role than they do. Theatre, of all the arts, has possibly the least written about it – outside the actual reviews of individual plays – and it is surprising, in a way, that we don't expect critics to engage in that. Theatre needs a more sophisticated critical response, in reviews or otherwise. Criticism is sometimes an important part of progress in an art form. The *nouvelle vague* movement in French filmmaking started as criticism. The already considerable French film industry produced the critical writings of André Bazin, and of the young enthusiasts like Truffaut and Godard, who began as critics in the tradition of Bazin, writing intelligently about film-making. Criticism became film; the films were examples of what they meant in their criticism. It is instructive to compare the French film industry, with its (to us) rather intellectualised but at least very thoroughgoing and exhaustive critical practice, and the British film industry which lacked it; with some important exceptions, British film still looked like filmed theatre from its beginnings until after the 1950s, because we hadn't really developed a theory of what film actually was – we simply hadn't thought about it, and it showed.

It is hard to imagine that, after a proper intellectual engagement with theatre, if it were applied to practice, we could end up with a narrower critical horizon than we have now. For one thing that is lacking now is a variety of form, let alone content, and some of this has partly to do with the critics, and their rather childish response to anything new. Scepticism is healthy, but there is no logical reason why it should be especially directed at new things. The mechanism is simply: if every time something new appears it is stamped on, then new things are less likely to appear. I have heard it many times from various horses' mouths, but here is one example from a manager of leading London new plays theatre. 'I can't put on your play, Gregory, because you know what will happen, don't you? The critics will destroy it and I'll have an empty theatre and I can't afford that.'

I wish I were making it up; it was certainly a candid moment. Now, of course, many readers may think this is proof that the system is working admirably to keep my plays off the stage, but they should also consider all the other exciting departures being denied them by the same phenomenon.

Critics have a very different attitude towards commercial theatre. Here they are the reverse side of the bully: the grovelling sycophant, impressed by great actors and their reputation, eagerly supplying the tired old phrases for the billboards, and eager to be part of the razzma- tazz of the first night; grubby little trainspotters huddled in their free seats, and leaving without even applauding, just so they can show off. They are tolerant and forgiving, willing to overlook all but the grossest errors of judgement and taste.

On the other hand with the new play in a studio they think they are observing an 'experiment' upon which they have been invited to pass judgement from a great height, and special scrutiny is employed to detect the least flaw. This is partly the fault of the theatre managements who do in fact foster the 'experiment' myth very willingly.

In fact there is rarely anything experimental about plays in studio theatres, while commercial theatres are taking enormous risks with other people's money, which seems like an experiment of sorts to me. Personally, though I have only ever had plays on in studio theatres in this country, have no recollection of making any experiments. I wouldn't like to give the impression that I think 'experiments' in form are a good thing in themselves. Personally I have never made an experiment in form, I have only ever written plays in the best way I could, and that is all any writer usually does, to write a play in the best way it can be written at the time, using the form that seems best suited. Innovation is probably best when it comes by accident (which is why all the talk of 'innovative theatre' is such nonsense). To search for new forms, to experiment as if any particular outcome is interesting, seems vain and rather silly to me. But when innovation does occur, as a by product of a writer striv- ing to express something well, then it is a travesty for it to meet resist- ance merely because it is unfamiliar. My argument is not that new forms

are important in themselves, certainly not that innovations in form are worth *looking for*, but rather that new forms are sometimes necessary or unavoidable, if certain things are to be expressed accurately; and it is destructive and unnecessary for that to be made nearly impossible by a stupid critical response. Usually this happens because critics are needlessly suspicious, and think they are being hoodwinked, or asked to swallow something for no good reason. Perhaps this is often the case, but it is their job to try to tell the difference between real and fake. To get it right, a degree of tolerance and open-mindedness is needed.

I have every sympathy with the desire to uphold and maintain a conventional style. There is much to be said for convention, for things to *not* change. The mysteries and advantages of complete stasis are rarely bruited and I won't do it here (that would be another book, published on another planet).

You can have both convention and innovation, of course. The problem is imitation. Innovation is good as long as everyone doesn't start copying it. Put another way, I might think it is inevitable that I, for example, should write in a peculiar way, but there is no reason why everyone else should have to. You might argue that convention is another form of copying, and that change and development can only happen if people copy innovation, but I would not agree with that. Change is neither necessary or desirable *in itself*. As for convention being a form of copying, it may be, but there is a big difference between copying *new* trends and following convention. Being conventional makes no claims and has no pretensions, whereas following new trends most certainly does, and is inherently dishonest. Conventions change slowly and slightly, by accident, their variations are infinite and subtle, their discipline is a boon. You are reading a defence of convention by a writer more or less exiled for not conforming to it. I hope that says something about the nature of innovation.

And of course, people don't necessarily follow a convention very deliberately, but they work within it, they master its rules, and combine it with their natural originality. There is easily as much genuine originality to be found in the work of those who work within the conventions as those who don't. There is also some truth in the argument that those who break the conventions do so because they cannot master them.

(Max Stafford-Clark, to name but one, claimed that such was the case with me, and I wouldn't deny it wholly.)

Innovation, though, is also a combination. Those who seem to have innovated most are in fact most steeped in the various phases and aspects of the convention they break; and they break it usually by chance or accident.

Various theatres and theatre courses do teach 'rules' in playwriting. That is up to them: 'guidance' seems a better term. But these rules at any rate should not be too narrow; and, furthermore, if you are teaching rules they should not be the wrong ones. To teach a fad as if it is a convention is foolishness, and I have seen it being done, in high places.

I will give an example, for clarity. The Royal Court (among other places, possibly) has been teaching playwrights to withhold information *for the first few minutes of a play*, to create 'suspense and interest'. Playgoers will by now be familiar with the two minutes of chattering characters whose conversation is (deliberately) incomprehensible to the audience. This is a fad, and it is nonsense. There can be no suspense before the audience is involved in what is happening. Until then they may not *know* what is going on, but they won't *care* either. For some reason, doing this makes a junior playwright feel clever (and some seniors too). Next time you see it done, I recommend you to just start whistling, and then at the end, ask them to replay the scene, so that you can now, having seen the play, know what that two minutes' dialogue was all about.

Neither do I think, incidentally, that 'rules are there to be broken' (surely one of the most stupid of all aphorisms). Rules are there to be followed, or they shouldn't be there. But, in the arts each 'rule' is merely a description of a method to achieve an effect. Innovation is not achieved by 'breaking rules', but by combining them to achieve different effects.

The day the critics were right...
(but changed their minds)

For once the critics were right. They reacted strongly against Sarah Kane's play *Blasted* and were right to do so – except that the reaction

was *so* strong it drew attention to the play, without which it would have sunk. They reacted with what is laughingly called Moral Outrage, and they were right to do so. (The expression 'moral outrage' is used as a pejorative, denoting hypocrisy: this is because our society no longer thinks it believes in morality.)

I was one of the lucky ones – for some reason, I must have been on some sort of list at the time – to be sent a script of *Blasted* by the Royal Court for my considered opinion. I told whoever sent it to me that I thought it was repugnant and badly written, and immature, and should not be shown.

I am of course fully aware that the whole world has decided the opposite. I have to say I am not surprised, and it doesn't affect my judgement one bit.

The strong critical response against the play, though entirely predictable, was a natural enough reaction, and yet it seemed to strengthen the Royal Court in its resolve to back the play. They must have felt they were back in the good old days of the Lord Chamberlain. Those involved no doubt felt, rightly, a natural protectiveness towards the poor girl who had written it, and rallied round where on other occasions, in other circumstances, they might have backed off it like cowards and let it sink, as they had done before.

I understand the sadness of her friends in the theatre who in the end could not save her from the madness and despair which took her life. My criticisms are given here because the affair seems significant; at the same time I acknowledge the good intentions of those involved.

It is a failing, and a significant one, in theatre that it is searching for authenticity. It was the search for authenticity that resulted in a girl suffering from a serious psychotic condition being made into a playwright and for her plays to be produced regularly in theatres around Europe.

Only such a hunger could cause a whole culture to mistake the symptomatic writing of a psychotic for something which ought to be played and watched. It is the romantic myth of the writer, and of writing as self-expression, taken to its natural limits where, if a person can achieve authentic self-expression, no matter what it is they are expressing, the

artistic criteria, so called, are satisfied. In societies where collective values no longer inspire faith, then the archetype of the individual reigns supreme, then no-one is looking for anything other than the expression of *an* individual. And when they see it, they feel that it reminds them that they themselves exist. No matter if that individual is pathological; in the mind of that individual is seen humanity, in a sentimental sort of way. It is called beautiful because it is real, because we have no idea of beauty, other than something as vague and all-inclusive as 'realness'. It is 'real' because seems to offer a sort of shared experience, a sense of what it is to be alive; which of course it does. Any expression of any individuality does that. Because the search for authenticity as a guarantee of truthfulness beyond the actual writing – to replace other judgements, really – overrides other criteria, we can have the situation where the problem behind the writing is authentic (real), but the writing itself, because poor, is not authentic (fake), as all poor writing is fake.

In our present era we seem to ask nothing more of writing than a confirmation that we are alive, or at least that someone else is alive, even if that life is an ill one, one that cuts itself short because it is ill. That is theatre as pure spectacle, without thought and without morality. By this I am not referring to Sarah Kane's plays as immoral, I am saying the theatre that wants them, and still wants them, is immoral. This is theatre for a society that accepts human sacrifice, for a night's entertainment, for a night's 'reflection' – like looking at a car accident, for discomfort or beauty or whatever they tell themselves they need and are getting. This is a hungry, rapacious society with no end to its wastefulness and appetite for blood, and more and more of it, to remember that it is human. Bring on the next one.

Within some decades, maybe, we will accept if someone actually kills themselves on stage. We are already at that stage in television, more or less, and because theatre now apes television rather than leads in a contradictory direction, it won't be long before we have 'reality theatre'. I see the reception of Sarah Kane's plays as a step along that road.

So how is it that the same critics who once reacted so strongly against *Blasted*, are now part of the apparatus which puts it forward as great

theatre? Either they were insincere at first, or rash, in the extreme, *or* their judgement is unduly affected by events and what other people think. Do they simply alter their judgements merely because the rest of the world alters its own? Where is their moral outrage now? And where is the judgement that the writing was not good writing? If they said it in the first place then they have a duty to uphold their view, to think about it and argue it further. Why can't they resist the march of success? There is a great deal of work which should be criticised and which isn't. The reason is that the critics we have are sadly trivial and cowardly, without the moral or intellectual equipment to sustain a position against the flow. People now say the success of Sarah Kane's work makes the critics 'look pretty silly', as if criticism was a matter of guessing if something is going to be successful or not. If they found the violence shocking or disgraceful: why didn't they continue to argue that point and show *why* it was? But they don't. Still less do they attack the mass of other violence on the stage and on the screen in our society. If they did, then perhaps they could have some influence for the good, but that kind of fight, against the orthodoxy and against popular culture, is never easy. It is most important when it is most futile. It will rarely earn you any compliments. Did they see that the writing was poor? They collapsed their judgement as the writing improved. Did they see the way easy juxtapositions were used to make an impact and that the impact was multiplied by the extravagance of the evil and violence? They maybe did but they were soon to get used to that technique! Did they notice that the categories of good and evil were no different from the stock characters on the left-wing establishment list of goodies and baddies, merely exaggerated in a childish way? If they did, they lacked the independence of mind to say so or to think that was a fault. Without the violence the play could have been a piece of agitprop at the Oval in 1985.

It would be stupid to say, as some have actually said, that the violence is not the point. Or even to argue that it is merely weak writing. That might be a way of appraising it but it would be fanciful to pretend that violence doesn't have a special nature. It does. It is the only thing, apart from illness or accident or age or starvation, which can extinguish human life. It is the ultimate threat, the ultimate image too. Kane's work

is not unique, it is part of a flow of violence; it is part of the way violence is used in entertainment. It is easy to use. It is used as emphasis. It is used instead of content.

In the theatre it has another aspect: it is taken as authenticity. So, if a sensitive girl takes the most extreme violence she can think of and puts it in her play it will resonate with the very worst and most shocking events people can 1) remember from having seen or heard about and 2) imagine. It will resonate with the aspects of the world we fear most and are most in awe of. But resonance is a pretty vague thing. We could say it 'reminds us' of other things. But to resonate merely as a means of emphasis is just like saying 'very, very, very, very much' and then it is a question of what it is very, very much of. Very, very, very, very much of the same old left-wing orthodox gallery of villains is not very much at all.

But to the establishment orthodoxy it is very, very, very, very much an emphasis of their own position. So a girl comes along and writes in blood on their walls for them, 'You are very, very, very right in all that you think': the natural authenticity of violence comes in just at the right time to salvage the whole establishment vision from its bloodlessness. I mean if you haven't got any blood in your veins, the next best thing is to show some on the floor. All we need now is some art to put it back in the veins so that life can go on, and goodness and hope can thrive. The trouble with empty emphasis is that it can only be added to with more of the same. How much violence will we need to accompany the platitudes of the *Guardian* newspaper put on stage, to make them seem new and fresh and radical? Perhaps we can have a real middle-aged, middle class man eating a member of the audience to show how horrid they really, really, really are.

The effect of Sarah Kane's play was to add the ultimate romantic myth of the writer to social and political platitudes to make them seem to come from another *sort* of place; the darkness of that part of the psyche that can produce horrible images seemed to add a poetic-romantic aspect to a world view which has lost its sense of its own romanticness. The heroism of a girl at the mercy of the wickedness of a world that can put such images into her head (and happily her background can give the impression the images come from fundamental Christianity in

some way) is just what is needed to put a new rush of optimism into the hearts of the self-righteous. That is why it is so easy for people to find the somewhat predictable paradoxical epithets to describe the plays, such as 'full of hope', 'gentle, beautiful'. That's how one of the big socialist writers could call *Blasted* 'quite a tender play really' because it makes us all feel that we are very tender and that the villains are very, very nasty indeed and brutalise us out of our tenderness which we nevertheless struggle to maintain in a playwriting sort of way. No wonder theatres are keen to put the plays on. They provide a much-needed endorsement of their existing world view at a time when otherwise we might have to start looking in another direction. Now *that* really would be uncomfortable. And it wouldn't stop being uncomfortable as soon as you leave the theatre and the red paint dries.

12 VIOLENT PLAYS OF THE 1990S

DAVID IAN RABEY, REFERRING to what he calls expressionist plays in the 1990s, says that they '…frequently stage explicit and violent scenes as a deliberate challenge to artistic and social terms of control.'[1]

What is the nature of that 'challenge'? Challenge is a word often used because it is vague. What is meant by it? Is it a 'partial rejection' or is it a '*gesture*' of rejection, or is it a sort of question, or a calling into question? For the so-called 'challenger', the more open-ended the interpretation of the word the better; the less they have to think what the challenge is meant to lead to.

However, these playwrights, if Rabey is right, are 'challenging artistic and social forms of control'. What are these artistic terms (rules or means) of control? Does he mean the unwritten rules of taste and expectation that indirectly govern what you are supposed to put on the stage? The difficulty involved in challenging these is, of course, limited in an atmosphere where shock and outrage are known to be bankable positives. To shock with graphic sex and violence is, and was already by the 1990s, to conform to expectations and to conform to well-established artistic trends coming in at the very tail-end of the shock bandwagon which started rolling, if not with Byron, then with Swinburne or Wilde.

The rest of society was already flooded with violence and had been for decades. Theatre merely stepped into line. This would have been a time to reject violence, not embrace it. (Typical of theatre to think it is leading the way when it's actually merely copying.)

By the 1990s you had to virtually dismember a living human being to raise an eyebrow. By this time, theatres and audiences were in more or less agreement that sex and violence were desirable and not shocking, but were more on the level of attractive curios likely to engender inter-

1 David Ian Rabey, *English Drama Since 1940* (Longman, 2003).

est. To refer to this compact as a 'term of control' is like calling a shop window a blindfold.

Theatre in the 1940s

Nigel: I say, chaps, anyone for tennis?

Theatre in the 1960s

Nigel: I say, chaps, anyone for revolution?

Theatre in the 1990s

Nigel: I say, chaps, anyone for murder, rape, buggery and torture?

Theatre of the near future

Jade: I hate you! Kill me, torture me to death, film it, kill my pets, steal my TV, etc…

But Rabey referred to a perception also that these writers challenged *social* 'terms of control' too which, if separated from the artistic 'terms of control', must refer to rules or laws about actual (not fictional) behaviour: acts of sex and acts of violence, in public or in private. Consensual sex is not illegal except in public and there is not much interesting to be said about that limitation except that it is more or less understandable not to expect people to fuck in the streets for fear of shocking or frightening the animals or children. Which leaves us then with violence, which is limited and controlled by law as it is in every society in the history of mankind. These playwrights, if we are to understand Rabey correctly, were perceived to be challenging that control. We now have to ask again, what is the nature of the challenge? Is it to say that society, in the form of laws or morality, has no legitimate authority to limit or control the use of violence? Does the challenge say that the law is not the right institution to restrict violence, or that such a restriction is undesirable? Is the challenge to this restriction a call for more violence? I can imagine a challenge to the social 'term' of control over violence to involve a call for *less* violence, but I find it hard to imagine, still less to justify, a call for *more* violence. Sadly, though, I do not see in any plays of the period a call for *less* violence, not even for less use of violence regulated by the state (since we could call imprisonment that), and so I am not sure where that leaves us in terms of locating the exact nature of the 'challenge'.

I expect that the playwrights concerned would be likely to disclaim any 'challenge' implied or imputed to their plays, and that they might say instead that it was simply a matter of honest depiction of reality. Sarah Kane, though, did seem to say that there was metaphor in her violence. Rabey does talk of this; in fact the opening quote continues:

> [...] to seize the challenge of dramatising the non-rational, use deliberate reference to earlier theatrical forms, and subvert conventional notions of theatricality and deploy stylised language and challenging stage directions to create a visceral modern poetics of intensely visual stage performance and mise en scène [...]

– which seems to mean in this context that *modern* and *visceral* are related, and since visceral here is being used to denote 'very violent' we have a presumption that in order to conform to modern expectations violence has to be supplied. Imagery is not new or subversive, especially since in this case it conforms to the most popular current imagery which is indeed emphatic and violent. Quite where the *subversive* is in all this is hard to see. And if you step back and see how it all fitted in to what was around it, any question of a challenge to dominant orthodoxy or to social values in a very violent society is surely put out of the question.

The power of metaphor has to be more than merely the power to emphasise. Obviously violence can be used to underline what you are saying: that is its function in real life too. But the real power of metaphor is surely suggestive. It is a matter of resonance; resonance with the imagination and with the contents of the unconscious. While some of the contents of the unconscious involve violence as a metaphor for destruction, renewal and death, the violence of the plays in Britain in the 1990s was always presented as real social and physical violence. The visceral nature of it made that abundantly clear and cannot be ignored or washed away. If the writers who used it, like Kane, claimed it was archetypal then it was the archetype in the mind of someone being controlled by an archetype, which had spilled into the visceral world. The point of evoking archetypes is not to surrender yourself to their destructive power or ask others to do so. The resonance of violent metaphors in the imagination is a sorrowful achievement with dire consequences. If all this is really just a matter of inept playwrights using the atom bomb of violence for emphasis they cannot achieve any other way, then we really do have a case of children playing with fireworks. If it is not that, if these are intended to be metaphors, then we can ask why peace and leniency, and mercy and gentleness are not metaphors worth using? Is it because they lack the emphatic impact?

The comparison with expressionist drama is mistaken for the very reason of the self-consciously visceral aspect of the modern version, and its self-consciously 'challenging' aspect too. In these plays, the deliberate verisimilitude is an important part of the gesture; there is a very real relationship to the way violence is seen in our lives (depicted), to

the way it enters into our lives through television and other media. In the modern world violence has first been removed and then put back again; the levels of urbane civilisation which succeeded in removing the spectacle of violence from everyday life reached its peak just before the media reintroduced it.

The horrors of the two world wars perhaps left no appetite for violence as entertainment: in the 1920s, 1930s and 1950s the attraction of witnessing visceral renditions of slaughter, the dismal sight of human flesh being torn to pieces, was perhaps neither novel nor desirable. It took a generation who hadn't been forced to witness the real thing, for faked violence to be feasible as titillation and an acceptable outlet for latent aggression (and as a conduit for violent aggression awakened by this titillation).

The dislocation between real violence and depicted violence contributes to the way violence has been used by the media. As often with such dislocations, the result is extreme manifestations, neurotic or psychotic. This is why the comparison with expressionist drama is so inaccurate. In 1760s Germany, a militaristic society even then, violence was still close enough to everyone's experience for it to not be under a taboo and for it not to exercise any particular fascination on any normal person. It was to be avoided when possible or used when necessary. It was each man's duty (no matter what his class) to serve in the army. A similar relationship to violence pertained from 1918 to 1950 in Britain. Part of the new post-war world was the banishment of violence. This was similar to the previous idea of it being familiar but undesirable, but with some important differences. There was a sense of it being no longer a part of civilisation, a thing which ought to be banished completely: the existence of the H-bomb and the atom bomb before it, and the growth of CND in the 1950s, were manifestations of this strangely paradoxical situation.

The spectre of the most horrific form of extreme violence ever, even worse potentially than the First or Second World Wars, drove many normal people to conclude that war was no longer possible, and no longer acceptable or desirable. Meanwhile, the realities of life required that Britain and other countries continued to defend themselves. Britain

got the atom bomb under Attlee, and Labour and Conservative govern-
ments continued to maintain a large (by Britain's standards) stand-
ing army throughout the period to enable Britain to fulfil its defence
commitments and to influence world politics, to play the superpower as
a counterpoint not just to Russia but to America. (The wisdom of this is,
now at least, evident.)

I mention this because there was now a rupture between the govern-
ments' (Labour and Conservative) perception of the need for military
force and a growing body of people who, faced with the prospect of its
potential horrors, withdrew from being able to countenance it – with-
drew, as it were, from taking responsibility for the need for violence. For
indeed it is a paradoxical or contradictory situation; or one with inher-
ent contradictions. For how can we defend ourselves without violence?
How could we have defended ourselves against Hitler without the use
of massive violence? The issue split the Labour party under Gaitskell in
1958, and again under Kinnock in 1983 when it helped condemn them to
more years of opposition.

This understandable and perhaps even necessary rupture in the
Labour Party and in the country can just as easily occur in an indi-
vidual. It is a rupture between the reluctance to condone violence and
the (denied) need to use it as defence against violence. In 1983, I, for
example, was prepared to die undefended rather than to countenance
that my country should inflict such hideous murder upon the Russian
people. Much as I feared the moment when the siren would go and we
would wait fifteen minutes for destruction, I feared almost as much the
moment of evil, seeing the sky filled with our own missiles on the way to
hit the enemy; that is what made me a unilateralist. The denial aspect of
it was not one which anyone at the controls, with responsibility for the
security of 59 million people, could easily afford.

At any rate, the psychological part is that the extreme horror of the
violence at stake had the effect, if you like, of confronting us with the
real nature of violence – for, of course, in reality the trenches were not
a lot better than Hiroshima. The fact that we allowed millions of men
to die that way shows how salutary the image of nuclear death was, in a
sense, to bring a degree of clarity. In fact, the British fight against Hitler

was just and unavoidable, and had the effect of a reminder that defence against violence using violence was sometimes necessary and unavoidable – it is a good argument for the continued need for war.

The bomb, then, meant that people began to believe that military violence was not a part of civilisation, whereas at the time of *Sturm und Drang* it most certainly was. When military violence is a part of civilisation then violence remains an integrated and regulated part of society. This doesn't mean that the societies are built on violence (which would be the typical modern academic thing to say about it); it means that they acknowledge its necessity and are aware of its nature, and importantly, the need for its regulation. Violence in such circumstances cannot really ever be a game, for it is always real. Such societies can be less or more violent than one another, of course, and violence can be less or more successfully banished from everyday life. (In Germany in the mid-eighteenth century I imagine it was less perfectly banished than in Britain in the 1930s, but that's a guess.)

But in societies where the necessity of military violence to protect civilisation has been questioned, and where there is a notion in people's minds of a society without violence, conditions are different, more polarised because of the nature of the presumptions which can form the idea of non-violence. For one of the ways to uphold a belief in non-violence is to claim that it is not necessary.

To embrace complete non-violence honestly you have to be prepared to be killed; for indeed it is fanciful to imagine that the aggressor, faced with your own non-violence, will embrace it (or you) too. Jesus didn't mean that if you turned the other cheek they wouldn't hit you. He didn't mean they would be stunned and shamed to compunction. It's not a game. They crucified him and he knew they would. Buddhists, insofar as they embrace non-violence (which is not always), know they will be beaten by their oppressors, and indeed they are. If Gandhi had been up against the Germans and not the British, he would simply have been killed. (And no doubt he would have knowingly gone bravely to his death.) If an intruder comes into your home and tries to kill your family, you can either let him do it or try to kill him before he does it. Reality definitely includes people who are cruel and wicked and who

would use violence to fulfil their wickedness. Complete non-violence must either accept that death at their hands is a possible consequence or it must pretend it is not the case. And of course we all have the right, in life as in politics, to decide when we do and when we do not condone personal or state violence in protection of our lives, and to decide upon the degree of violence. CND decided that the degree of violence planned made defence not worth it: such was its awfulness, it was better to die undefended, if the circumstances so warranted it.

But it is the kind of thinking which pretends that such is not the case, to which I want to turn our attention; because it is that form of thinking which is neither idealistic nor brave nor honest. It is merely ignorant and dishonest and childish, especially when it seems to form a political outlook. It is dishonest because it usually leaves the real decisions, the real and unpleasant choices, up to someone else. It allows a compartmentalisation, which puts all wickedness into the box occupied by people who are in positions of responsibility and who are forced to or prepared to take their responsibilities, while on the other hand it promotes a picture of human nature which is patently untrue: a view which is not so much naïve as it is actually perverse.

For the view that pretends that the only violence in the world, or its origin, is state/military violence, and which pretends that violence is not a part of human nature which needs very strict regulation, will make some very important errors, the kind of errors which lead, which have led, to very serious consequences in society.

Please note, I am not arguing that violence is inevitable in society, I am arguing the opposite, but that it doesn't go away by pretending either it's not there or that there is nothing wrong with it.

So in a society where certain people could indulge a view which failed to acknowledge the necessary use of violence to resist violence and to uphold civilisation, it was also possible to lose sight of the absolutely vital need to repress and regulate violence. (This also happened to coincide with a period when repression was considered to be a bad thing *per se*, and perhaps due to the influence of Marcuse or at least ideas like his, which sought to depict all repression as a sort of capitalist ruse to keep people at the wheel.) Violence became dislocated from its place in

the picture of reality, became something which could be used as a toy, a pawn in the social politics of the period, to the point where it could be seen as something which could be 'democratised', as something which you could claim everyone had a right to. This gives us a situation where it would be commonplace to claim that writers 'stage explicit and violent scenes as a deliberate challenge to artistic and social terms of control', and for this sort of view of it to be accepted without question by audiences, critics and students of drama.

We are talking about a period where violence is perceived as gesture, ie something without consequence (the very opposite of its true nature), and at the beginning of this period of course that was *nearly* true – the low levels of violence in our society gave the false impression, to those handed the new toy of permissiveness in entertainment, that violence was not a risk, that it could be played with, that it didn't have consequences. This effect is increased if we consider that always the people in control of communications, ie entertainment, are middle class and therefore one step further removed from the reality of violence. This is something they can maintain even while levels of actual violence are completely altered from low to high.

And so we had a situation where violence was able to be used, in entertainment, as a means of selling, a means of achieving credibility and giving an impression of realism. This is the period, and we are still in it (at its other end), where the familiar pattern is a gradual increase in the levels of violence depicted, to the extent that we all think of that process as something inevitable, like the weather; as if the course of history and 'progress' (as it is seen) inexorably includes this increase in depicted violence. It was also, at its beginning, a period where playwrights could make a spectacle out of their personal meditations on whether or not they dare to advocate violence to get their way in politics; where the privileged classes could play games where they pose as violent revolutionaries and see this as a confirmation of their credentials. This would be pathetic if it weren't so despicable. It was all a part of the period where violence was a harmless game, so harmless in fact that it was even safe enough for the left-wing public schoolboys and girls to play with.

Meanwhile, slowly, the effects of this were being felt in society, the effects of relaxing the control of violence. The indulgence of and glorification of youth gang culture in films and other media and the eagerness of the new left-wing establishment to associate itself with 'rebellion' or 'youth' or merely with any sort of aggression, set the course for social developments during our whole era. They were willing to associate themselves with any form of violence, except the state violence necessary to uphold the civilisation which gave them the social ease which made their positions possible.

It was at this time that the left found it impossible to countenance the violence traditionally used by beat policemen to keep order at the level of the street (the level where that order was most beneficial to the whole population, popular or not). To those for whom violence was a game, it was a game they preferred, for 'political' reasons, to be in the hands of youth and criminals rather than the police, and they saw to it that the balance of power was shifted from the beat police (who were abolished by Labour, 1966/67) to the casual criminal and thug.[1] This was because, when violence is a game with no personal consequences, it is possible to indulge one's sense of vanity before engaging common sense; therefore it became and remains extremely unfashionable to have any regard whatsoever for authority. This meant that the beat police constable who unarmed kept order amongst the drunks and the thugs with his fists was now painted as a brute and consigned to the dustbin, while the knife-wielding thug who preyed, in packs, on anyone weaker than himself became the rebel hero. This monumentally stupid attitude, this self-indulgent puerile nonsense which passed as political radicalism, has given us the nasty mess we have today where even children are not safe from the rampaging violence of the streets; where the old, the weak, anyone with an unusual appearance, the destitute, the middle-aged, the young and strong, the good, the bad and the ugly, are prime targets for casual murder, rape and torture. And no, I will not tire of repeating it in this book. Are you tired of reading it?

This was already the context in the mid-1990s where the violent

1 See also the Tory Police and Criminal Evidence Act 1984.

crime rate was the highest it has ever been, and where the nature of the violence too was particularly cruel and deliberate and often designed to inflict as much pain as possible. This was the context where playwrights 'challenged the terms of social control'. The only social control conspicuous in the field of violence was the lack of social control. That lack indeed would have been a fitting target for playwrights, but this was beyond the scope of their thought, boxed in as they were in the little world where authority and control and repression is bad and freedom to destroy oneself and others is still being regarded as good, a positive, a sign of life, a manifestation of the irrepressible human spirit.

Subsequent to the surge of depicted violence on stage in the mid-1990s, which gets all the attention, was its absorption into the norm in theatre, where extreme violence or the mention of it, passes into the grammar of playwriting, so that new playwrights try to emulate their immediate successful predecessors. It is now commonplace, it has now passed into use as the laziest, lamest means of either emphasis or pretence at authenticity. I cannot count how many plays I have read where a character, usually a young one, routinely commits or describes hideous violence, torture and mutilation – all else can be lacking from the play, it can lack any intelligence behind it at all, but that violence will be there, like a cliché on job application forms. Weak writing now uses violence.

So, what about the argument that in order to describe a violent society you have to show violence? What's the merit in describing it? What is needed is far more than that. The play's attitude to violence has to be different from the society which has created it and which condones it. If it is not different then the play is merely a part of the same process. And by different I don't just mean more protected, cossetted and middle class. I don't just mean if violence is presented in an artistic way, or as art as in Sarah Kane. It is not sufficient for violence to supply a fulfilling 'theatre moment' of shock – reflection – and some kind of lame 'synthesis'. No. By different I mean that the writer and the play must be analytical and explicitly so, and violence has to be problematic. The play has to examine and question and comment upon the very means by which

violence has come to be there, and by which it is kept there, and what it is being used for. We hardly need to see it; haven't we seen enough?

During this era where violence has been separated from its consequences and from its legitimacy by naïve and hypocritical thinking, the nature of violence has changed – it has grown increasingly sadistic. Playwrights and filmmakers have picked up on this with relish, and learnt that the best way to depict violence is not the kind that occurs from a rage, but one which is carried out casually – for fun. This is a development in society too – they feed off each other; there are plenty of self-professed 'copycat' killers who learned 'how cool it would be to do that to someone for real' from a film. The middle classes always deny this phenomenon exists.

Casual killing 'for fun' is a development which has outstripped the law's ability to describe it. The law has not yet been adjusted to encompass the new trend of casual murder. Our law still is framed to deal only with an age where the most meaningful distinction was between premeditated murder and unpremeditated – this was to take into account the influence of the passions, including anger, which might lead to killing. There have, therefore, been several trials of casual killers who have merely killed for fun, on a whim, who have escaped the worse charges or sentences, because their crimes were *not planned*. This has meant that someone who has stabbed someone four times in the heart, legs and guts can claim to have not had the intent to actually kill; where it would be better described as 'simply didn't care one way or the other whether he killed or not'. Life, in other words, has become so cheap that the laws which have governed murder for hundreds of years no longer match the moral depravity of the population. The psychology of the average murdering brute on our streets was simply not conceivable to lawmakers of the past, and our present variety of legislators have not yet caught up, having their heads planted firmly where there is no light or logic or recognition, no willingness to recognise the extent of their monstrous creations.

Using someone's head as a football, or a group of young men murdering a defenceless girl in a park, is not enough to earn a life sentence. Neither is murder by making your victim drink petrol (there is hardly

any end to the list of horrors that could be made here) and other forms of torture which previously would have seen the prison doors close on the wretch forever. Life is cheap, suffering is cheap, torture is excusable and negligible, nothing of that sort weighs very heavy in the scales of justice because we have significantly lowered the price at which we set life. This, in a society where those who hate violence most actively and vocally limit their objection to it to when it is in the hands of the military or the police, where it is under control (which distinction they would of course laugh at). But they don't see that the cheapening of life in our own society directly affects the military. Soldiers are men and they are a product of our society like the rest, their conduct in battle will be partly determined by their upbringing, while mitigated by the military law. If this seems obscure, ask yourself which group of soldiers you would prefer to meet as a civilian of a hostile nation – Tommies from the 1930s or squaddies from contemporary Britain? I know which I would fear most; and it has nothing to do with the military. We have created a society by a number of means, where sadistic torture and casual killing is the norm, not to a special criminal class, but to anyone. Many horrible murders occur as a result of chance encounters where there has been no hostility before; a chance encounter with someone of no previous record of violence or mental illness, or of any other sort of criminal behaviour, can result in an episode of extended casual violence and torture from which you will meet your eventual death.

The sadistic enjoyment of violence is now a regular ingredient in the emotionless killings which occur weekly. And this is also how violence appears on our stages. And the reason is not that it is depicting reality; the reason is that violence exerts the same fascination to the writer as it does to the murderer. The fascination is related to the complete freedom from constraint. The moment to fear, in real life, is when the casual burglar or assailant in a park overpowers you and then realises 'I can do what I like now'. Then you are really in for it. Torture and murder. For no reason, just the thrill and 'enjoyment'. The lack of restraint is not about the law or police or other interventions, it's about the absence of restraint inside – no moral feelings, no compunction. That really does exert a fascination, and, I imagine, is somewhat provoking to a certain

kind of mind. Perhaps rightly, the weak-minded individual feels a kind of resentment of the total freedom he may enjoy from moral restraints, freedom to do anything. Their victim becomes a piece of meaningless meat to them – precisely because society, including parents, has said that it is so, has not convinced them of the reality of the 'other', nor of the reality of their own duty to be moral beings.

Films, television and theatre 'enjoy' the same freedom to toy with violence, and to explore it, which is, of course, a form of sadism, or worse, *indifference* to the meaning of violence, indifference to pain and suffering. Violence removed from the serious consequences of it leads to dislocation from any need for moral restraint, and that is where we have ended up. We have had decades of playwrights using violence as a free ride to success.

Violence needs to be a focus of criticism in plays which seek to change the nature of our society for the majority of people. We do not need to see more violence: we need it to be resisted.

13 BANISHING COMMON SENSE

Why common sense is banished from politics and education

IN THE SPHERE OF politics and opinion, as well as in education and higher education, anyone invoking common sense, using it, or asking for it, risks being suspected of being either stupid or right-wing or both. Funnily enough 'common sense' is often the way a working class person would characterise their thinking; by strange coincidence the middle class left tend to think of the working classes as either stupid or right-wing or both.

What does it signify when it becomes subversive to demand common sense?

By its very nature common sense cannot be properly defined and doesn't of course lend itself easily to academic/intellectual 'analysis'.

But common sense isn't the only concept to defy definition. The Taoist 'way' retreats as you advance towards it and resists being expressed in terms hostile or inimical to its meaning. The deconstructionist theories of Derrida, too, for example, also elude proper definition except in their own terms. As far as we know, these theories seem to claim there is no special connection between the author's intention, and the meaning of a text (except Derrida's own). Derrida's impenetrable language *deliberately* makes comprehension extremely difficult, hiding as it does the simple platitudes that lie buried within, while making endless speculation as to their meaning inevitable. (Students can test this by asking their teacher to paraphrase a page of Derrida. He, or she, will wriggle out of it.) Common sense is often used as an argument against the incomprehensible Derrida, and dismissed by academics defending Derrida who say that 'common sense' 'seems to mean whatever the user of the word wants it to mean, and cannot be defined' – which, amusingly, is exactly the same with Derrida. And yet Derrida is not only studied in universi-

ties, but his ideas and their derivatives form much of the basis for the academic approach to a text. And common sense is not admitted. What distinguishes common sense from other ideas which elude definition by being complicated, is that though it cannot easily be defined, it can easily be understood. It in fact requires no definition to be understood. Common sense only needs to be defined *after* it has been understood, if at all. Derrida, for example, cannot be used *before* it has been defined because there would be nothing there to use.

Common sense: it is the last thing the middle classes will be able to steal from the working classes. It's what the middle classes need to destroy, in order to finally defeat the working classes. Common sense is one thing that can make simple kindness preferable to doctrinaire cruelty.

Common sense, in the context of deconstruction, is that which insists on the difference between one thing and another, even though the philosopher has 'proved' that such difference is an illusion. The difference between evil done and evil not done, the difference between good and bad, right and wrong, life and death: these will be the final battlegrounds between the theory which seeks to pretend that difference between one thing and another is subjective to the point of non-existence, and those who will have to fight for the duty to resist what is harmful.

At present to a large extent, the theories of deconstruction, and its offshoots, dominate universities.

The government's policy of enabling as many people as possible to go into further education has resulted in 43 per cent of the population going to university. You will be familiar with the argument which questions the value of the education they receive once they get there. The standards of education at all levels have been very significantly lowered to enable the government to achieve the statistics it wanted. This has seemed like cheating because the achievement of having 40 per cent of the population going to university is not the same if the universities are often largely polytechnics re-named; even less so if the education at the former polytechnics is not even what it once was.

This also applies of course to A and O levels (GCSEs) It is pretty widely known that in all these exams governments have been simply cheating to get better results. It was recently revealed by a question in Parliament that even over the last 10 years the percentage needed for a pass in SATS, for example, has been lowered by five per cent. This helps only the government to get better results. Some SATS are not even intended to be for pupils.

Apart from the government cheating at exams, which is the case at school level, the Higher Education level results do involve the other aspect of lowering standards, simply in order to make further education more *accessible.* So there is an intention of inclusiveness which is defensible, if not particularly wise in the long run. Standards are lowered so that more people can benefit from it, while there is a consequent loss of highly trained workers. (This last, of course, has consequences for the economy and the well-being of the country in general.)

But while it is true that standards in education at all levels have been lowered for both of the reasons just mentioned, that doesn't mean that the nature of the educational ideology is any less middle class than it was. On the contrary.

Educational theory has changed dramatically even since the 1980s both in schools and in universities. It has been changed as middle class ideology has changed. The result is a kind of education which, curiously, is more exclusively middle class in its ethos than ever before. Along with being dumbed down, it is an education which is more ideological and more highly intellectualised than ever before; it is only accessible to those willing to adopt the rules of thought, and the jargon which the theories have produced to replace knowledge. Or to put it in the almost invisible jargon of government teacher training speak; 'for most teachers, attending to subject knowledge content is not going to have a big outcome for pupils'.[1] The techniques are highly specialised and quite literally exclusive: they are exclusive of one thing and one thing in particular – common sense.

1 Dylan Williams, Institute of Education, *Assessment for Learning.*

'Tony Blair's Schooldaze'

Chapter One: In which Tony gets the idea for his education policy

Common sense in the academic world is anathema. It is considered laughable. It is a standpoint which will earn the contempt of your teacher.

It is the attitude which does not belong; so that while the path of the working classes into higher education has been to some degree made easier, once they get there the education they receive, as well as being below standard compared to what went before, is now one which requires the student to adopt an exclusively middle class ideology and to leave their common sense at the door; the common sense which is all our birthrights, the common sense which is the very meeting ground of the greatest poets and thinkers and the common man.

It is the enemy of the bureaucrat because if it were powerful it would make bureaucracy unnecessary and impossible. It is the enemy of ideologies for the same reason.

Now the new constituency of students must submit entirely to the control of the middle class teacher, and jargon is the means by which he subjugates them. He sets himself above the text and above the student and above common sense itself. That way the working class student must cease to be working class. In the past, it was similar; through contact

with the bourgeois world of literature and academia, the working class man was made, inadvertently or otherwise, middle class, in a number of different ways. Now the *aim* is different. Now it is most definitely inadvertent, because the purpose is not to make him middle class: the purpose is now the more radical one – to make him submit to a specific ideology, which is based on a denial of reason, and the theory of the impossibility of truth: deconstruction.

All this is connected to the banishment of common sense in the political sphere; the working class view which expresses itself in common sense has been all but outlawed by its own party. And now we see how it has also been outlawed from education at all levels. The academic practices which outlaw it at 'university' level, also outlaw it as school level. This is also where it meets politics. Any child expecting to be taught with maps to know where countries are, to learn to do simple sums, to learn language and grammar, to learn history by being given information and access to books and knowledge will not just be disappointed but will be treated as a freak and will be told: 'That is *old* geography, maths, etc.' Indeed, 'old geography' and 'old maths' have been identified by the Marxists and Maoists as middle class and therefore banished; this is the analysis which has reformed education. The solution to this broadly believed and yet far-fetched exaggeration of the definition of the term 'middle class' (whereby the whole of western civilisation's accrued knowledge is bourgeois and therefore false) has been to replace conventional knowledge with *pure* ideology and jargon, which is almost *completely* useless except as a tool to enforce the new middle class ideology. It is as if slightly contaminated food has been replaced with pure poison.

Schools, like universities, are still completely dominated by the ideology of the middle class elite which itself has become esoteric in nature, not to say perverse. The gulf between the working class and the middle class in schools is wider than ever. In the 1960s the left decided it was the middle class culture upon which education was built which caused the gulf; now it is the deconstruction of that culture, and the concealment of that culture and the shutting out of the working classes from the posses-

sion of it, which creates that gulf. It is in fact the battleground where the future of the country may well be decided.

The working classes who now enter higher education are immediately subject to indoctrination and jargonisation for which they have been amply prepared by their schools. The deconstruction of knowable knowledge begins: they will be left not only none-the-wiser for the 'education', they will be stripped of the last vestiges of common sense and left disinclined to use it. All of which suits the middle class masters very well. For it is not education they are there to receive, but re-education in the sense of brain-washing; indoctrination into the blend of Maoism and deconstructionism which forms middle class educational/academic theory.

The battleground is right there. Why is it a battleground? Because when the working class realises that once they are admitted to further education they have a right to determine the education they get there, then middle class ideology will be under attack. Of course, it *looks* as if that is indeed what has happened already. Because standards have been deliberately lowered it *looks* as if the presence of the working classes has lowered them.

But that is not what has actually happened. It was the middle class's own ethos which had changed; It is the middle class who introduced deconstructionism, it was the middle class that decided that standards should be lowered. It was the middle class that decided – just coincidentally at the moment when the working classes were already gaining greater access to knowledge – that there is no such thing as knowledge, that there is nothing to know, nothing to learn, no maps worth looking at, no books worth reading (except the dumbed-down kind), no way of studying literature at university except with the guiding hand of the deconstructionist, the teacher who will help them pick through the ruins of culture and identify all the pieces according to whatever the ideology wants to call it.

Access to culture and knowledge is snatched away at the instant of attainment: as if by magic, the wilful destruction of the very notion of education itself (except in the private or very best schools and universities). The whole thing is once again the preserve of the elite. There's

no point getting to 'university' any more because they won't teach you anything. It's harder than ever before for a working class child to get the same education as the elite because they have all but abolished that education, and unless you get to Oxford or Cambridge you can more or less forget it. (Even there it's not what it was, and will soon disappear.) It seems they would rather burn the city down than let the mob get their hands on it.

Educashun fo da Nation

Miss Prism: Oww, bless! Education has just been abolished, you missed it!

So while they attribute this dumbing-down to the working classes, they seek to rob that class of the very means of independent thought – common sense. All through school they claim to be no longer teaching knowledge but teaching people how to *attain* knowledge. In fact in practice, as any parent should know, what this actually means is that they teach nothing during lessons, and homework is to look it all up on the internet, which means 'cut & paste'. All through school they *claim* to be teaching children *not to know anything* but to think for themselves – the truth is the opposite. How can you think even the simplest thought, except those of bewilderment, when you don't know anything? Modern

working class children often lack the grammar of thought required even to form a sentence. Denied access to any knowledge, except the *passive* interactive whiteboard (ie the computer/internet) and trained already to mistrust their own language of thought and to replace it with a randomly invented jargon of phrases with no known origin or meaning, the working classes are then left unable to think independently. Children at school are brow-beaten into using just these selected phrases of jargon: applying them *is* the exercise itself. So at the very moment when a thought might occur, the phrase or jargon will come to replace it. Children are taught the mental habit of uttering meaningless phrases they do not understand at the very moment when independent thinking is required. Independent thinking can only happen when that part of the human condition is engaged which expresses itself as common sense – if that is not engaged all you will get is indeed a regurgitation of phrases, in this case government-sponsored ones. The danger to the country is enormous, and our eventual enslavement to any nations who preserve real knowledge and real education and training in their unreconstucted education systems. – but the danger to the working classes in particular, right now (which is the subject of this chapter), is plain to see.

Resistance to it, on the other hand, opens a door to the possibility of real rebellion – to the reassertion of rights, as a class, to determine their own environment, to control and shape the destiny of their country. For while the middle classes may have decided it is fitting to destroy culture and knowledge, the fact is that it is not theirs to destroy. The middle classes have presumed that culture and knowledge are of no use, of no interest and do not belong to the common man. And in that they are very wrong. They have chosen for their own ideological purposes to destroy it and to destroy all access to it, but it is not theirs to destroy. To them, the very idea of a working man or woman enjoying and possessing literature or history using an understanding rooted in common sense, is laughable – not just unlikely, but worthless, shallow, stupid. In other words they don't like his dependence on the text, or his *independence* from the teacher. But the common sense understanding so despised by the educational professionals just happens to be the one shared by the

originators of the texts, the writers, the historians and artists, and it is the basis of all shared humanity – the enemy of ideology.

The day the working classes in all the universities demand access to knowledge and literature first hand and demand the right to retain their common sense, then we will see a class revolution which, instead of ruining the country as the middle class revolution has done, will be on the way to restoring it.

It is tantalising to imagine the disruption that an insistence on plain common sense could cause to tutorials around the country; the teachers would respond by saying it is meaningless, they would say it's all right as far as it goes, as a starting point but – they would then throw it out, or not. If not, or if you persevered, the whole modern academic structure would start to crumble. The far-fetched non-sense occupying reams of cyberspace would quickly start to look arcane – then it would start affecting politics… The day might soon follow when the working classes insisted on the right to express themselves in politics in the same way.

An academic anecdote to be interpreted *ad lib*

A friend of mine teaches at a leading university. When I told him I was reading *Dracula* by Bram Stoker, he said glibly, 'Oh yes, I teach that as late nineteenth-century anxiety over the end of empire and racial mixing.'

I replied that this was 'a load of bollocks', and ventured to remind him that it was about vampires. He insisted it wasn't. (He admitted later to having a rather bad evening, being tired from a long term.) I insisted it was about vampires. Such was his insistence that I withdrew in the interests of temporary decorum to playing the long game, saying that it *'might'* be about vampires, which he finally conceded could be one of the many readings of the 'text'. I said that most people who read the *book* would think it was about vampires and added that it was very likely the author's intention at any rate to write a book about vampires (to write a scary book to earn some money). He retorted that the author's conscious intention was irrelevant.

I said I felt sure that, being an Irishman, his anxiety, about the end (sic) of the British Empire was likely to be somewhat limited, especially since it was at its height in the 1890s in any case.

He said that what we were enacting was the old argument between authors and academics.

I said we were enacting the old argument between bullshit and common sense.

He said you would no more claim a common sense reading than you could 'guess' at the author's intention, and I said any 'reading' of a book is indeed a meeting point of the author's ability to write the book and the reader's ability to read it. A remark which my friend announced was 'meaningless'. On which point I promptly demurred to his experience in remarks of that nature and contented myself with asking if the academic method would at least allow *the possibility of* what I was calling the common sense reading being the closest at least to the author's *conscious* intentions, or to concede the theoretical possibility of *one* reading being more appropriate than the others; and he said that of course no such thing could ever be conceded. At which point being an honest fellow and no fool, my friend blushed deeply and offered his apologies. 'I don't normally contradict myself in such an absurd manner,' he said, and we adjourned for pie and milk. He punctuated the meal with further apologies for being so absurd as to insist upon his original reading as being *the* right one and reassured me that he usually strove to remind students of the variety of possible interpretations by making them read, in parallel to his own, an interpretation of the novel as Repressed Homosexuality Angst, to keep their minds open. I didn't have the heart to say that giving further injections of poppycock, in order to neutralise not only his own perverse reading but also the possibility or likelihood of anything like a common sense view, only made matters worse.

Later, I thought I would write, for a joke, an essay assessing the direct opposite of his End of Empire Angst idea, and show (from my extremely scant knowledge of Stoker) that *Dracula* was an Irish Nationalist tract about British exploitation of Ireland and the way to defeat it. I had satisfied myself with a whole load of neatly fabricated parallels to my idea, in the novel; names and places all slightly altered fitted a neat anti-British

metaphor filling a couple of pages of notes. I then looked up something about it on the internet and found that not only did my friend's theory exist there, fully documented and argued, but so did *mine!* My made-up one, my completely-dreamt-up-out-of-thin-air! argument was there in black and white as a serious counterbalance to the End of Empire Angst idea.

As luck would have it, for the two sides, and in the interests of academic postulation of empty fraudulent rubbish, Stoker had mixed parentage – Catholic Irish mother and English or Anglo-Irish father, I can't remember which (similar to mine, in fact) – which according to them fuelled the two conflicting views. And guess what; the conflict (real or imagined) between the two (imagined) 'views' of his parents were so polarised that it apparently resulted in such 'anxiety' (a favourite word of academics for their projections) surrounding gender identification, that Stoker was very likely not just a repressed homosexual but also a latent transsexual, the evidence of which can be found in the text (if you twist it a bit).

If that is true then anyone with parents of differing race or opinions is likely to be 'gender-confused' as a result. That explains a lot.

I set my pen aside: to entertain my friend with a parody, that would exceed reality enough to look like a parody, would require more extravagance of imagination than even my confused Anglo-Irish psyche could generate.

14 THE ORGAN GRINDERS AND THEIR MONKEYS

IT'S HARD TO SAY how many playwrights there are. There are at least one hundred whose names would be recognisable; there are hundreds on the Doollee website[1] of modern British playwrights with two or more professional productions.

A playwright earns about £6,000 for a play in a medium-sized theatre, or between £6,000 to £10,000 for the Royal Court Downstairs and the National Theatre. (Of course a play on at the Olivier or the West End can earn a lot more.)

For a playwright to earn the National average wage (£22,000) he would need to have about four plays performed per year, or two plays per year performed plus another £10,000 in other money, say from teaching or being a writer-in-residence or from reading scripts for theatres.

There are about 65 producing theatres in Britain, producing a total of roughly 240 plays per year between them. Of these only a small proportion are new plays. This means only a proportion of all playwrights can have even one play on per year.

Only a small number of playwrights who start off having plays produced write more than a handful of plays in their whole careers. This very obviously adds up to there being a lot of playwrights who get first or second or even third plays on, and are then dropped.

It is in this context that we should see the theatres' support for 'Young Playwrights' schemes and their various programmes are encouraging, or even, in one writers' group leader's words, 'forcing people to write plays'. Theatres, it seems, have an insatiable hunger for new writers, which they prosecute with an evangelical fervour, seeking them out, probing into unchartered corners to find the hidden talents which can be forged with

1 www.doollee.com

the help of the theatres themselves, the directors and writers on their staff, into real live playwrights.

This matches the thirst for 'authenticity' with the need to control playwrights. Young people taken as seedlings and nurtured into growth are of course pretty certain to absorb the rules and presumptions which govern plays and playwriting in the theatre world.

Playwrights who have been sought out and 'helped' in this way are sometimes the ones most likely to be unable to sustain a writing career, as it becomes clear that mere submission to the will of their masters and box-ticking in their writing doesn't go further than a few plays, by which time the masters are out looking for more fresh young blood. (Academics will notice that my views on theatres are actually the result of Vampire Anxiety, due to my mixed parentage.)

When the certitudes and platitudes and over-confidence of the young person give way to the doubts, confusions and ambiguities, not to say moderation and modulation of thought that comes with adulthood (sometimes) – that is the time the young playwright ceases to be of interest to the theatres – and that is the time the playwright might actually produce something worthwhile.

This would never do because it would be less 'sexy', it might be less marketable, it might lose the 'authentic' stamp of youth, and this is what theatres want from their playwrights, not maturity. They want, in fact, to find the voice of the present, the voice of disaffection (which is seen to reside in youth alone). They want to find the answer – not to any specific question, since they often lack even the intelligence to have thought what the question might be. The question might not be about life itself, it might not even be about society or any aspect of that society, it might not be about people, it might simply be about how to sell something to the audience. It might be a question about how the theatre can manifest itself as an authentic part of the commodity market of culture or counter-culture. It might just be a question of how the middle-aged, middle class managers and directors can manifest themselves as something other than what they are. Sex-by-association, we could call it – the sense of fulfilment and satisfaction a person of the manager class needs to get if he is to avoid feeling circumscribed by his or her position in an

unequal society, and where they can satisfy their greed for self-identification which so characterises their class.

This involves denying having had their privileges and a denial of the responsibility that ought to have come with it. It involves refusing to act their age, and clinging to an essentially infantile and irresponsible posture.

They need to feed on young fresh blood for this. They need to gorge themselves with youth and inexperience and even childishness in order to stay young themselves, in order to feel free. Like wealthy Californians seeking to lengthen their lives and their wealth perhaps to eternity, these seek to extend their social existence beyond the natural borders of their class and age and actual position. For it is a situation they cannot abide, they cannot admit; they would rather the world turn upside down and let blood run down the streets to avoid it. Life, success, the present, the future, they want it all. Roll up to the young playwrights group.

Once they've had their first two or three plays on, most playwrights spend the rest of their lives begging bowl in hand, supplicants at the gates of the theatres, cajoling, begging, hoping, despairing, having nervous breakdowns, dying or fading away, while the theatres go in search of new 'voices'.

Let's be clear – this is not about one generation getting thrown on the scrap heap while the one below it gets to have a great time: this is successive streams of people being used in the same way by theatres.

They take a couple of plays from you then spit you out and go and get another one. It of course reflects the power gap between writers and artistic directors. Writers are to be used exactly in the way that suits the career needs of the directors – not the way which best serves the public, not the way that would get the most out of a writer. It's an unnatural situation where one set of people are given the task to 'look for' another group and to choose them, and keep on choosing them, to declare when they are interesting and not interesting. Worse than this, the choosing group get to 'decide' what criteria makes for 'interesting' or not.

Many aspects of this reflect the interests of directors, even the very weakness of the writer's output itself. This may seem absurd when they seem so keen to find the right voice, the next big star, but it is revealing

to look at the kind of voices allowed to speak and the function this has in keeping directors where they are, in control.

Firstly let's get one idea out of the way – the notion put about by directors that writers couldn't possibly run theatres. The reasons given are these: they have the wrong sort of psychology (as if they all have the same sort of psychology); they aren't interested in the details of administration and the daily working of a theatre and lack the patience (ditto – some do, some don't, just like directors); they are too consumed by personal rivalries with other writers, to be able to run a theatre (as if directors aren't also consumed by personal rivalries amongst themselves). The writer David Lan successfully runs the Young Vic, and that theatre is as open to other writers as other theatres, if not more so. In fact, the idea of writers resenting one another resemble other arguments (such as the colonialist one) showing why a subjugated group must remain so.

In fact, as far as I have noticed there is solidarity amongst writers. Of course, this doesn't mean that certain writers in positions of influence, where they are attached to theatres and share decisions over other writer's plays, don't sometimes abuse their position to suppress rivals. I *know* it happens, but it isn't the norm and it isn't any more common than amongst directors. Any system built on lackeydom will produce lackeys.

Alan Ayckbourn has his own theatre: all he has to do is to write a play and hey presto it's on. He doesn't have to submit it to directors looking for the Zeitgeist. He only has to satisfy the public. What a coincidence that he is one of the most prolific and successful of playwrights. He certainly produces many excellent plays and has a fully achieved voice of his own, writing with great precision.

Sadly we cannot each have our own theatre. But I am glad Alan Ayckbourn has his. There are too many playwrights even for each to have one production per year; many playwrights do not get enough to sustain a career on any level. To some the cost of that is high – personally, psychologically, financially – but to all it means a waste of ability. Sometimes the best way of being true to one's job as a playwright is to stop writing altogether, and that is what several have done. That way any

further denigration and compromise is prevented, integrity and dignity are upheld – but it is a dreadful, fatal stalemate.

For all the talk of nurturing and looking for new voices, and God knows what, for some playwrights –and not the least original or talented of their generation – the truth is a very real opposite. I would even venture to say that Britain is unique in the way it resents and seeks to destroy its talent, especially the most individual ones. In a culture where we talk endlessly of quirkiness, eccentricity, individuality, originality, etc, it looks very much like a system where utter conformity is the only way. Where the real lone voices are very literally and concretely frozen out, starved out, silenced. If you have someone to speak up for you, all well and good; if not, then you are led into an unseemly and fruitless struggle.

'Nurture' in this context, simply means getting the playwright to do what he is told – and if he will do it then he will be allowed to slip through the net that keeps the others out. 'Nurture' means there is a body of directors and managers who have an idea what they would like, and they are willing to help the playwright to get there. And the writers that can learn the rules, the writers that will uphold them and even go about teaching them, spreading the gospel – they will succeed. There is a whole network of groups, classes and courses propagating the whole sorry business of playwriting. There is no denying Britain has a thriving industry of playwriting second to none in the world – we have more 'playwrights' than anywhere else – but in many ways it is an abject collusion between the downtrodden and their masters. (The best that could happen to playwriting in this county is that 90 per cent of them become directors' assistants. Then see how the director class deals with the glut.) It is a nasty system of collaboration, and of manipulation of the second-rate by the third-rate.

Theatres have ensured that there is an unlimited oversupply of writers – it's just how employers always like their workers, in an over-abundance. This has added to their power and enabled them to subjugate the writer entirely. Nothing would horrify theatres more than having to accept the plays that a more limited pool of writers choose to write. They would feel positively insulted to accept such a passive position – the

arduous process of sifting though mountains of scripts is actually quite cheap, it bypasses playwrights, it keeps power where it belongs, in the hands of the theatre managers – the dominion of the masters with their office girls and boys – the bureaucrats who are the administrators of the *ancienne régime*'s aristocracy. A pointless and meaningless self-serving aristocracy that absorbs a vast amount of public money and could just as well be all swept away.

This rule of administrators has erected for itself, as in many other spheres, a whole language and 'culture' which supports its existence and makes itself seem essential and central, when in fact it is disposable and peripheral to the real business of theatre. Go to the website of any regional theatre and try to read their statements and reports, and you will feel instantly convinced by the sheer scale of the organisation and the money involved. It is most impressive, most intimidating; it makes me feel, as I write about it, like an amateur, a fantasist, and an intruder who knows nothing of theatres. Compared to these vast organisations an actor, a writer, even a director, is like a sparrow to a skyscraper, a nasty piece of flesh stuck to the grinding mechanism. The expansion of buildings and their functions has actually taken these institutions clear of the reach of reason or logic or art. They are simply out of reach, cannot be reformed; they are beyond criticism, their success is final.

The solution can only be to start again, to start new theatres that are real, theatres with just actors, writers and directors (in that order).

Let the big theatres wither and die on their enormous swollen boughs – when the money gets cut off.

15 WHO CHOOSES WHO?

Turning over the theatres to actors, writers, directors, in that order

LOOKING AT THE THEATRE from the audience's point of view, they go to see the actors, not the directors and not the writers. It is therefore likely that the most healthy theatres would reflect that importance in the 'power structure'. At present, actors are somewhere at the bottom of the pile, hired as and when needed, talked about as rather despised hirelings, treated in fact in a way which reflects not their importance but their lack of power (which is very different). The further theatre has moved in that direction the deader it has become

Directors as a class are in fact two classes. If there is one type in the theatre likely to be rivalrous it is them; for, like actors and writers, they are often hired far too infrequently to make a good career, and their rate of pay is not higher than a writer. So they need a few productions per year to get by. But since theatre companies do mainly plays by dead writers there are more shots for directors. (Directors sometimes point out that writers can have second or multiple productions of a play, but this is not common.) But for directors the possibilities for power are *far* greater. Writers and actors are almost categorically excluded, by directors, from management, and it is almost exclusively directors who are expected to apply to run theatres. This gives us a peculiar situation where those who are arguably *least* essential to the production of plays are those with all the power. It is as if to continue to exist at all they need to have *all* the power. When the day comes that we realise they are so easily dispensable, then they will be removed; their power will be no more.

As a group the quality of their work is relatively hard to assess. Given a good play with a good cast it's hard to ruin it (but not impossible). Those who get off to a flying start, from Oxford for example, are given good plays with good actors and generally succeed. If the theatre can

pay for a good designer then the job is sewn up: any director who leaves them to it will get a moderate result. From a series of these he can drift into a reasonable career, and if he is well connected or good at networking and a conformist, he can end up running a theatre quite early on, and whether he runs one or not, he will at any rate be put in a position where he will be judging writers and actors who are his superiors in age, experience and ability. This is not to say that the director's craft is not an art it is. Good directors, who do actually direct, in detail, are important to getting the best results; but this can be the writer, or an actor, or a director. Naturally, most directors pretend that only directors can direct (and that writers definitely *cannot* direct: this is one of the most vital fictions if they are to preserve their power).

There are some excellent directors, talented and artistic, and I am lucky enough to have worked with them. Don't think I don't like directors, I do. (Some of my best friends are directors...)

The fact that many directors are only directors because they *say* they are is worth remembering. Take two friends at university: one chooses to call himself a director and does a few student productions, and the other calls himself a writer – the director will end up sitting in judgement over his friend for the rest of their lives. It is easy for all to see the writer's failings, it's all down there in print to be seen in the script. Most new directors choose famous, old, proven plays, and build their careers on tested material. Less can go wrong, and no-one can sit and judge over you unless they have recently seen your work, and unless you really, really blew it badly, it will always be a matter of opinion.

Quite the opposite would be the more natural situation. There are many people who could direct a good play, but fewer who could write one. It is more suitable for the writer to select the director than the other way around, or indeed he can direct it himself.

But who is to choose the play?

Actors, of course. And if not actors then writers, then directors, in that order. In the order of their relative importance to the process. This would better serve the audiences.

And who is to choose the actors? Well, who chooses the directors now? Other directors. So other actors can choose the actors.

If you put power in the hands of, let us say, a constantly rotating group of actors, and even writers, if they were expected to chose simply according to their preferences, there would, I think, be less likelihood of any consistent artistic policy, other than the selection of plays on their individual merit. That would be an enormous advance on what we have now, which is all the impositions between the plays that get written, and the audiences they are intended for. Impositions of a director's search for his theme, or the best play for his career, or for the next great writer, or the Zeitgeist, which he seeks to control, or to predetermine or in some cases to silence, like Herod. If the aim is to achieve the maximum variety of style and content then the replacement of policy with merit would be the simplest way to achieve it – merit being something which can be found in any style, with any content. A 'good piece of theatre' may seem like a vague criterion, but its vagueness is its main advantage.

16 RECLAIM THE THEATRES!

WE LIVE IN AN era, not unique, of powerful agencies, other than just governments, those whose primary aim is not just to make money, but to extend their influence. Large corporations and international organisations, such as the EU and the World Bank, all use their considerable power to influence people's minds in a way which suits their requirements. It is an era where the definitions of human qualities and aspirations are largely under the control of immense systems which dwarf not just individuals but communities.

It is a time when art should be on its guard against these enormous influences if it is to maintain any of its role as a critic of society. The alternative is to celebrate the dominant orthodoxy. What artists have to realise now is that, even at their furthest fringes, they are confirming the new orthodoxy. In fact, the further out they think they are, the more likely they are to be hugging the coast.

Artists have to be clear in their minds about the shifting of names and ideologies that has taken place. It is fairly silly to carry on as if nothing has happened, as if conditions were the same now as they were in 1930 or in 1950, as if the role of the dissenting artist can be pursued in the same way now as then. There is no point rebelling against a shadow of a class which is long passed. When the rebel has become the master, then you cannot go on serving him and still call yourself a rebel. You have to judge the tree by its fruit; if Marxism and deconstruction and other philosophies claim to be the force of rebellion and change, you must look to see if they are, or if they are in fact the means by which very powerful agencies perpetuate the misery and chaos of modern society, and all the suffering it brings to the least powerful within it. It is no longer a matter of style alone. It is no longer a question of what *you* would like to think of yourself as being. Finally there must come a time when a generation will take responsibility for how things actually *are*, and try to change them for the better, with *no regard for ideologies.*

If there is always need for rebellion, because power often is complacent and then misused, then what is proving difficult in our era, in Britain at least, is identifying correctly where the power rests and where any rebellion to correct it ought to be directed. Theatre, and the other arts, seem the most confused of all over this, seem the least able to see past the wrongly attributed labels; partly because they are among the beneficiaries of the confusion, and of the new order.

It is not an easy task, perhaps, because of the inappropriate naming of things in our era. For this reason it is most important for artists and writers to be independent-minded and to resist the ready-made presumptions, the lists of friends and enemies made up for us by the orthodoxies; it means a writer must constantly be on his guard against these creeping into his thinking; it means, in fact, having the courage to tear it all up and start again. To the average writer whose mind is formed by identification with the left it is, no doubt, a demanding process. To the younger generations who have been subjected to the government control which has been substituted for education it may be difficult in another way. They have to identify what parts of their thinking have been formed by the propaganda and jargon of the left-wing capitalist consumer training they have had forced down their throats.

They will have to search the annals for old references. Hopefully the innate scepticism of the school pupil will help them do away with some of the lies of the present generation's 'educators'. And yet, at the same time, they have to beware the effects of the waters they are cutting loose into. It is a society where violence and impatience and intolerance lie waiting. For renewal they must seek far into the past for wisdom and decency. They have to turn their eyes away from what shines brightest.

The best way to really rebel at the moment is to prefer the past to the present. If you are a student, try it and see how wild your teacher will get.

For theatre to be alive again, it has to reject not only the dead hand of government, no matter what its ideology. It has to reject the values of consumerism, and that now includes many of their own dearest-held presumptions: that means what they think of as individualism is in fact

egotism; what they think of as rebellion is actually to become a degraded violent pawn in a violent manipulation; what they think of as courage is arrogance; what they think of as youth is only stupidity.

The enquiring mind they are taught to have is, in fact, only the mind most pliable to the *diktats* of rationalism, that same rationalism which swept away everything which could have resisted the two materialist ideologies; it is a mind which is automatically pressed into their service, and there are many such minds.

The effect of bureaucratisation is to effectively build ideologies that are hostile to art into the structure of arts institutions themselves. For the theatres to regain any artistic freedom and become places where these ideologies can be fought, they have to have a revolution against bureaucracy too. This can mean nothing else than to sack non-artistic staff. And if you lack the power to sack them, lock them out of the building. This for two reasons: 1) because they use up the money which could be spent on producing plays; 2) because their very presence in the theatre perverts the function of theatre and makes art less possible – that is, they are a positive hindrance. One way they are a hindrance is that their preponderance in the building simply lessens the status of the artistic staff. Anyone can feel it in a theatre. It has gone so far that sometimes you might see an actor lurking about and think: 'Is he *allowed* to be there?'; and the answer is, yes if he keeps to the designated areas.

What we need is theatres populated almost entirely by artistic staff. Be prepared for the vested interests to declare that this is naïve – then sack them.

17 FINDING THE FUTURE IN THE PAST

A message to the young reader

FORTUNATELY, NO MATTER HOW bad the present, and no matter how inevitable and unavoidable that present seems to be, there will be always be a future generation and there is always a chance that they will reject the destiny that has been handed to them. Today's gun-toting rebels are tomorrow's old guard, and they can be overthrown.

As far as theatre is concerned we want plays that wouldn't be accepted by theatres, plays that would be rejected and passed over. Then we want to remake the theatres until they are the kind of theatres that do accept them.

A new generation of playwrights would not accept the doctrines and values of the old theatre, conventional left-wing theatre and its immoral, nihilistic, cynical and often violent successor.

Refuse to accept the conventional values of both the political establishment, and the writers and directors who are part of it (and that's almost everyone), refuse to absorb the values of entertainment culture, of the impatient philistine attitudes of your own generation, the violence and intolerance.

Reject the temptation to build your future and your vision on the ignorance created by the education you have been given by your masters, the previous generation.

You will need to set about repairing your ignorance by finding a new respect for knowledge and for culture, in precisely the old meaning of the word so hated by the establishment. Seek for renewal in the dustbin of history, where the present establishment has put much of what is valuable.

Fight the tendency for your manners and social values to be determined by technology, as it is now taken for granted that they should be.

Morality must always overrule technological expedience, or we will set ourselves inside a tyranny.

Seek freedom from the destiny that has been preordained for you, look for inspiration beyond the immediate prison of the physical and social world that has been built for you, and sold to you as your own. Look beyond it for an understanding of morality and ethics, and the world of the spirit and the indefinable and the undefined. Look for gentleness and love, look for patience and moderation, equality and kindness, look for peacefulness; look for slowness and reject the rash impatient form of cruelty and bullying which is being sold to you as 'youth'. Find again the youth that is purity and innocence and hopefulness; reject the rashness and greed and cynicism that has been made your inheritance.

Look for love of your own country and a love of every other country; not the twisted self-hate and the militant partiality and its world of villains and favourites that is born of doctrine, of either left or right.

Learn to love the past more than the present; because that way you will learn humility and self-restraint and wisdom that will save you from spending your youth in a present designed by your immediate predecessors.

Refuse to celebrate what they tell you has been the path to the present. Look for what they have destroyed and rejected and salvage that. If you don't, you will be falling for the trick and taking the bait that will make you conform while believing you are doing otherwise.

Look beyond our own age and epoch and look as far into the future as you need to, but look further into the past which is where human life exists. Learn what it is to be human from the past; if you don't you will take your idea of humanity from the present and inherit nothing but symptoms and nothing of the healthy body, and thereby be manipulated by your immediate predecessors, who have sought to close off access to the past, and eliminate any alternative to the world they have created.

Remember, the lies of the past are better than the lies of the present, if for no other reason than that no-one believes in them any more.